Baroque & Rococo

Baroque & Rococo

Marco Bussagli
Mattia Reiche

Baroque & Rococo

Baroque & Rococo

STERLING

New York / London
www.sterlingpublishing.com

STERLING and the distinctive Sterling logo are registered trademarks of Sterling Publishing Co., Inc.

Library of Congress Cataloging-in-Publication Data

Bussagli, Marco, 1957-
 [Barocco, Rococò. English]
 Baroque & Rococo / by Marco Bussagli and Mattia Reiche ; [English translation Patrick McKeown].
 p. cm.
Originally published: Barocco, Rococò, written by Marco Bussagli and Mattia Reiche.
Includes bibliographical references and index.
 ISBN 978-1-4027-5925-3
 1. Art, Baroque. 2. Art, Rococo. I. Reiche, Mattia. II. Title. III. Title: Baroque and Rococo.
 N6415.B3B8713 2009
 709.03'2—dc22

2008051371

10 9 8 7 6 5 4 3 2 1

This book originally edited under the title *Barocco, Rococò*, written by Marco Bussagli and Mattia Reiche, published in *I Grandi stili dell'arte*, edited by Gloria Fossi, Giunti Editore, 2006. Pages 358-539

English translation by Patrick McKeown

Managing Editor and Art consultant: Gloria Fossi
Series graphic design: Lorenzo Pacini
Italian Layout: CB Graphic di Cristina Baruffi
Iconographical Research: Cristina Reggioli
Italian Indexes: Alessandra Manetti

Photograph Credits
Archivio Giunti, Firenze (foto Nicola Grifoni, Firenze; foto Rabatti & Domingie, Firenze); Araldo De Luca, Roma; Archivi Alinari, Firenze; Erich Lessing/Contrasto; Foto Scala; Granataimages.com; Olycom; SIE; Front cover: © The Bridgeman Art Library/Archivi Alinari, Firenze

The publisher is prepared to fulfill any legal obligation regarding those images for which a source could not be found.

Copyright © 2007 Giunti Editore S.p.A., Florence-Milano
www.giunti.it
Translation copyright © 2009 Sterling Publishing Co., Inc.

Published by Sterling Publishing Co., Inc.
387 Park Avenue South, New York, NY 10016
Distributed in Canada by Sterling Publishing
c/o Canadian Manda Group, 165 Dufferin Street
Toronto, Ontario, Canada M6K 3H6
Distributed in the United Kingdom by GMC Distribution Services
Castle Place, 166 High Street, Lewes, East Sussex, England BN7 1XU
Distributed in Australia by Capricorn Link (Australia) Pty. Ltd.
P.O. Box 704, Windsor, NSW 2756, Australia

Printed in China
All rights reserved

Sterling ISBN 978-1-4027-5925-3

For information about custom editions, special sales, premium and corporate purchases, please contact Sterling Special Sales Department at 800-805-5489 or specialsales@sterlingpublishing.com.

Baroque

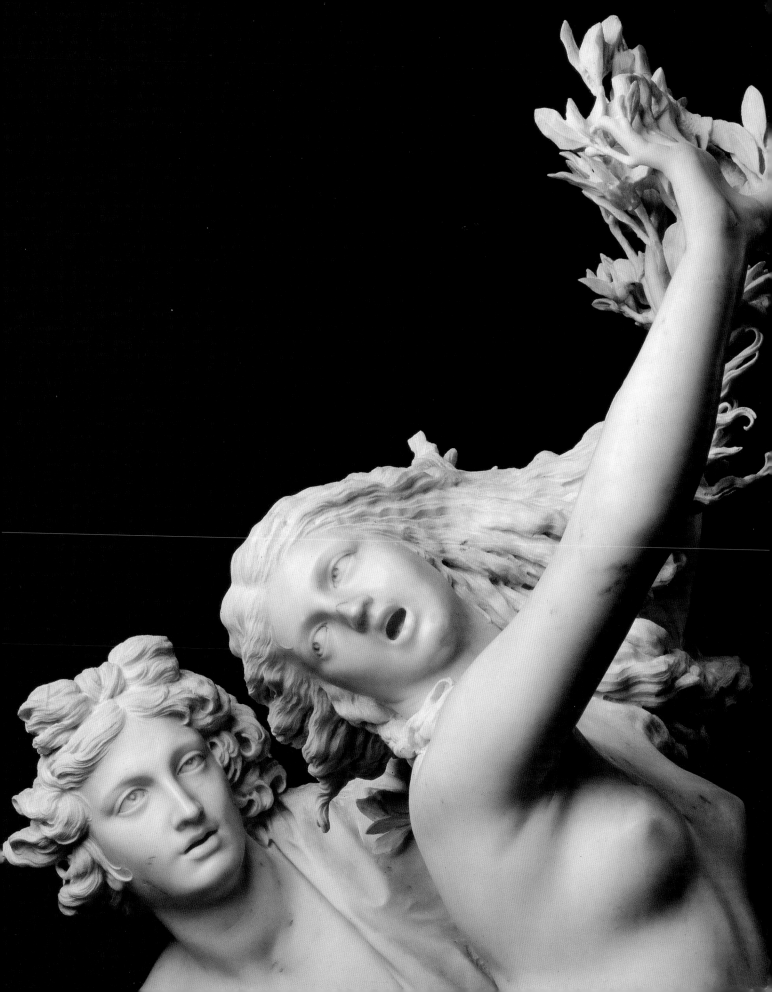

Previous page:
Gian Lorenzo Bernini
Apollo and Daphne, detail
1622–25, marble.
Rome, Borghese Gallery.

Opposite:
Gian Lorenzo Bernini
Cornaro Chapel
1647–51.
Rome, Santa Maria
della Vittoria.

Below:
**Carles Morató and
Antoni Bordons**
Miracle Altarpiece
Eighteenth century.
Solsonés, Lleida,
El Miracle.

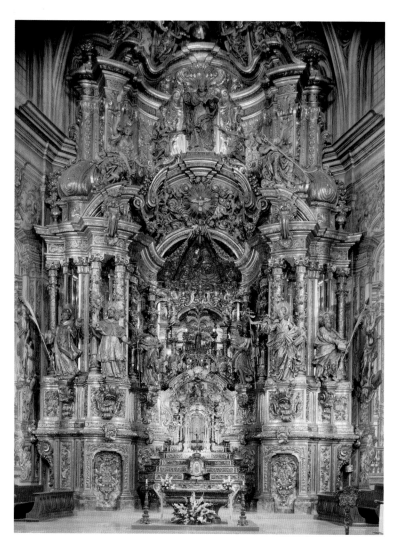

The Theatricality of Baroque

If there is one author whose work clearly represents the main features of the Baroque age, then that author is Pedro Calderón de la Barca, a huge talent in Spanish and world literature. His masterpiece, *La Vida Es Sueño* (*Life Is a Dream*), is both a metaphor for the human condition and a hymn in praise of Baroque artifice.

In the story, Basil, king of Poland, consults the stars and discovers that his newly born son will grow up to be a tyrant. In an effort to prevent this, the king locks little Segismundo in a tower in the mountains. He makes it known that the child died at birth and entrusts the boy to the care of his loyal servant,

Clotaldo, who deliberately raises Segismundo without education, like a savage. Before resolving to exclude Segismundo from the legitimate line of succession, King Basil decides to put his son to the test. He has the servant bring the sleeping boy to court, where he is told of his true identity when he wakes up. Now treated as the prince he really is, Segismundo, ruled by his instincts, soon behaves in a violent, arrogant, and selfish manner. The only person who kindles any feelings of love or gentleness in him is Rosaura, whom he met during his unknowing imprisonment. King Basil decides that he has indeed acted wisely and, after his son falls back to sleep, Basil takes him back to the tower. When the prince wakes up, he is convinced that the whole experience was just a dream and that life itself is a dream. Death and dying awaken us from that dream, and thanks to this, we conserve the memory of the good we have done. In the meantime, King Basil has abdicated in favor of Infanta Estrella and Duke Astolfo (who seduced and abandoned Rosaura). However, the old king is disappointed by how the pair rules. Segismundo is freed in a popular uprising and, now at the head of an army, defeats his enemies. After his victory, the new king, who has learned his lesson, bows to the will of his father, marries Estrella, forces Astolfo to make amends by marrying Rosaura, and inaugurates a new reign of wisdom and prosperity. Apart from the work's great stylistic beauty, Calderón's story contains all the ingredients of the Baroque poetics. It is also a useful guide in helping us understand the figurative aspects of the new style. One of the most consistently striking features of the story is the persistent gap, the ambiguous relationship, between fiction and reality, a theme that would be central to many works in the seventeenth century.

The idea of the theatrical, of the stage, was also a cornerstone of the Baroque aesthetic in the figurative arts, and Calderón wrote another marvelous work on the subject. In his *El Gran Teatro del Mundo* (*The Great Theatre of the World*, 1633),

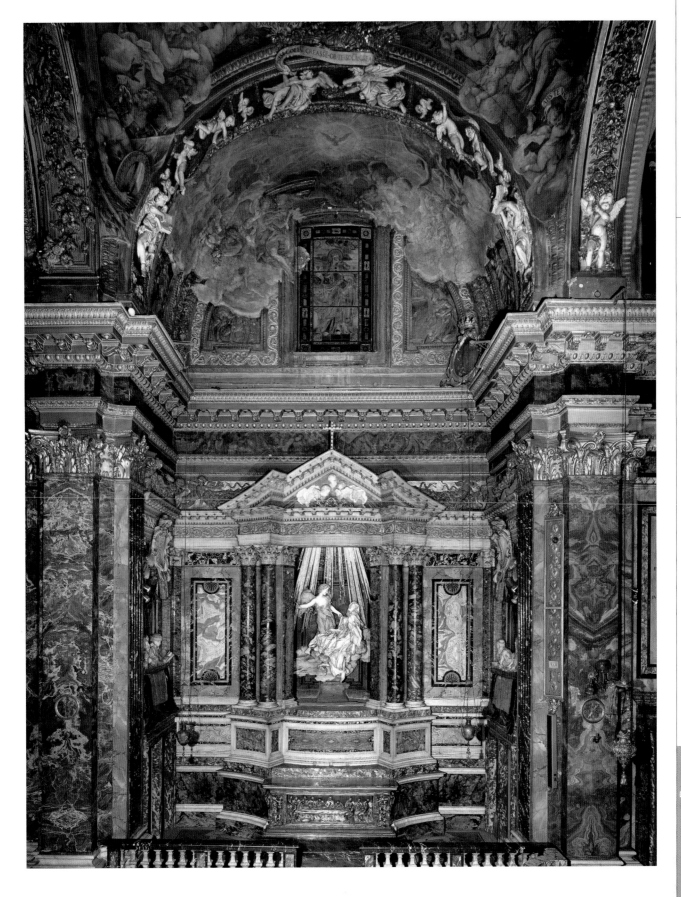

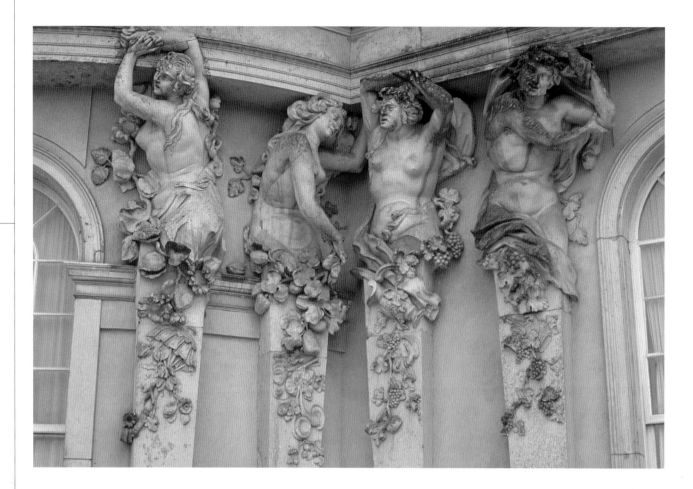

Georg Wenzeslaus von Knobelsdorff
Caryatids, detail of facade decorations
Mid-eighteenth century, marble.
Potsdam, Sanssouci Palace.

the world itself is called upon to prepare a stage where seven characters—the rich man, the king, the peasant, the beggar, Beauty, Discretion, and the unborn child—enter and exit the stage from doors in the cradle and the grave to receive prizes and punishments from the Author, who is acting as God. It is worth noting how the idea of artifice—a stylistic device from literature—and of allegory, metaphor, and other figures of rhetoric including hyperbole and synecdoche can also be found in the works of the great architects, painters, and sculptors of the age. A reading of Calderón's works takes us into the intimate core of the Baroque poetics, and we acquire an understanding of how it is reflected in the artworks of the period—art that was international in scope and movement, and thanks to Spain also reached the colonies in the Americas, giving Spain a leading role in the development of the figurative arts and architecture over the course of the century.

Defining Baroque

It is by no means easy to find a single point of convergence for such a complex phenomenon as the Baroque, but a useful starting point might be the origin of the word itself. In all likelihood the word is the result of a cross between the French word *baroque*—derived from *barocco*, the Portuguese word for "rough pearl," the type of pearl that had already been widely used in late Renaissance jewelry—and the Italian word *baroco*, which referred to a figure from rhetoric, an Aristotelian syllogism already familiar to scholars, which in turn produced sophisms and Byzantinism. We could illustrate the idea by borrowing from a verse by Antonio Abbondanti da Imola (1627) and claim that "salted meat quenches thirst." The reasoning here is clearly captious. Taking as our starting point the fact that salty food, however well washed down with wine, only serves to make us

thirsty, by logical progression we can reach the conclusion that a salty sausage quenches thirst, because eating one prompts us to drink a lot.

Such questions of meaning, which can all be traced back to the origin of the word *Baroque*, coincide with a number of aspects that recur in the seventeenth-century poetics, although it should be pointed out that the actual term *Baroque* was not used until the eighteenth century when it was applied by the critic Francesco Milizia (1725–98) from Puglia. Milizia, an admirer of the new Neoclassical style, used the Italian term *baroco* almost as a term of abuse. Writing in his *Dizionario delle belle arti del disegno*, he declared that "*baroco* is the superlative of the bizarre, the excessive and the ridiculous." Out of this one definition an entire negative critical tradition developed, lasting for the entire eighteenth and nineteenth centuries, and in Italy persisted up to and beyond 1946, the year in which the philosopher Benedetto Croce wrote his scathing, relentless assessment of the period in his *Storia dell'eta barocca* (*History of the Baroque Age*). Today, however, from an objective standpoint, we can now fully appreciate Baroque art and culture, and as our brief etymological analysis of the term shows, the roots of the movement can be found in France, Italy, Spain, and Portugal.

A profound cultural shift separates Baroque from the Renaissance. The enduring feature of the fifteenth and sixteenth centuries was the central role of politics and religion (later challenged by Mannerism). The mind-set of the Renaissance was anchored in what we might call a Ptolemaic view of the world, which translated into a political status quo where pope and emperor were fixed points on the same axis. Change in the seventeenth century brought a radical redistribution of power to a multitude of centers, both in politics (the sprawling empire of Charles V had given way to a plurality of nations) and in religion (the Catholic Church was no longer the only entity; there were a number of different faiths, some of which clashed with one

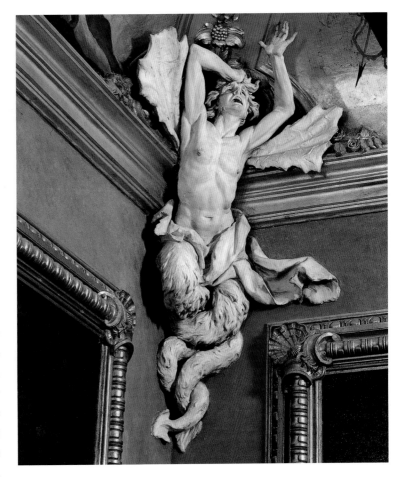

another and among themselves, as in the persistent Huguenot issue). Naturally, the upheaval was also felt in literature and the figurative arts.

Thus it should come as no surprise that while the Renaissance held the circle to be the perfect geometric form, Baroque preferred the ellipsis. Indeed, once the period abandoned the Aristotelian and Ptolemaic view that planets and stars described perfect circumferences in their movements, in light of the findings of Kepler and Galileo, even the heavenly bodies seemed to conform to an elliptical pattern.

In a sense, the plurality of centers of power, just like the plurality of worlds glimpsed by Giordano Bruno, was heralded by Pope Sixtus V's re-organization of Rome. The city's layout was hallmarked by obelisks installed in its many squares, connected by new roads, including Via Sistina. The hierarchical pyramid model of social organization was gradually, albeit slowly, leveling out, becoming

Giovanni Baratta
Monstrous Figure
Early eighteenth century, molded stucco.
Florence, Marucelli Fenzi Palace.

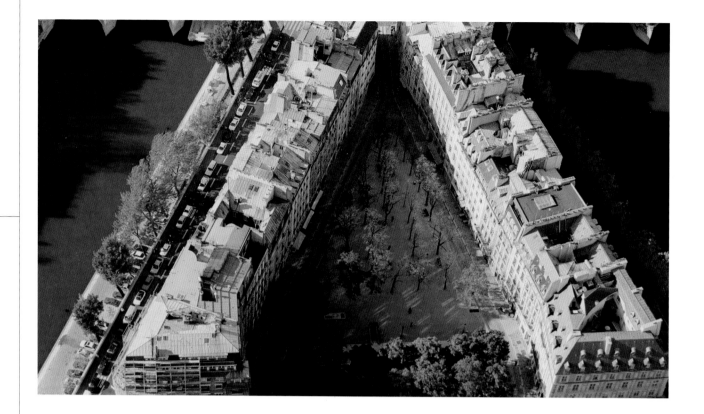

Above:
Aerial view of Place Dauphine
1607.
Paris.

Right:
Gian Lorenzo Bernini
River Ganges, detail of
the *Fountain of the Four Rivers*
1648–51, travertine and porphyry.
Rome, Piazza Navona.

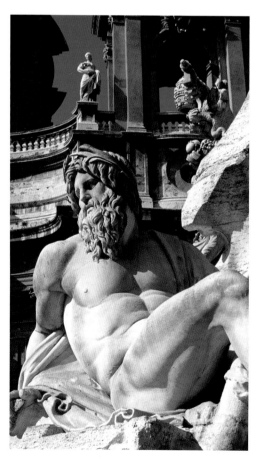

horizontal, so that every individual had a role to play as part of a much greater whole, whether religious or secular. In other words, every individual, within the limits of his or her role, was a player in the world's great theater, where the stage is the whole universe and the script, written by God, corresponds to everyday life. It is thus hardly surprising that one of the major components of architecture was not strictly structural but visual, where every square and piazza (again, a rhetorical device) was a stage, and roads and avenues were like the theater wings where actors waited to make their entrance. This is the case with Piazza Navona, one of the focal points in Baroque Rome's vast arena.

The multiplication of nodes within the city became a model that was exported to the rest of Europe, as can be seen, for example, in the wave of *places royales* (the round Place des Victoires and the rectangular Place de Vendôme), created with the express purpose of conveying a clear political message, underlining the glory of the sovereign. Here, the prototype was triangular Place Dauphine,

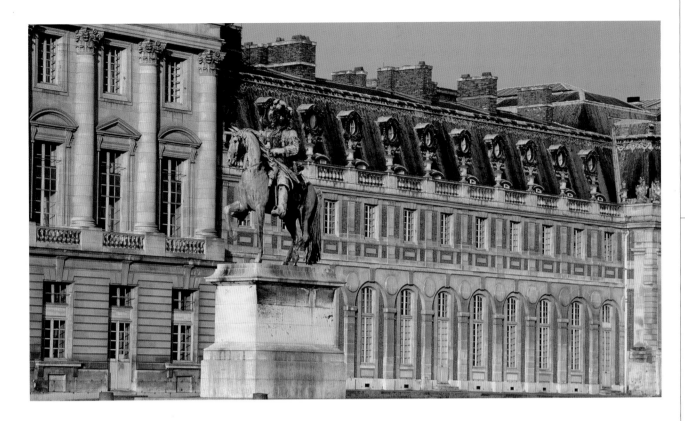

commissioned by Henri IV in 1605, and organized—as were all ensuing squares—around a statue of the monarch set at the center of the urban space, the statue of the king acting as a cipher, a metaphor for the heart of the city. The same features can be found in the urban development of Versailles. The expansion of the village and château reprised the "trident" layout of Piazza del Popolo in Rome (already there before Carlo Rainaldi embarked on that phase of the pope's rebuilding program that saw the construction of "twin churches" on either side of the piazza) and increased the number of open spaces. The urban expansion of Versailles, begun in 1661, kept pace with trends in Paris and replicated the idea of city squares as points of exchange on an unencumbered, free-flowing road network (see page 14). The three avenues that converge on Place d'Armes (which, along with the stables, in turn open onto the vast space before the château) are like radials that inject a certain energetic thrust into the urban fabric crossed by perpendicular roads.

In the Baroque city, the square has its counterpart and continuation in the monument. For that matter, the whole of Baroque architecture is monumental, and so are city squares. While the square is an empty space, the monument is an imposing structure with a clear message, a solid presence with ideological significance. In this sense, the quintessential monument is, of course,

Place d'Armes, with equestrian statue of Louis XIV in front of the palace Versailles.

Gian Lorenzo Bernini *Equestrian Statue of the Sun King* (preliminary model) c. 1669, terracotta. Rome, Borghese Gallery.

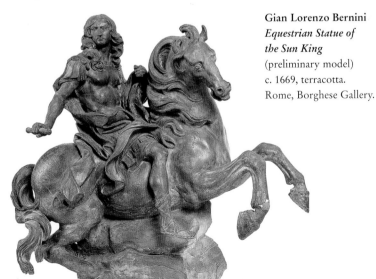

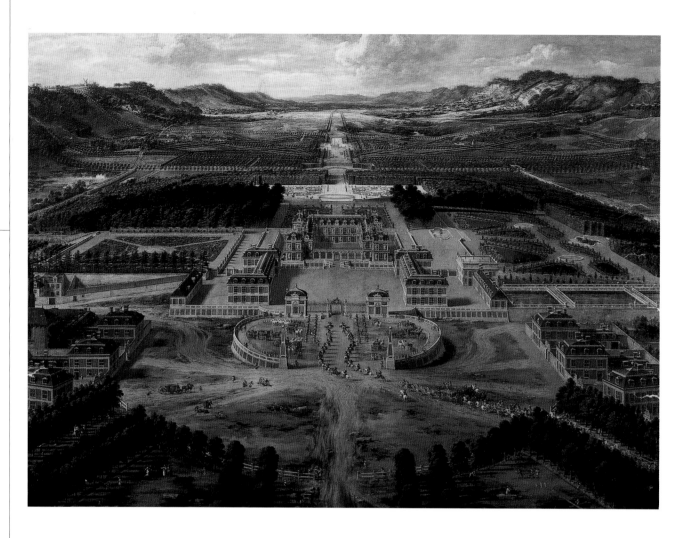

Pierre Patel
Chateau de Versailles
c. 1668, oil on canvas.
Musée et domaine
national de Versailles.

Versailles, the architectural representation of absolute monarchy, a small universe where the sovereign is the prime mover and the sun that lights up creation. Louis Le Vau began work on Versailles in 1661 and continued until his death in 1670. The château was finished in 1690 under Jules Hardouin-Mansart, who put every effort into making the palace even more sumptuously flamboyant. The front of the building was expanded toward the park, changing the original late Mannerist layout. Initially conceived as an immense U shape facing the village of Versailles, the château stretched out its wings, as it were, as though to welcome anyone who might decide to visit.

Gian Lorenzo Bernini's colonnade in Saint Peter's in Rome embodies a similar, though more spiritual, concept. As Bernini's brother recounted, the great architect explained his choice: "Given that the church of Saint Peter's was to stand as a model for all the others, then it was only fitting that it have a portico which as with open arms welcomed Catholics to confirm them in their faith, heretics to bring them into the Church, and infidels to enlighten them with the true faith." As we can see, square and monument come together in a grand, seamless reciprocity that would be repeated, on a smaller scale, in the courtyards of France's hotels and in the layout of El Escorial (which could also boast classical ancestry, as in the emperor Diocletian's palace in Split, Croatia). The intersection of the external space (which squeezes its way into the built-up environment, leaving behind Nature to become urban space) and the building interior—a fundamental component of Baroque architecture—is achieved through the facade

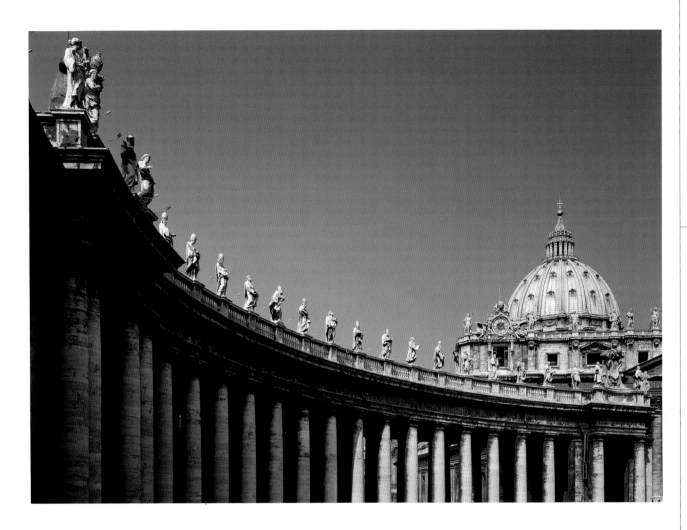

(which does seem to feel the burden of this mediation), achieved by use of the kind of malleable structural plasticity that was simply unknown in the Renaissance. This new movement, which derived from the prototypes designed in Italy by Carlo Fontana, Pietro da Cortona, and Baldassarre Longhena, rippled outward, spreading abroad, as in the church of Les Invalides in Paris, built on the same axis as Hôtel des Invalides. The complex Baroque concept of space also found its way to Scandinavia, thanks to artists like Nicodemus Tessin the Younger, who had trained in Rome under Fontana and Bernini, thus showing the new style's resilience and versatility in adapting to new cultural and artistic contexts.

Other distinctive features of the Baroque are its predilection for artifice and pretense or illusion, which were given shape not only in literature and

Above:
Gian Lorenzo Bernini
Colonnade of Saint Peter's Basilica, detail
1656–67.
Vatican City.

Left:
Francesco Borromini
Trompe l'oeil perspective gallery
1653.
Rome, Spada Palace.

Baroque

architecture (as is evident in the illusionary perspective Borromini devised for Spada Palace in Rome) but also in other spheres of the figurative arts.

Sculpture

A typical example, perhaps the earliest manifestation of Baroque sculpture (which first came to light in Italy, unlike Rococo), can be identified in the statue *The Martyrdom of Saint Cecilia* by Stefano Maderno, which is traditionally said to depict the martyr in the same position in which her dead body was recovered from her tomb (1599) by Cardinal Paolo Emilio Sfondrato, who commissioned the statue for the church of Santa Cecilia in Rome (the statue was recently returned to the church after restoration work). Implicit in the relationship between the work of art and "the real thing" is the mechanism of artifice that aims to present the simulacrum of the saint as real and to persuade the viewer that the event it represents is also real.

The same logic lay behind the creation of the Sacri Monti, the holy mounts that were developed at the time of the Counter-Reformation and became common across Europe. In these places, described as "mountain theaters" by Giovanni Testori, the Passion of Christ was "enacted" through painted wooden statues and sweeping paintings meant to inspire and awe the devout. The most famous is the holy mount of Varallo, which was given its final layout during the eighteenth century.

Persuasion, rhetorical art exercised through artifice, was thus one of the characteristic features that pervaded a great deal of seventeenth-century sculpture. A particularly striking example is the *Cattedra*, the throne of Saint Peter (shown on page 18), which was conceived as a veritable stage set, a device capable of transforming natural light into divine glory. Indeed, this is what seems to happen, thanks to the window behind the throne concealed by the radiant glory of the Holy Spirit. In rhetorical terms, the triumphal arrangement of the *Cattedra*—the wooden chair contained within Bernini's visually stunning outer shell actually dates from the twelfth century—is a synecdoche, a representation of the whole by one of its parts. The *Cattedra* alludes to the glory of the Catholic Church, of which it is considered the most meaningful part.

Facing page:
Pier Francesco Mazzucchelli (il Morazzone), Gaudenzio Ferrari, and assistants
Ecce Homo
1609–12.
Varallo, Sacro Monte.

Stefano Maderno
The Martyrdom of Saint Cecilia
1601, marble.
Rome, Santa Cecilia in Trastevere.

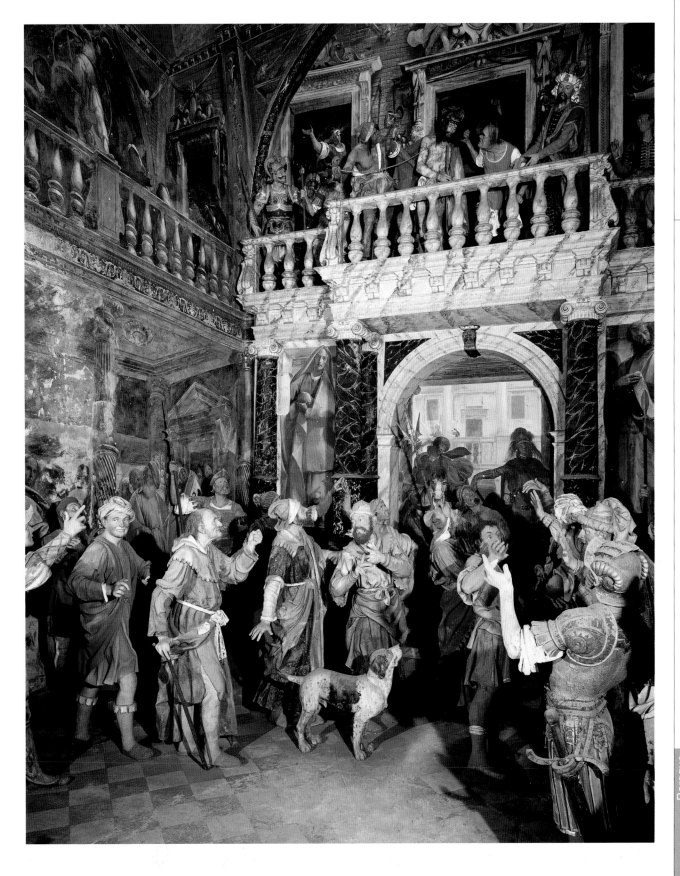

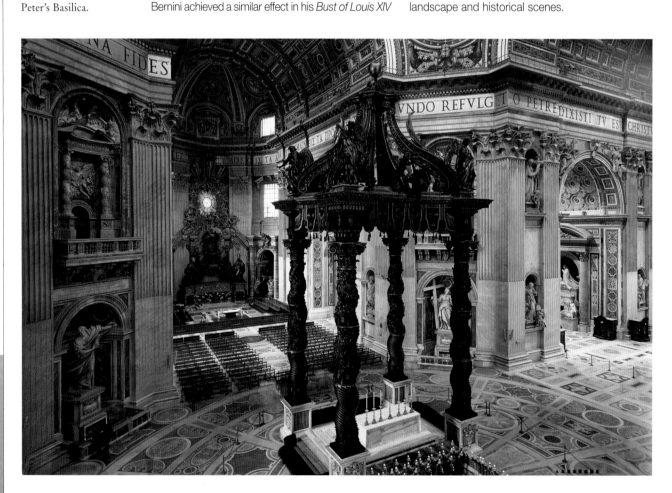

Baroque balcony decoration
Noto, Nicolaci Palace.

Gian Lorenzo Bernini
View of transept with baldachin and throne of Saint Peter
Vatican City, Saint Peter's Basilica.

Thus, rhetoric and theatricality had explicitly persuasive functions within the framework of Baroque expression, and this expression was by no means limited to the religious sphere. An example would be the *Equestrian Statue of the Sun King* designed by Bernini and meant to pay tribute to the figure of the sovereign dominating history (a preliminary model, shown on page 13, can be seen in the Borghese Gallery), which François Girardon then transformed into *Marcus Curtius Jumping into the Fiery Chasm*. In Bernini's original design, the towering horse was an allusion to the monarch's heroic aura and his role in the world. Bernini achieved a similar effect in his *Bust of Louis XIV*

(Versailles); the monarch's face is transfigured by the windswept cloak, giving him the appearance of a secular vision.

Painting

Maintaining the precise definition of Baroque that we have endeavored to apply so far, in the sphere of painting, the style is to be found mainly in those wide skies that decorated the ceilings of grand palazzos and churches, where artifice and persuasion once again were brought to the fore. The complex diversity of seventeenth-century painting is not limited to those painted ceilings, of course. The period sees the rise of genre painting, starting with the keenly observed still lifes of the Flemish masters and continuing with the development of the landscape and historical scenes.

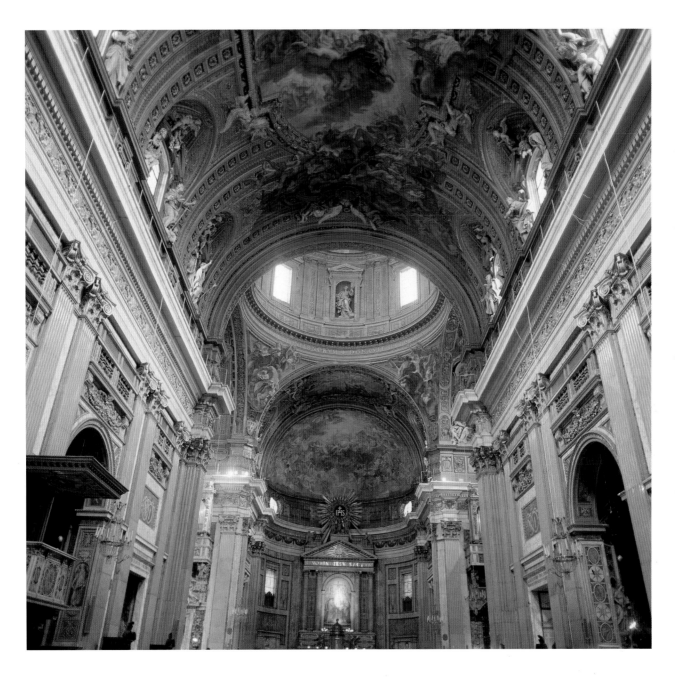

In the course of the seventeenth century, artists were drawn to the study of classicism and to new experiments with light and color. Mannerism's legacy of a palette of bright colors that lasted throughout the seventeenth century with few variations was used by artists of the caliber of Annibale Carracci, Carlo Maratta, and Nicolas Poussin. This school of artists also appropriated the classicist roots of depiction. The century also saw the rise of another group of artists, inspired by a single, strong-minded, powerful personality: Michelangelo Merisi, known as Caravaggio. This highly creative artist trained under Cavalier d'Arpino and the Bergamo painter Simone Peterzano. The style of his mature years represented a real upheaval in the use of colors and classical models: the palette became much darker, shifting focus onto light and shade, which were also imbued with symbolism. Although Caravaggio had no direct pupils, the new Caravaggesque style was imitated by many,

Giovanni Battista Gaulli (Baciccio)
Interior view of church with cupola and vaulted ceiling
1672–83.
Rome, Church of the Gesù.

Diego Velázquez
The Lunch
1618, oil on canvas.
Saint Petersburg,
Hermitage.

Caravaggio
*Crucifixion of
Saint Peter*
1601, oil on canvas.
Rome, Santa Maria del
Popolo, Cerasi Chapel.

Facing page:
Jusepe de Ribera
*The Deliverance of
Saint Peter,* detail
(full on page 25)
signed and dated 1639,
oil on canvas.
Madrid, Prado Museum.

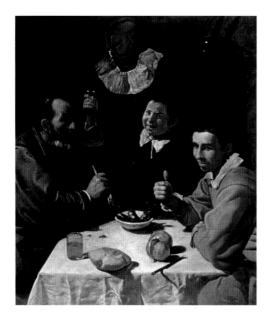

exerting considerable influence on painting throughout the seventeenth century. His style shaped the work of leading painters across Europe, starting with Gerrit van Honthorst, who was dubbed "Gherardo delle Notti" ("Gerard of the Nights") because of his approach to color and shading. Many other artists followed in Caravaggio's footsteps, including painters of the talent of Rubens, Vouet, de La Tour, Velázquez, Van Dyck, and Rembrandt, to list only some of the more famous. All of these great painters took up Caravaggio's mantle and brought their own personal interpretations to his style without following him slavishly, producing new and very distinctive variations, which in turn became models for later generations of painters.

The dynamic and varied world of seventeenth-century painting also encompassed other styles and artists. Among them were the Bamboccianti, who took their inspiration from Caravaggio and the Flemish painter Pieter van Laer (1592–1642). The working-class inhabitants of Rome's Via Margutta, where van Laer lived, called him a *bamboccio* (puppet) because of his stature and physical appearance. A group of artists gathered around this rather singular individual; they eschewed rhetoric and kept their distance from the mythology of official art. Instead, they concentrated on genre painting, capturing scenes of everyday life and depicting for posterity the reality of the human condition of the time.

Architecture

Plasticity of form was the dominant hallmark of Baroque architecture. The tendency was to produce dynamic, flowing surfaces, as we can see, for example, in the masterpieces created by Bernini and Borromini in Rome.

Baroque was fundamentally a Roman phenomenon, and from Rome it radiated outward over Italy (the work of Baldassarre Longhena in Venice, Guarini in Turin, the San Felice Theater in Naples) and Europe. Bernini's design for the Louvre

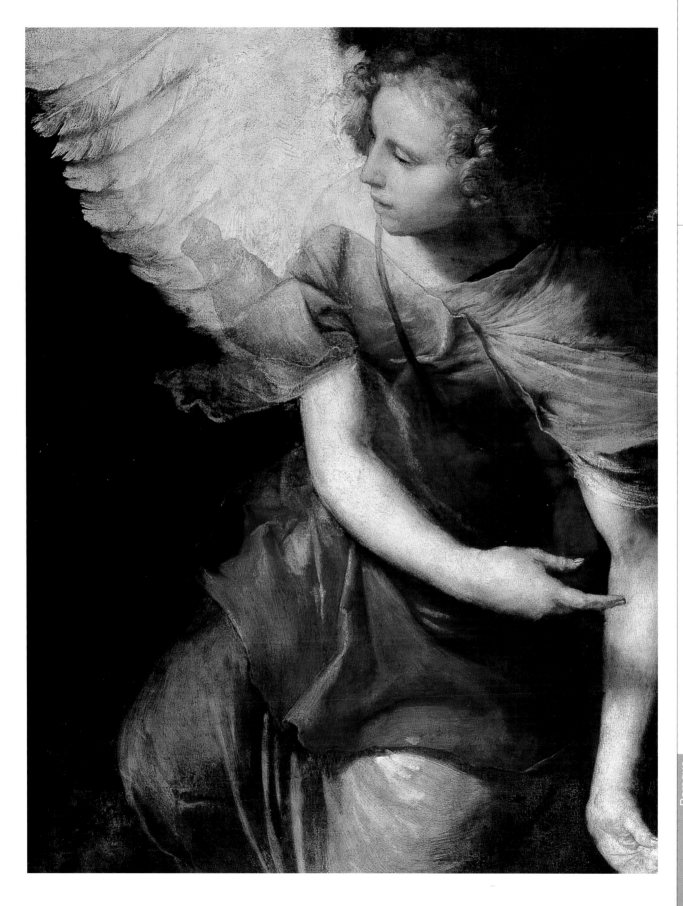

Peter Paul Rubens
*Nature Adorned by
the Graces*
1615–16, oil on canvas.
Glasgow, Museum and
Art Galleries.

Facing page, top:
**Sanssouci Palace
and gardens**
Potsdam.

Facing page, bottom:
Cloister
Early eighteenth century.
Salamanca, Clerecía
(Church of the
Holy Spirit).

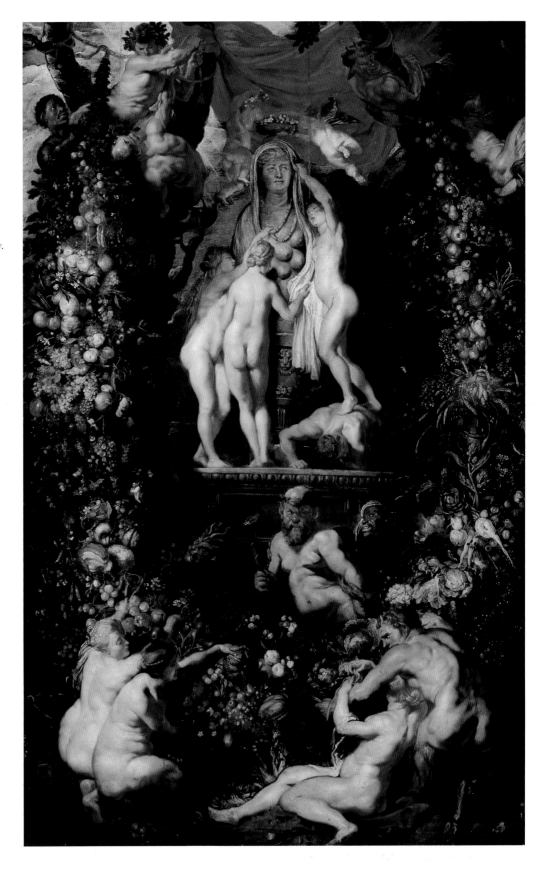

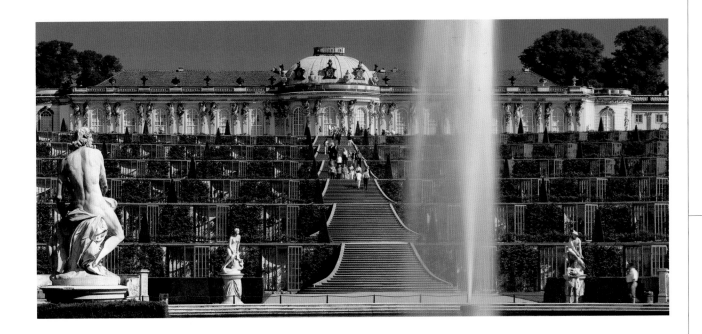

(which was never actually implemented), with its cylindrical central block and two wings, is an exemplary illustration of how this feeling for Baroque plasticity was exported; Bernini's influence would resurface, for example, in the Sanssouci Palace in Potsdam, designed by Georg Wenzeslaus von Knobelsdorff (1699–1753) for Frederick II of Prussia, with construction starting in 1745. Although it is in fact a late Baroque building, Sanssouci can be considered a contemporary reworking of Bernini's plans for the Louvre, with the similar cylindrical main block and side wings.

We can find significant earlier examples in Spain, starting with the first great work by Juan Gómez de Mora (1586–1648): Madrid's Plaza Major, built between 1617 and 1619, which for centuries was a destination for tourists, the curious, and art lovers.

In 1617, Philip III—at the bequest of his recently deceased queen, Margaret of Austria—called upon Gómez de Mora to design the Clerecía at Salamanca, the Jesuit complex completed during the eighteenth century. The building clearly shows the Italian influence on Spanish Baroque architecture (the high dome and the facade with its lateral twin towers recall Bernini's work and the work of Rainaldi and Borromini on Sant'Agnese in Agone in Rome).

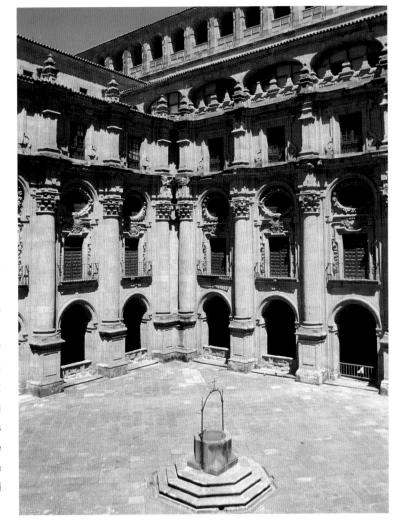

Light

Light constituted a veritable revolution for Baroque art. Until Caravaggio tackled the issue in his monumental painting *The Calling of Saint Matthew*, bright colors and cheerful atmospheres had been the rule, and Caravaggio himself had used a light, almost sunny palette in his *Fortune Teller* (1595, shown on page 43). After his radical shift in approach, his works began to be dominated by intense shadows and a warmer light. A number of artists then fell under the influence of what was known as the Manfredi method (named after the style's best-known exponent, the Roman painter Bartolomeo Manfredi), and the Caravaggio style soon spread across Europe, adopted by artists like Rubens, Rembrandt, Ribera, Murillo, Valentin, and Régnier. Light was not always invested with mystical force; the huge success encountered by genre paintings had transformed what had begun as a symbolic necessity into a powerful stylistic device. In churches, where natural light is bathed in transcendental significance (as in Bernini's scenic device, the Cattedra in Saint Peter's), the decision to "pierce" ceilings and domes to allow visions of Paradise implied using natural light to theatrical effect.

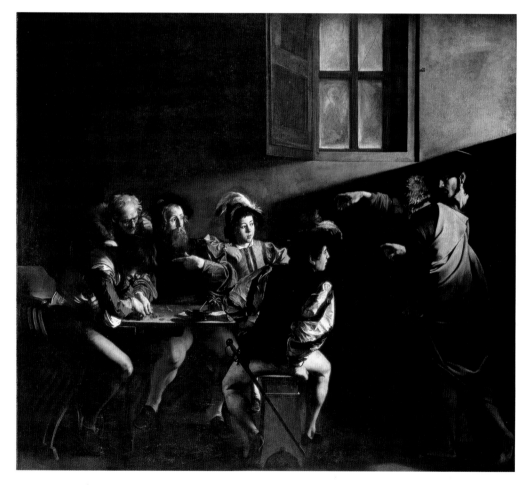

Caravaggio
The Calling of St. Matthew
1599–1600, oil on canvas.
Rome, San Luigi dei Francesi, Contarelli Chapel.

Facing page, clockwise from top:
Gerrit van Honthorst
Adoration of the Infant Jesus
c. 1620, oil on panel.
Florence, Uffizi Gallery.

Jusepe de Ribera
The Deliverance of Saint Peter
signed and dated 1639, oil on canvas.
Madrid, Prado Museum.

Gian Lorenzo Bernini
Throne of Saint Peter
1657–66.
Vatican City, Saint Peter's Basilica.

Georges de La Tour
The Newborn
c. 1640–50, oil on canvas.
Rennes, Fine Arts Museum.

Nicolas Régnier
Card Players (La Buonaventura)
c. 1620–22, oil on canvas.
Budapest, Museum of Fine Arts.

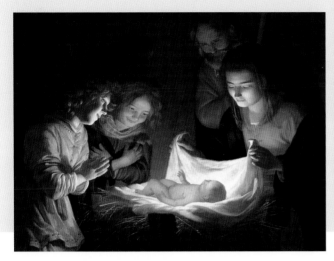

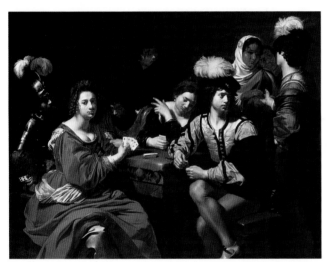

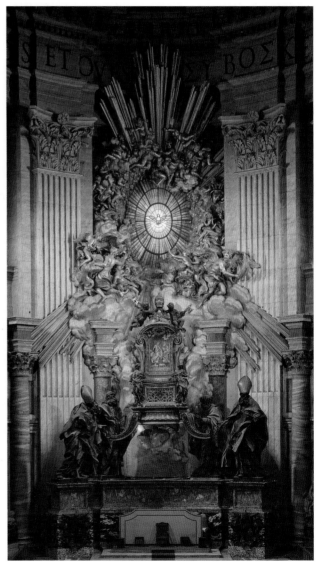

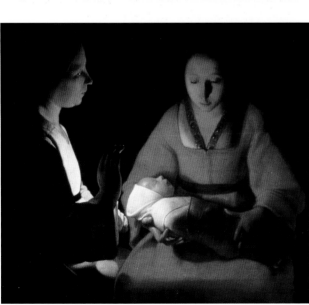

Still Life

In the seventeenth century, the various academies of painting established a ranking of pictorial categories and genres that placed the painting of historical subjects (the category included scenes from the Bible) at the top of the list of artistic output, followed by other genres that gradually became less important—and less prestigious—as they slid down the list. Among the other genres was still life, which in previous centuries had been considered merely an accessory, like landscape, to more important works. Thus, if we exclude the paintings of ancient Rome and rare examples from the early and late Middle Ages—for instance,

Taddeo Gaddi's *Alcove with Liturgical Objects* in the church of Santa Croce, Florence, or the inlaid wooden panels in Federico da Montefeltro's private study, in Urbino—we have to wait until Caravaggio and his *Basket of Fruit* before we encounter the first modern still life (see below). Caravaggio excluded all other narrative themes from this famous painting, making the fruit and wicker basket the main subjects of the canvas. Furthermore, Caravaggio's painting includes symbolic elements referring to sin and the transience of life, themes that were to become among the most common and profound of the genre.

Close analysis will show that even those paintings depicting tables laden with food, and in appearance devoid of any deeper

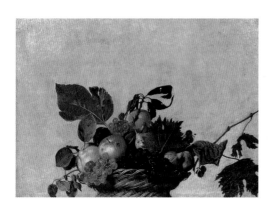

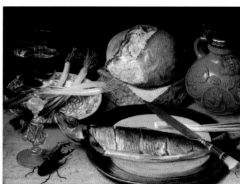

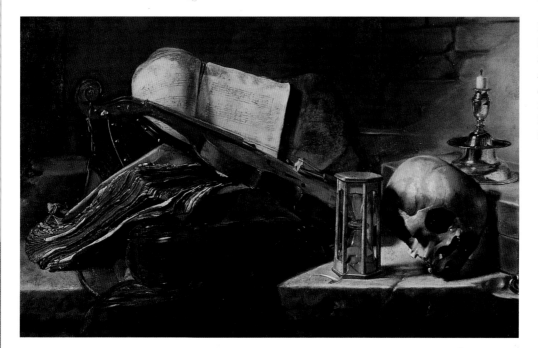

Clockwise, from far left:
Caravaggio
Basket of Fruit
1597–98, oil on canvas.
Milan, Ambrosiana
Picture Gallery.

George Flegel
***Still Life with Fish and
Stag Beetle***
1635, oil on panel.
Cologne, Wallraf-
Richartz Museum.

**Followers of
Rembrandt**
***Still Life with Sheet
Music, Violin, Hourglass,
and Skull***
1627, oil on canvas.
Heino, Hannemade
Stuers Fundatie.

significance, are in fact teeming with religious and moralistic symbolism. This is the case with *Still Life with Fish and Stag Beetle* painted by George Flegel in 1635, where the bread and wine allude to the sacrament of the Eucharist; the fish is an old Christian symbol; and the stag beetle, like the woodworm gnawing at the little table, is a reference to evil and sin. It goes without saying that in some paintings the message is even less veiled, as in the *Eucharist in Fruit Wreath*, painted by Jan Davidszoon de Heem in 1648, where the cornucopia is an immediate allusion to both secular and spiritual abundance.

Many paintings, produced by different schools in various countries, feature some form of warning against allowing ourselves to be deceived by the transient nature of earthly life. Two particularly eloquent examples are a painting by followers of Rembrandt (shown opposite) and the fine *Allegory of Transience* painted by Spanish artist Antonio de Pereda (1608–78). Placing a watch or hourglass next to the skull underscores the notion of *vanitas* or memento mori. The still life, however, was much more than a pretext to remind viewers of their mortality and the fact that they were going to die. From the seventeenth century onward, the genre offered artists an extraordinary opportunity for greater and lesser talents alike to practice and display their finest creative and technical skills.

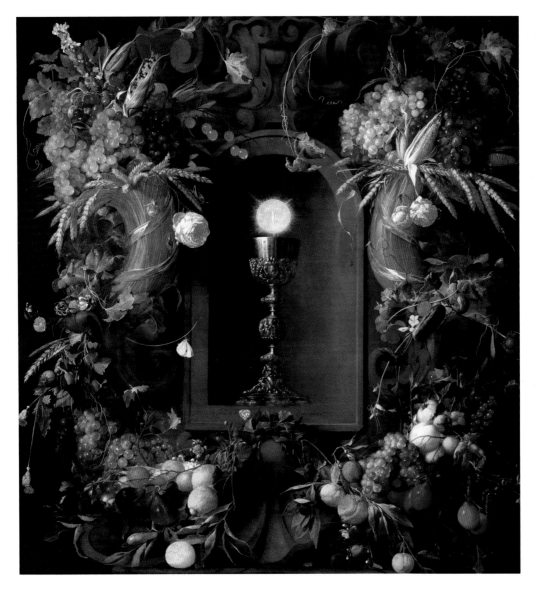

Jan Davidszoon de Heem
Eucharist in Fruit Wreath
1648, oil on canvas. Vienna, Kunsthistorisches Museum, Old Masters Picture Gallery.

Landscape

Landscape painting is, in fact, a relatively recent addition to the history of painting and was not granted official status as a genre before the seventeenth century. Prior to that period, landscape had never been considered an autonomous art form; rather, it had always been seen as an accessory to historical, religious, or mythological scenes, or in the case of fifteenth-century portraiture, it sufficed to serve as a background. Landscape as a genre, in the full sense of the word, developed as part of the artistic culture of the Low Countries, in a region of Europe where geography—in the form of an immense stretch of low-lying plain—encouraged approaches to dealing with the perception of distance.

At the turn of the century, a major work overturned the conventional relationship between figure and landscape in Italy. In *Flight into Egypt*, which Annibale Carracci painted for the Galleria Doria Pamphilj, the members of the Holy Family move through a typical Italian landscape, with hills populated by shepherds and flocks, where the human subjects seem to disappear because the real protagonist of the painting is the landscape. Carracci's painting was hugely influential and indeed engendered a new artistic genre, which shaped the style, for example, of Paul Bril (1554–1628), a

Annibale Carracci
Flight into Egypt
c. 1604, oil on canvas.
Rome, Galleria Doria
Pamphilj.

Claude Lorrain
Port with Villa Medici
Work signed and dated
1637, oil on canvas.
Florence, Uffizi Gallery.

Facing page, top left:
Adam Elsheimer
Flight into Egypt
1609, oil on copper.
Munich, Old
Pinacotheca.

Flemish painter who came to Rome to stay with his brother Matthijs, or Adam Elsheimer (1578–1610), a German artist who came to Rome in 1600 and alongside Bril became a leading seventeenth-century landscape painter.

No discussion of landscape would be complete without mention of Nicolas Poussin, who dedicated a number of paintings to the genre, including his depictions of the four seasons, as well as Claude Lorrain, who introduced the theme of the idyllic, Arcadian landscape, or Salvator Rosa, whose landscapes were intense, striking tonal arrangements. Rembrandt also experimented with the genre, producing some highly atmospheric compositions.

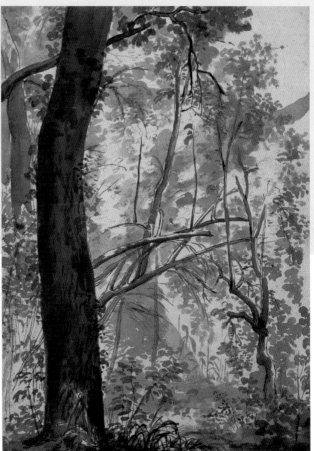

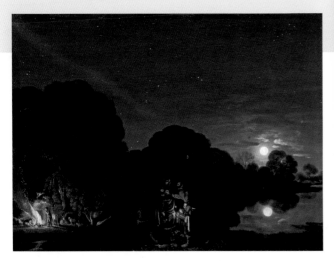

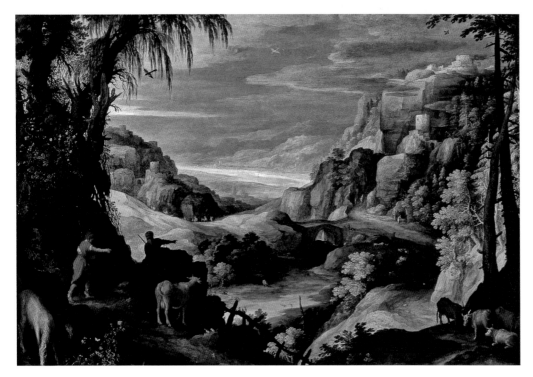

Above:
Nicolas Poussin
View of a Wood
Pen and gray and brown watercolor over black chalk.
Vienna, Albertina Museum, Collection of Graphic Arts, no. 11440.

Left:
Paul Bril
Landscape with Mercury and Argus
Work signed and dated 1606, oil on copper.
Turin, Sabauda Gallery.

Portraiture

In the seventeenth century, the most obvious outward sign of the inexorable growth and consolidation of the merchant middle class, caught up in its frenzy to exploit lucrative international markets to the extreme, was an enduring attachment to portraiture. Not that the portrait genre was absent in previous centuries, but in the seventeenth century it proliferated as never before, evolving into a multitude of variations. The full-length portrait became increasingly popular, whereas it had once been the privilege of kings. Indeed, monarchs now preferred to be painted on horseback or as they strolled in the countryside or along the seashore (see *Portrait of Charles V on Horseback* by Van Dyck on page 89). Horseback portraits were so popular that some of the larger studios, including that of Velázquez, painted a number of finished horses in advance to save time, ready to accommodate the rider according to the patron's requests. Portraits often had two subjects, as in Rubens's *Rubens and Isabella Brant in the Honeysuckle Bower* or Rembrandt's wonderful *Portrait of Cornelius Anslo and His Wife Aaltje*. The man's gesture is a reference to the orating skills that made Anslo famous.

The great innovation in the genre was the group portrait. These paintings were often commissioned by an organization or

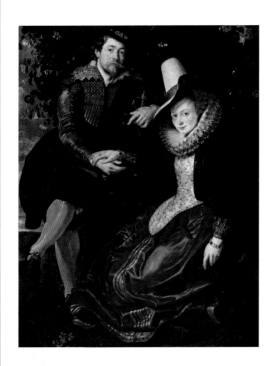

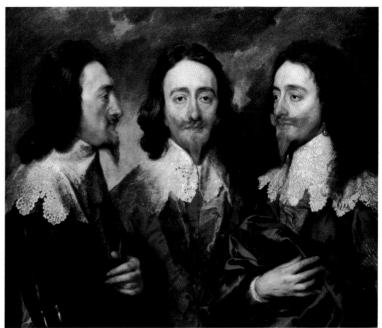

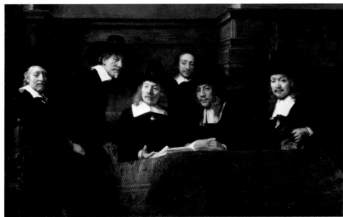

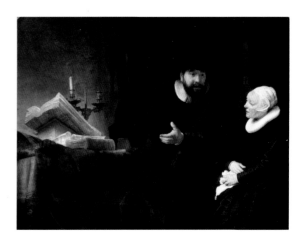

institution that wanted to enhance the prestige of its members while preserving their memory for posterity. One of the most important and iconic paintings of this type is Rembrandt's *The Syndics of the Amsterdam Drapers' Guild*, in which six individuals smile from the painting that they themselves have commissioned from the artist. The price of a portrait could vary, depending on where the persons were portrayed in the painting: costly if they were in the foreground, less expensive if they were in the background. This was the case for the members of Captain Frans Banning Cocq's militia company depicted in Rembrandt's 1642 *The Night Watch* (shown on page 76).

Clearly, the portrait also gained prominence in the seventeenth century because of this new function: increasingly, portraits came to represent a "slice of life." They were, to borrow an expression from our own age, a snapshot that managed to capture an otherwise ephemeral moment. A highly significant example of this concept can be found in one of the most celebrated and studied portraits in the history of art, *Las Meninas* by Velázquez. Here, the infanta of Spain (shown with the painter himself and other members of the court) stares at us as she prepares to pose for the painting that would make her immortal.

Right:
Diego Velázquez
Las Meninas (The Maids of Honor)
1656–57, oil on canvas.
Madrid, Prado Museum.

Facing page, clockwise from far left:
Peter Paul Rubens
Self-Portrait with First Wife, Isabelle Brandt
1609–10, oil on canvas.
Munich, Old Pinacotheca.

Anthony Van Dyck
Portrait of Charles I
1635–36, oil on canvas.
Windsor Castle, Royal Collection.

Rembrandt
Portrait of Cornelius Anslo and His Wife
1641, oil on canvas.
Berlin, National Museum.

Rembrandt
The Syndics of the Amsterdam Drapers' Guild
1662, oil on canvas.
Amsterdam, State Museum.

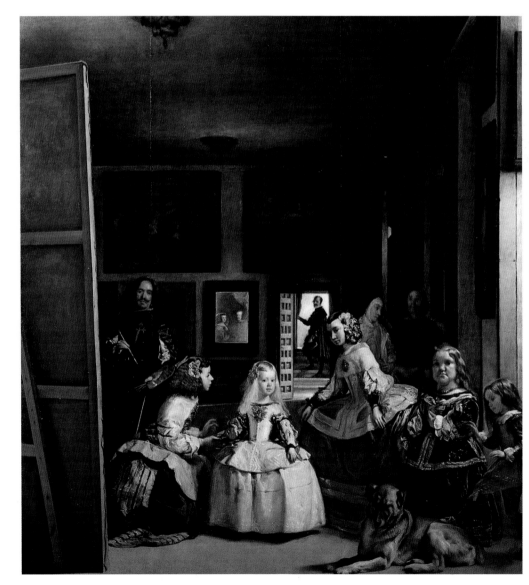

Furniture

During the Baroque period, pieces of furniture were considered small monuments and were subject to the same architectural and aesthetic conventions as buildings. Indeed, in some particularly successful cases, Baroque chairs, tables, and frames were designed by architects of the talent and standing of Bernini. As Le Corbusier later explained, Bernini felt obliged (by professional honor and because that was what his clients demanded) to provide a "full package" that ranged from the design of a spoon to an entire city, including the furniture.

During the seventeenth century, furniture and furniture designers became increasingly important, including André Charles Boulle (1642–1732), a cabinetmaker who worked for Louis XIV, the "Sun King." It is no coincidence that when we hear mention of the "Louis XIV style," we think of the chests of drawers in the Trianon or the astonishing Fontainebleau clock with its sun-bearing carriage. These masterpieces were crafted in Boulle's Louvre workshop and were easily matched in splendor and craftsmanship by the pieces produced in Bernini's workshop on Via della Mercede in Rome, designed to furnish Palazzo Chigi in Ariccia. The production of these pieces of Baroque furniture not only entailed the transfer of stylistic

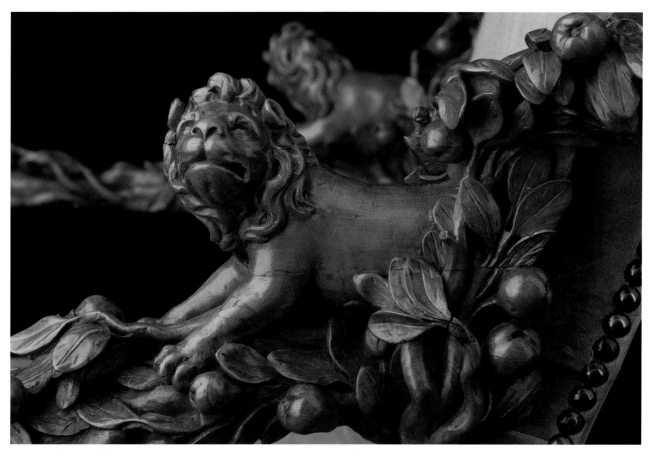

Above:
Andrea Brustolon
Carved lion armrests
End of seventeenth century, varnished sculpted wood.
Rome, Quirinal.

Facing page, from top:
André Charles Boulle
Cabinet, detail
End of seventeenth century, ebony and tortoiseshell.
Paris, Louvre.

Grand Duchy production
Cabinet with clock
End of seventeenth century, ebony, gems, rock crystal, and gilded bronze.

Gian Lorenzo Bernini
Saint Lawrence
1617, marble and wood.
Florence, Uffizi Gallery, Contini Bonacossi Collection.

devices from architecture to objects on a much smaller scale, but was also accompanied by the contemporary taste for artifice and invention—including skillfully executed intaglios, which allowed many craftsmen to reproduce leaves, mythological scenes, blossoming branches, and much more. The use of marquetry, inlays, gilded bronze and the addition of brass, copper, and even tortoiseshell pieces for decoration, combined with a fondness for full gilding, all served one purpose: to amaze. For the same reason, furniture took on new shapes as well during the seventeenth century. The ordinary bed was transformed into the four-poster baldachin, the ottoman chest was paired with the divan, and the "cabinet," now with a

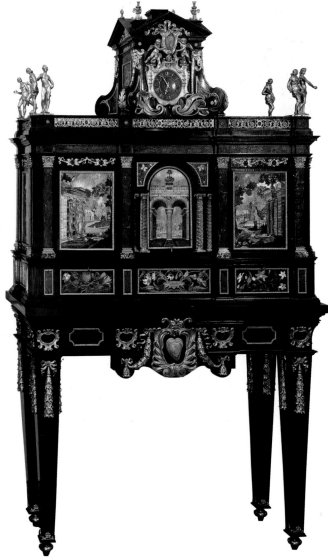

rounded front to match the bulging, convex facades of the new Baroque buildings, was filled with secret drawers and also served as a writing desk.

The Art of Transportation

We may feel that busy streets are modern problems, but traffic congestion was already an issue in the seventeenth century, when rich aristocrats liked to move from place to place in carriages. Two episodes in Rome, both of which occurred during the papacy of Pope Alessandro VII (1655–67), illustrate the situation as it was

then. The pope decided to remove the ancient Portogallo arch from its site on Via del Corso, because the monument hindered traffic and caused bottlenecks on the long, straight road. The pontiff also commissioned Pietro da Cortona to reorganize the building and the square in front of the church of Santa Maria della Pace. We know from historical accounts that every Sunday the square became jammed with the carriages of nobles and leading citizens leaving church, which prompted the pope, a member of the Chigi family, to commission the building of a new square, to be constructed in the space left by buildings that had to be expropriated and demolished. At this time, traveling by carriage was a luxury, an art in itself, given the splendor of some of

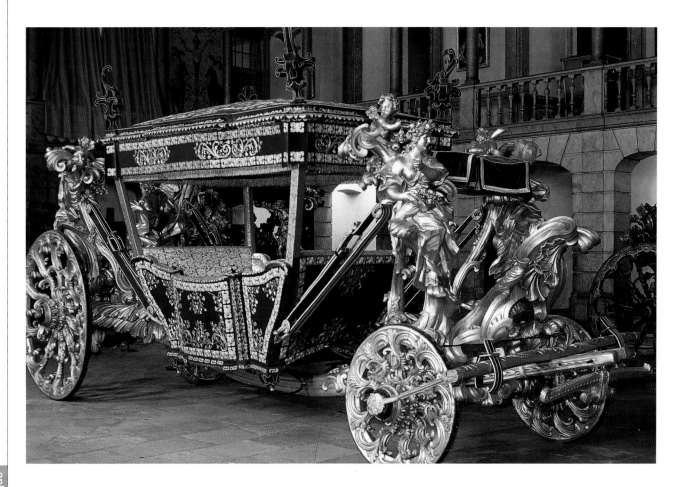

Honor carriage
Seventeenth century.
Lisbon, National Coach
Museum.

the carriages that may not have been comfortable or practical, but were outstanding examples of fine craftsmanship. Talented artists like Ercole Ferrara (1610–86) willingly turned their skills to designing and decorating carriages. Ferrara made every effort to render the carriages of the pope and other members of the wealthy Chigi family all the more sumptuous. Bernini designed the carriage used by Cristina, former queen of Sweden and a leading figure in Rome's cultural and political circles.

Thus, one's mode of transportation was considered an art form in itself, as witnessed by the various surviving carriages now conserved in museums across Europe (like those on display in Pitti Palace, Florence, or in Los Remedios convent in Seville).

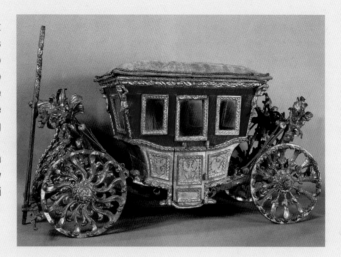

Gian Lorenzo Bernini
Study for the drapery and decoration of a carriage
c. 1673, watercolor ink on paper.
Stockholm, National Museum, inv. THC 2089.

Model of a Baroque carriage
Seventeenth century, gilded wood and fabric.
Vatican City, Vatican Museums.

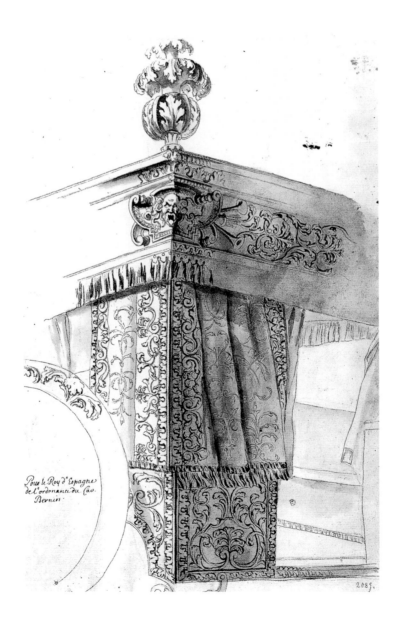

Gian Lorenzo Bernini
(b. Naples 1598, d. Rome 1680)

Gian Lorenzo Bernini
*Self-Portrait as a Young
Man,* detail
c. 1623, oil on canvas.
Rome, Borghese Gallery.

"A man of rare qualities and sublime genius . . . born by divine will and for the glory of Rome to bring splendor to this earthly world." That was how Pope Urban VII described Gian Lorenzo Bernini. Painter, sculptor, architect, and creator of stage settings and plays, Bernini was considered in his own lifetime to be the Michelangelo of his age. Without a doubt one of the most significant driving forces behind the renewal of the language of Italian art in the eighteenth century, Bernini is rightly considered today by many scholars to be the founder of the Baroque aesthetic. Born into the profession—his father, Pietro (1562–1629), was a sculptor of some distinction—Gian Lorenzo began his career as a sculptor, working alongside his father. Pietro Bernini was able to make use of his connections and acquaintances to introduce his son to the rarified, golden world of commissions from cardinals and indeed the pope himself. Thus, barely twenty years old, Bernini began his association and friendship

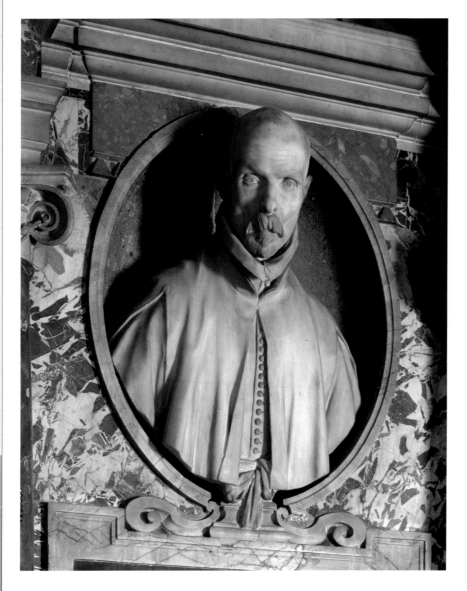

Gian Lorenzo Bernini
Bust of Pedro de Foix Montoya
c. 1621, marble.
Rome, Santa Marina di
Monteserrato Church.

Cardinal Maffeo Barberini, the future Pope Urban VIII and direct superior of Pedro de Foix Montoya (the cardinal was prefect of the Segnatura, or Justice Minister), used to say that the bust of his *referendarius* (a position Montoya had already held under Pope Paul V) executed by Bernini seemed more lifelike than the real one. The cardinal had introduced Montoya to Bernini, and the great artist produced, among other works, the celebrated busts *Damned Soul* and *Blessed Soul* for the high-ranking magistrate. Well educated and scrupulous in the execution of his duties as a civic and criminal magistrate, Montoya was very aware of the heavy burden of responsibility that weighs on someone who has the power of life and death over others.

with Cardinal Scipione Borghese, crafting for the cardinal some of the most quintessentially significant works of statuary of the entire Baroque age, from *Aeneas, Anchises and Ascanius* (1618–19) and *Rape of Proserpine* (1621–22) to *David* (1623–24) and *Apollo and Daphne* (1622–25), all conserved in the Borghese Gallery. At the court of Cardinal Borghese, Bernini also had the opportunity to meet the future Pope Urban VIII, who in 1624 would commission the baldachin at the center of Saint Peter's Basilica. This work may rightly be seen as Bernini's attempt to transform the ephemeral devices that were so typical of Rome's religious celebrations into something more solidly monumental.

From that moment, Bernini began his meteoric rise. He was nominated master of the papal foundries, superintendent of the Acqua Felice aqueduct, and architect of Saint Peter's. With his tombs for Pope Urban VIII (1628–47) and Pope Alexander VII (1671–78), Bernini more or less invented a new type of funerary memorial. (Both tombs can be seen in Saint Peter's Basilica.) His career experienced a significant upset when the bell tower of Saint Peter's collapsed, and it was only the project for the *Fountain of the Four Rivers* that helped him regain the favor of Pope Innocent X. During the papacy of Alexander VII (1655–67), Bernini executed such grand works as the colonnade of Saint Peter's. His statues of saints in ecstasy, including the *Blessed Ludovica Albertoni* (1671–74, San Francesco a Ripa), are also justly famous.

Gian Lorenzo Bernini
Aeneas, Anchises and Ascanius
1618–19, marble.
Rome, Borghese Gallery.

Gian Lorenzo Bernini
David
1623–24, marble.
Rome, Borghese Gallery.

While the *Aeneas, Anchises and Ascanius* group may still show signs of his father Pietro's influence, the statue *David* is clearly young Bernini's first monumental masterpiece. Begun as a commission for Cardinal Montalto, the still largely unfinished work was acquired by Scipione Borghese when the cardinal died. According to the sculptor's son and biographer, Domenico, the statue's face is Bernini's own, and he observed his features in a mirror patiently held up by no less a dignitary than Cardinal Maffeo Barberini, enthralled by Bernini's artistry.

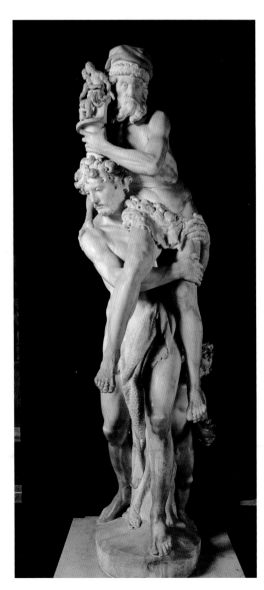

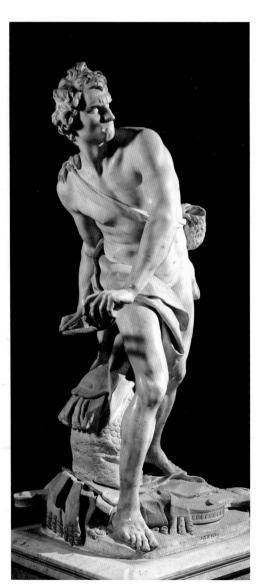

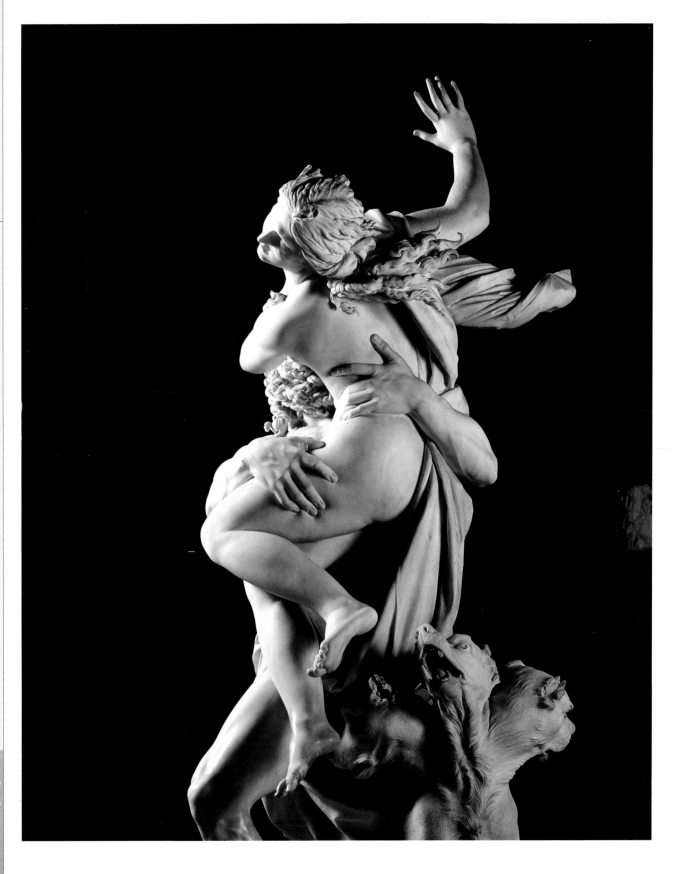

Facing page:
Gian Lorenzo Bernini
Rape of Proserpine,
detail
1621–22, marble.
Rome, Borghese Gallery.

Right:
Gian Lorenzo Bernini
Ecstasy of Saint Theresa
1647–51, marble and
gilded bronze.
Rome, Santa Marina
della Vittoria, Cornaro
Chapel.

One of the most famous
of all Baroque
masterpieces, this marble
group dominates the
sumptuous Cornaro
family memorial chapel
that Cardinal Federico
Cornaro commissioned
from Bernini (see page 9
for the full view). The
iconography is inspired
by Saint Theresa's own
description of her
experience of divine
ecstasy: "I saw next to
me ... an angel in human
form, young and
beautiful.... In his hand
I saw a golden spear ...
which seemed to pierce
my heart."

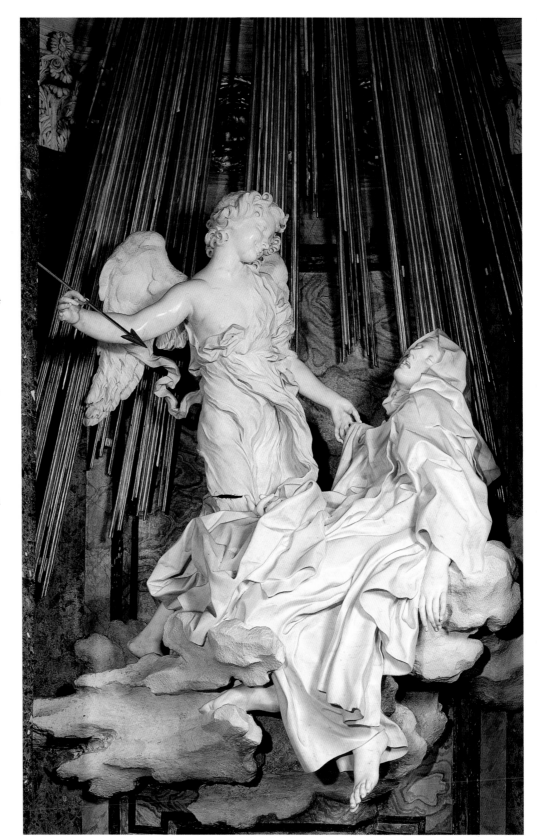

Francesco Borromini
(b. Canton Ticino 1599, d. Rome 1667)

Borromini may be considered Italian Baroque architecture's alter ego. His seemingly capricious, almost willful art stands at the opposite end of the spectrum to Bernini's carefully balanced artifice. The two great artists were, perhaps inevitably, great rivals. Borromini worked under Bernini on the monumental Saint Peter's baldachin, and both men worked as assistants to Carlo Maderno (1556–1629) on the construction of Barberini Palace. A troubled spirit (he eventually committed suicide), Borromini crafted some of the greatest works of the Baroque age. Apart from a period in Naples where he worked on the *Filomarino Altar* in the Church of the Santi Apostoli, he was active mainly in Rome, where he designed the church of San Carlo alle Quattro Fontane and worked on the facade for the Filippini Oratory, the church of Sant'Agnese in Agone, and the college of Propaganda Fide, as well as supervising restoration work on the interior of the basilica of Saint John Lateran (1646–49).

Anonymous
Portrait of Francesco
Borromini, detail
c. 1630, oil on canvas.

Francesco Borromini
Church of Sant'Ivo alla
Sapienza
1642–62.
Rome.

In 1632, Borromini was appointed architect of the Sapienza, and in 1642 he was commissioned to build what was to be a chapel annexed to the papal school (*Archiginnasio pontificio*) and that would go on to become the Church of Sant'Ivo. Construction was conditioned by the existing courtyard and the Sapienza building itself, begun earlier by Pirro Ligorio and continued by Giacomo della Porta. The layout of the church recalled the six-pointed star of Solomon, itself a symbol of wisdom. The base of the cupola, with its six curved lobes, supports a tiered canopy surmounted by a lantern (skylight) topped by a helicoidal cusp.

Battistello Caracciolo
Tobias and the Angel, detail
c. 1622, oil on canvas.
London, Walpole Gallery.

Battistello Caracciolo
Liberation of Saint Peter
1615, oil on canvas.
Naples, Pio Monte della
Misericordia.

Caracciolo's painting
shows clear signs of
Caravaggio's influence.
Eight years earlier,
Caravaggio had painted
his acclaimed altarpiece,
*The Seven Works of
Mercy*, for the same
institute. The liberation
of Saint Peter is here
interpreted as an act of
divine charity toward the
man who was to be the
first pope. Founded in
1601, the Pio Monte
della Misericordia was
also meant to be a tool
for charity to aid the
needy, in an attempt to
redress the scarcity of
attention paid to social
issues under the Spanish
viceroys. The wingless
angel could be any
young man, underlining
the intrinsic nature of
human charity.

Battistello Caracciolo
(b. Naples c. 1570, d. 1635)

In all likelihood, the young Giovanni Battista Caracciolo (known as Battistello) served his apprenticeship in the workshop of the late Mannerist painter Belisario Corenzio, and there is firm evidence that Caracciolo was Corenzio's assistant for the frescoes in the Monte di Pietà. Battistello's style underwent a radical change in the wake of Caravaggio's stay in Naples in 1606. The sudden change in Battistello's artistic approach is further proof of the forceful impact of and powerful influence exerted by Caravaggio's work. After seeing paintings executed by Caravaggio in Naples between 1606 and 1607, Caracciolo painted the *Immaculate Conception with Saint Dominic and Saint Francesco ad Paola* for the church of Santa Maria Della Stella. From 1618 onward, his stays in Rome and Genoa provided the framework for a more articulate style, thanks to his encounters with the work of the Carracci family, Guido Reni, and their followers. Upon his return to Naples, he was acclaimed as an indisputable master of his art.

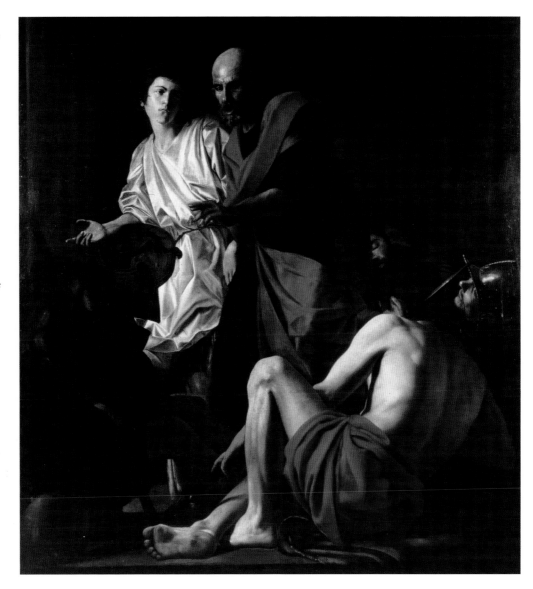

Ottavio Leoni
Portrait of Caravaggio, detail
c. 1600, chalk on blue paper.
Florence, Marucelliana Library.

Caravaggio
Michelangelo Merisi da Caravaggio
(b. Milan 1571, d. Porto Ercole 1610)

Called "Caravaggio" after the little town where he spent his childhood, Michelangelo Merisi's full artistic worth and profound humanity have been acknowledged only relatively recently. The enduring image of Caravaggio (fueled in part by his rather hectic lifestyle and his brash and rebellious nature) as a "damned painter" is so deeply rooted that many today still imagine that he was without religious faith or was the son of a humble and destitute family. On the contrary, for a time, Fermo Merisi, the painter's father, was master of the house for the marquis of Caravaggio and must therefore have been part of minor local nobility. The family later left Milan following an outbreak of plague, which killed Caravaggio's father and grandparents. Thus, Michelangelo, who was born on September 29, the feast of Saint Michael, spent his early youth in Caravaggio. In 1584, he began his apprenticeship in Milan under the

Caravaggio
Boy with Fruit Basket
1591, oil on canvas.
Rome, Borghese Gallery.

This early work is the result of Caravaggio's apprenticeship in the Cavalier d'Arpino's workshop, where he painted a number of scenes involving fruit. The basket is the precursor of the still life now in the Ambrosiana (see page 26). Framed by a triangular arrangement, the boy offers the viewer a riot of colors that brighten up the predominately dark tones of the work.

Opposite:
Caravaggio
The Fortune Teller
1595, oil on canvas.
Rome, Pinacoteca
Capitolina.

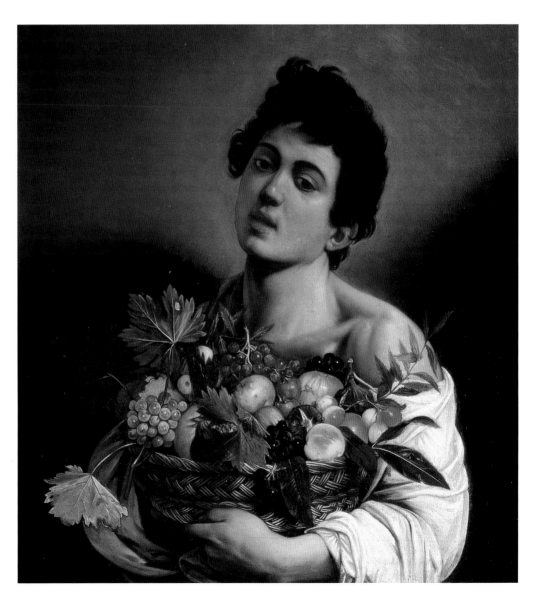

painter Simone Peterzano. After the death of his mother, when he was just over twenty, he went to Rome, where he was offered hospitality and protection by Cardinal Francesco Maria Del Monte, ambassador for the Grand Duke of Tuscany (who later received the *Bacchus* that is today housed in the Uffizi Gallery). Caravaggio was welcomed into the cardinal's home and introduced by him to the educated, cosmopolitan prelates of the Roman Curia, who soon became patrons. Del Monte also commissioned a number of works from Caravaggio, including *The Musicians* (New York, Metropolitan Museum of Art) and the version of *Lute Player* today in the Hermitage, Saint Petersburg. Del Monte was also responsible for Caravaggio's first public commission: paintings of the *The Calling of St. Matthew* and *The Martyrdom of Saint*

Matthew in the Contarelli Chapel in the church of San Luigi dei Francesi (1599–1600). Thus it was in Rome that Caravaggio honed his style and deepened his painterly knowledge. Although he was dazzled by the sophisticated Christian symbolism that was cherished by the cardinals and theologians who commissioned his works, Caravaggio's somewhat impetuous and reckless character soon led him into trouble with the law. He spent the last few years of his brief life more or less on the run, spending time in Naples (*The Seven Works of Charity*), Malta (*Beheading of John the Baptist*), Messina (*Resurrection of Lazarus*), and Palermo (*Adoration of the Shepherds*), waiting for the papal pardon that reached him too late.

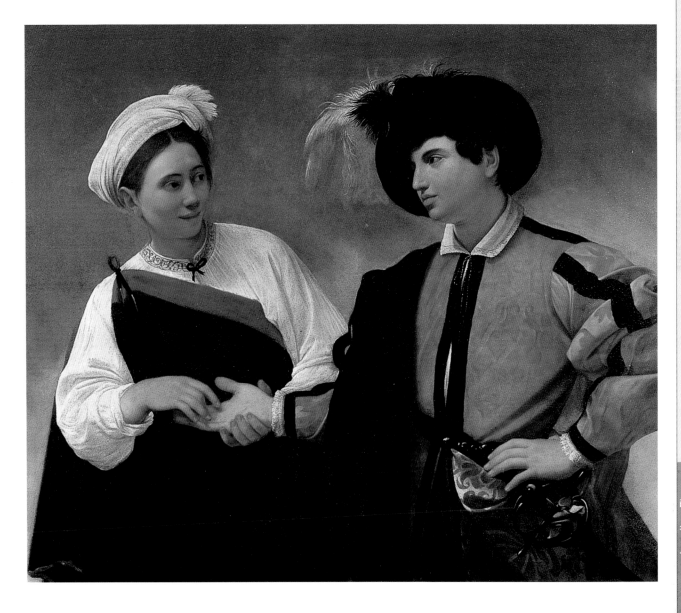

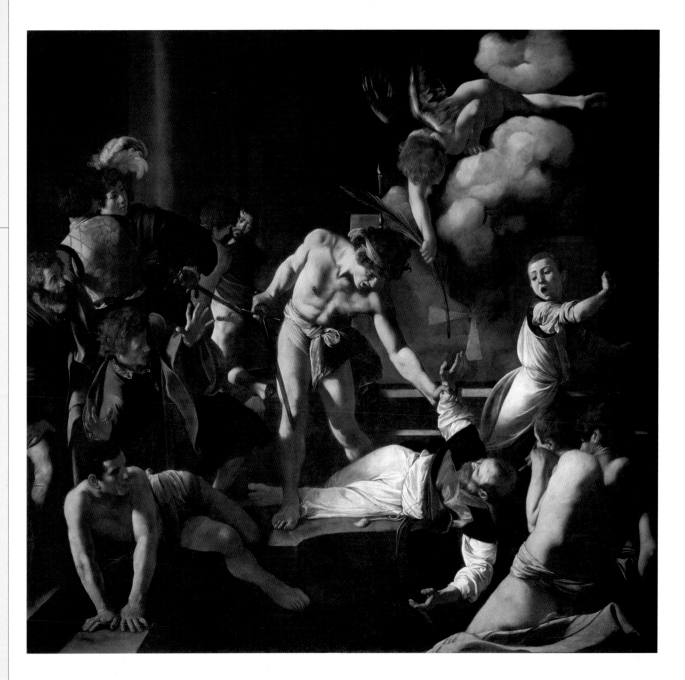

Caravaggio
The Martyrdom of Saint Matthew
1599–1600, oil on canvas.
Rome, San Luigi dei Francesi.

Executed for the Contarelli Chapel in the church of San Luigi dei Francesi, this is the final work in the Saint Matthew trilogy. A former tax collector for the Romans and a sinner, he converted after receiving the call from Christ. Here, Matthew undergoes martyrdom at the end of his sermon in Ponto, Greece. Matthew's feeble gesture of defense becomes the same gesture with which he receives his martyr's palm and eternal life. Among the figures in the background, a frowning artist steals a glance at the imagined scene at the end of mass.

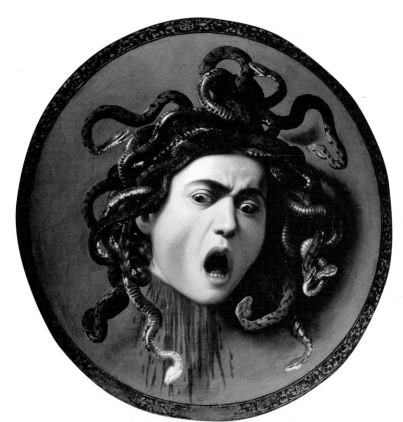

Left:
Caravaggio
Medusa
c. 1600, canvas on wood.
Florence, Uffizi Gallery.
A gift to Ferdinando de' Medici
from his ambassador in Rome
and patron of Caravaggio,
Cardinal Del Monte, the shield
depicts with graphic realism the
recently severed head of the
Medusa and lingers in an
unflinching description of facial
reaction, which Caravaggio had
already explored in his *Boy
Bitten by a Lizard*.

Below:
Caravaggio
Beheading of John the Baptist
1608, oil on canvas.
La Valletta, Cathedral of San
Giovanni Battista.

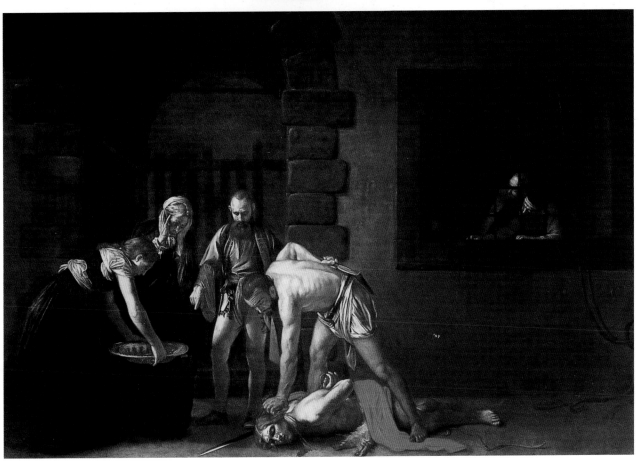

Leading Figures | *Caravaggio*

The Carracci Brothers

Agostino (b. Bologna 1557, d. Parma 1602); Annibale (b. Bologna 1560, d. Rome 1609);
Ludovico (b. Bologna 1555, d. 1619)

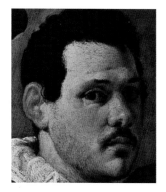

Annibale Carracci
Self-Portrait, detail
c. 1585, oil on canvas.
Milan, Brera Art Gallery.

Artistic and cultural developments for the prolific Carracci family from Italy's Emilia region were intricately linked with the cultural circle known as the Accademia degli Incamminati (or Accademia del Disegno), which was a touchstone for art and artists in Bologna and beyond. The academy was founded in 1582 and later renamed the Accademia dei Desiderosi by the theoretician Giovanni Puetro Bellori (1613–96) because of "the desire everyone had to learn." The goal of the academy when it was created was to overcome the legacy of late Mannerism, which had more or less trapped painting in a straitjacket of rules and theoretical regulations founded on an overly elaborate and hollow sense of beauty. The Carracci circle intended to bring new life to painting by subordinating theory to the real practice of art. Masters, assistants, and pupils were all considered to be equal, part

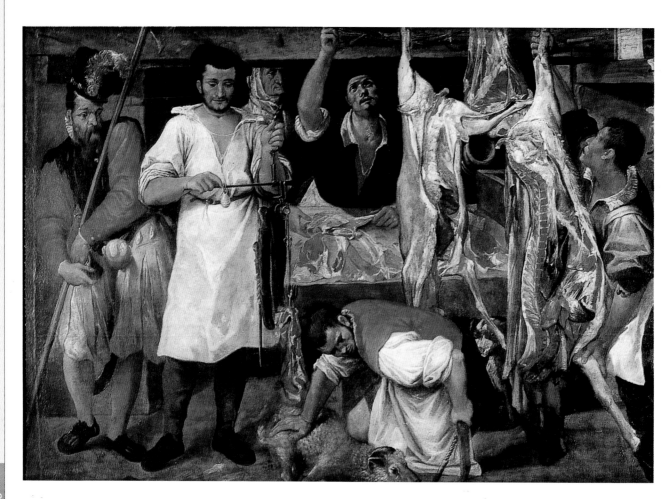

Annibale Carracci
The Butcher's Shop
1583–85, oil on canvas.
Oxford, Christ Church.

Facing page:
Annibale Carracci
The Beaneater
1583–84, oil on canvas.
Rome, Colonna Gallery.

of the same grand adventure and driven by the same goal: to reinvigorate the art of painting. The group paid special attention to the roles of drawing and good draftsmanship as well as the studies of anatomy and perspective.

Agostino Carracci, the older brother of Annibale, was the group's main theoretical exponent; given his cultural sophistication and natural ability to teach others, he was an ideal master as well as painter. His style reveals his close study of artists Tintoretto, Correggio, and Raphael. Agostino took part in the execution of a number of works in Bologna (Fava Palace, 1583–84) and Rome (Farnese Gallery, 1595–1600). He broke away from his brother and went to work in Parma for Ranuccio Farnese (1592–1622).

Annibale was without doubt the most talented and creative painter of the Carraccis, the real force behind the innovation of the artistic language, and the least inclined to theorizing. "We painters," he once said to Agostino, "need to speak with our hands." Apart from his work on the decorations for Fava Palace and Farnese Gallery, Annibale's paintings include *The Butcher's Shop* (1583–85 Oxford, Christ Church) and *The Beaneater* (1583–84, Rome, Colonna Gallery). The radically innovative choice of subject matter in these works had a profound impact upon late-seventeenth-century painting. Landscape takes on a significant role in his *Flight into Egypt* (c. 1604, Rome, Doria Pamphilj Gallery). Ludovico Carracci, cousin of Agostino and Annibale, worked in particular on religious scenes (*Annunciation*, 1585).

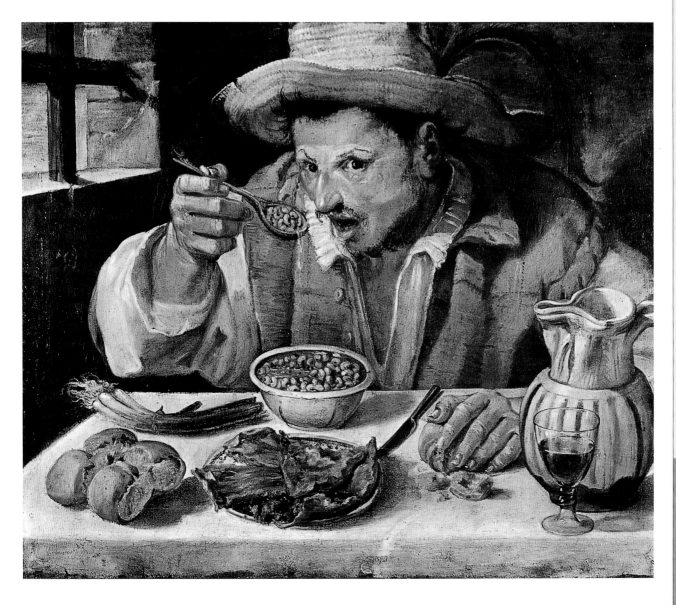

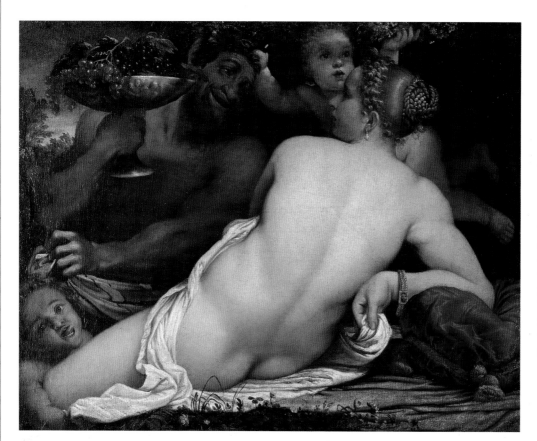

Annibale Carracci
Venus with a Satyr and Cupids
c. 1588, oil on canvas.
Florence, Uffizi Gallery.

According to the Bolognese writer Carlo Cesare Malvasia, who was close to the Carracci academy, in order to help his cousin, Ludovico Carracci himself posed for the figure of Venus seen from behind (undressed down to the waist). The satyr and the figure of Eros on the bottom left are said to represent earthly love, while Venus and Anteros represent divine love.

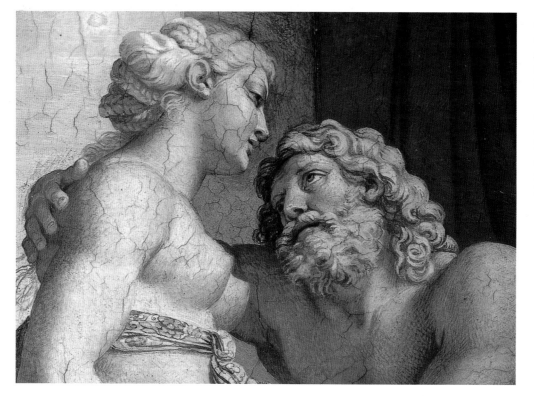

Left:
Annibale Carracci
Jupiter and Juno, detail
c. 1597, fresco.
Rome, Farnese Palace.

Facing page:
Annibale Carracci
The Triumph of Bacchus and Ariadne, detail
1598–1601, fresco.
Rome, Farnese Palace.

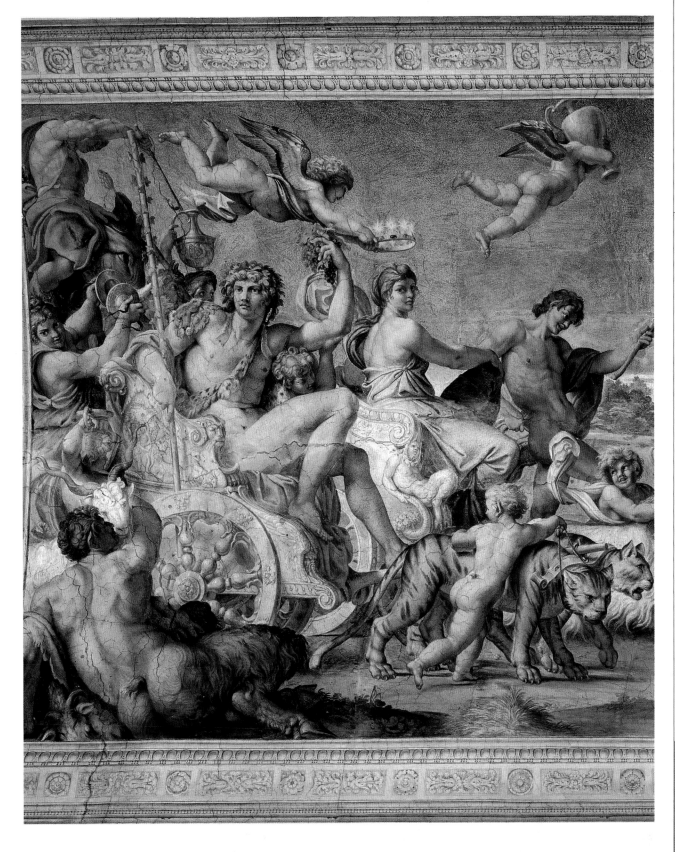

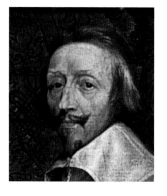

Philippe de Champaigne
Portrait of Cardinal Richelieu, detail
1635–40, oil on canvas.
Paris, Louvre.

Philippe de Champaigne
(b. Brussels 1602, d. Paris 1674)

This great painter's success began when he moved from Brussels to Paris in 1621, when he was almost twenty. Champaigne's careful execution and composed style greatly appealed to the royal family, for whom he began to work in 1628, painting, among other works, *Louis XIII Crowned by Victory* (1635, Paris, Louvre). His acquaintance and then friendship with Cardinal Richelieu ensured him a steady flow of commissions. The Louvre also houses a very well-known portrait of the cardinal by Champaigne for which the artist did a number of exceptionally fine studies. The artist's friendship with Cardinal Richelieu was also strongly spiritual, as can be seen in a number of Champaigne's religious choices, influenced by the presence of the nearby Jansenist convent of Port-Royal; it was above all a relationship in which painting was the moral support for persuasion. Champaigne was one of the founding members of the Académie de France.

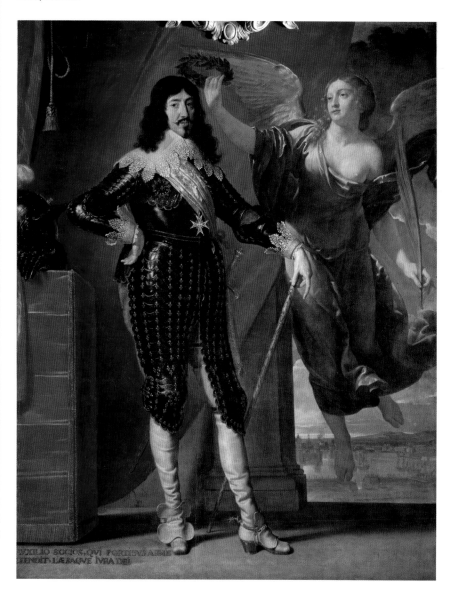

Left:
Philippe de Champaigne
Louis XIII Crowned by Victory
1635, oil on canvas.
Paris, Louvre.
The painting commemorates an episode during the Siege of La Rochelle, when the troops led by Cardinal Richelieu had taken the Protestant bastion.

Facing page, from left:
José Benito de Churriguera
Altar of San Segundo, Bishop of Ávila
End of seventeenth century.
Cathedral of Ávila.

José Benito de Churriguera
Altarpiece in the Sagrario chapel
Late seventeenth/early eighteenth century.
Segovia, cathedral.

José Benito de Churriguera
(b. Madrid 1665, d. 1725)

José Benito de Churriguera
*Sketch for the catafalque of
Marie Louise d'Orléans, Queen
of Spain*, detail, 1714. Madrid,
National Library of Spain.

José Benito was the oldest and most famous of the three Churriguera brothers (Joaquin was born in 1674 and died in 1723; Alberto was born in 1676 and died in 1750). The work of the Churriguera brothers defined taste in Baroque and late Baroque Spain to such an extent that the adjective *Churrigueresque* was coined to describe the movement they started. In this highly expressive, powerfully florid style, the decorative elements entwine themselves about the surface they are meant to embellish, rather like splendid plants blossoming out of Classicism and art itself. José served his apprenticeship under his father, José Simón de Churriguera, a sculptor from Barcelona who later moved to Madrid. José worked with his father until 1709. Like his father, José also specialized in the production of *retablos* (wooden altarpieces with foldable panels that were common throughout Europe from the eleventh to the seventeenth centuries; there is a particularly beautiful example in Segovia Cathedral). José also worked extensively as a sculptor. The Churrigueresque style later spread to Spain's New World colonies.

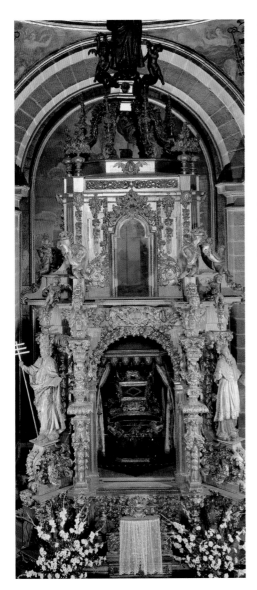

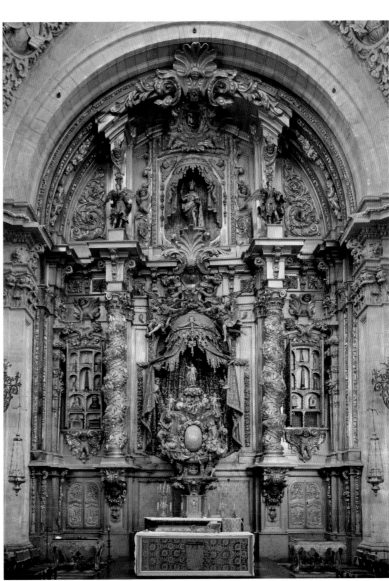

Pieter de Hooch
*Courtyard of a House
in Delft*, detail
1658, oil on canvas.
London, National Gallery.

Pieter de Hooch
Couple with a Parrot
1668, oil on canvas.
Cologne, Wallraf-
Richartz Museum.

Pieter de Hooch
(b. Rotterdam 1629, d. after 1684)

De Hooch was born in Rotterdam and was apprenticed to the workshop of Nicolaes Berchem, one of the leading painters in Haarlem, who had a number of talented pupils including Jacob Ochtervelt and Karel Dujardin. De Hooch later moved to Leiden and then Delft for work. He stayed in Delft from 1654 to 1663, moved to the busy city of Amsterdam until 1677, and then returned to Rotterdam. His early works show the influence of his teacher and make ample use of landscape and stretches of grassland. During his time in Delft, his style shifted toward the approach to interiors practiced by Fabritius and Vermeer. His scenes capturing everyday life and his constant experiments to achieve atmospheric lighting distinguish him as one of the narrators of ordinary Dutch society (*The Mother*, Berlin, National Museum). His commissions in Amsterdam were dictated for the most part by the requirements of his aristocratic patrons (*At the Wardrobe*, Amsterdam, State Museum).

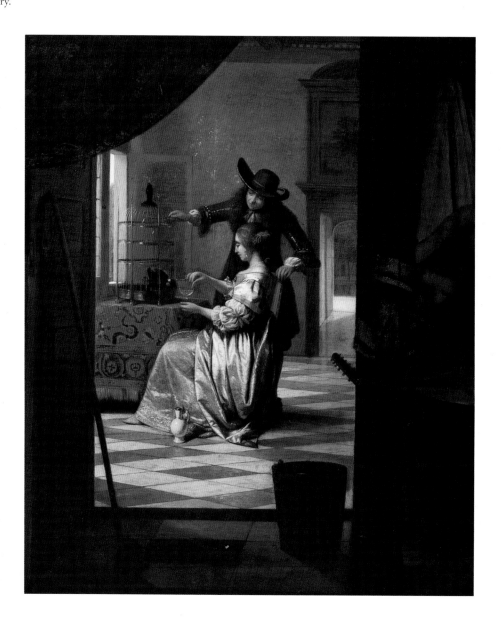

Georges de La Tour
The Fortune Teller, detail
c. 1632–35, oil on canvas.
New York, Metropolitan
Museum of Art.

Georges de La Tour
The Dream of Saint Joseph
1640, oil on canvas.
Nantes, Fine Arts Museum
of Nantes.

De La Tour miraculously
transforms the light of the
candle into transcendence.
There has been some
debate over the subject of
the painting, but in all
likelihood the source is a
passage in the Gospel of
Matthew (1:18–24), in
which an angel appears to
Joseph while he is thinking
of sending Mary away
(rather than repudiate her)
because she is pregnant.
The angel explains that
Joseph has nothing to fear
and that he will fulfill the
will of God if he takes
Mary as his wife, and
quotes a passage from
Isaiah (7:14). De La Tour
takes the diverse narrative
elements, including the
prophet, present in the
form of the open book,
and transforms them
into a scene from everyday
life that the light suffuses
with a powerful sense of
spirituality.

Georges de La Tour
(b. Vic-Sur-Seille 1593, d. Lunéville 1652)

The son of a baker, de La Tour was without a doubt one of the most astounding talents of seventeenth-century French art. He brought a personal touch to his interpretation of Caravaggio's legacy, which he may have encountered during a journey to Italy he is thought to have made between 1610 and 1616. Throughout his life, his goal was to make his way in society, and in this he was quite successful. He married Diane, daughter of Jean Le Nerf, a minor noble and silversmith to the duke of Lorraine. They had ten children, but only three survived. One of these, Etienne, succeeded in obtaining his letters of nobility in 1670. Strong-willed and occasionally violent (he beat a city watchman and a farmer with a stick), thanks to his talent de La Tour became rich and famous, as well as a landowner. Indeed, his heirs inherited a large fortune. His nocturnal scenes are enduringly acclaimed and can be admired in museums all over the world.

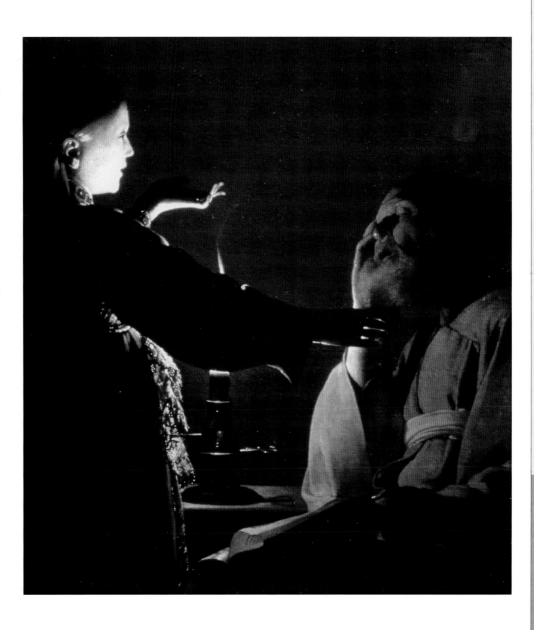

Domenichino
Portrait of a Young Man
(thought to be a self-portrait),
detail. Work dated 1603, oil on
canvas. Darmstadt, Hessisches
Landesmuseum.

Domenichino
Domenico Zampieri
(b. Bologna 1581, d. Naples 1641)

Born Domenico Zampieri, Domenichino was the common diminutive of the artist's given name. His real nickname, which he was given by his fellow artists, was Il Bue, "the ox," because of his hardheadedness and constant stream of work. He served his apprenticeship in Bologna, first under the Flemish painter Denijs Calvaert and then under Ludovico Carracci. He arrived in Rome in 1608 and worked with Annibale Carracci on the frescoes for the Farnese Gallery. His first independent commission was for frescoes in the Abbey of Grottaferrata, where he decorated the Chapel of the Santissimi Fondatori (1608–10). His theoretical ideas were close to those of Monsignor Riguardo (whose portrait he painted). One of the dominant episodes in his career was his clash with fellow artist Giovanni Lanfranco, who even went so far as to defame him. Domenichino tried to show that his talent was comparable with Lanfranco's in his work for the church of Sant'Andrea Della Valle. Greatly pained by the result of the comparison of their work, Domenichino left Rome for Naples in 1630.

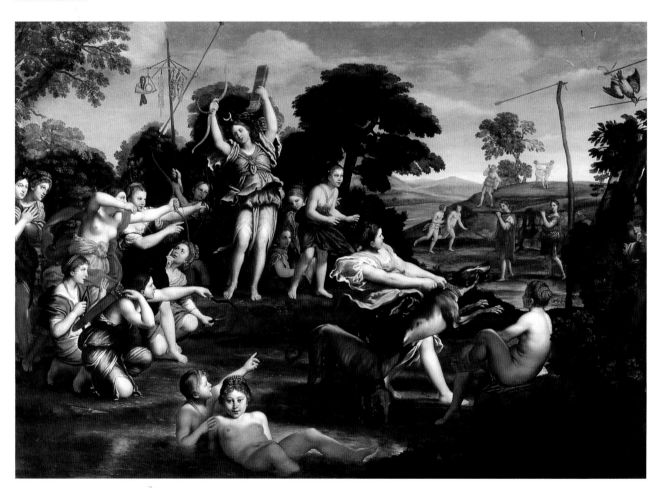

Domenichino
Diana's Hunt or *Diana and Her Nymphs at Play*
1616–17, oil on canvas.
Rome, Borghese Gallery.

Facing page:
Domenichino
Cumean Sybil
1616–17, oil on canvas.
Rome, Borghese Gallery.

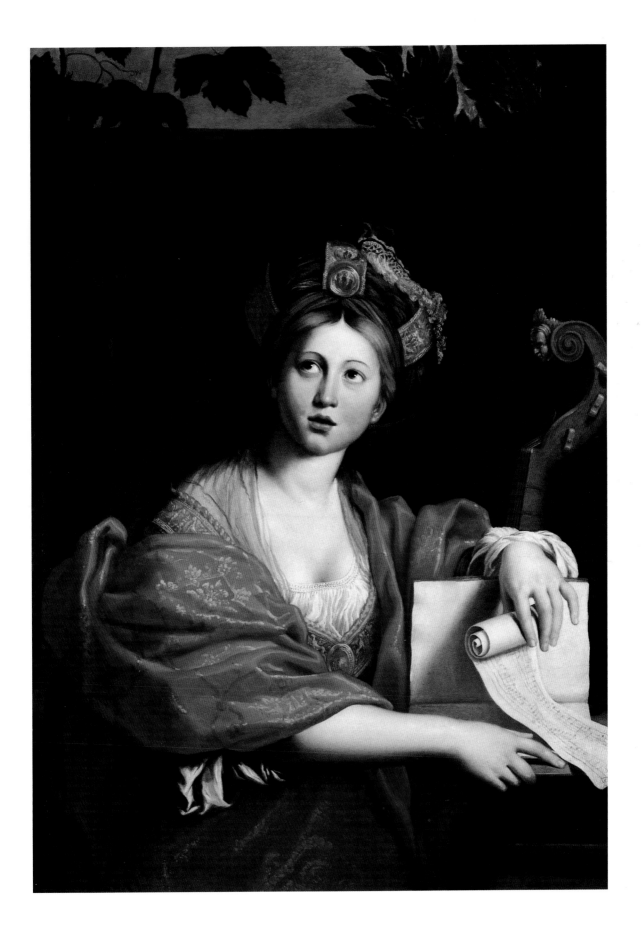

François Duquesnoy
(b. Brussels 1597, d. Livorno 1643)

Duquesnoy was known, erroneously, as the *fiammingo* ("the Flemish one") because of his native land. Perhaps surprising given the fact that Duquesnoy had served his apprenticeship under his father, Jerôme, his work was clearly influenced by the Baroque atmosphere of Rome, where he was active from 1618 at the age of twenty-one to his death. He was an exponent of Classicism with ties to Algardi and Poussin. He began his varied and prolific career working on intaglio carvings and ivory statues before shifting his attention to portraiture. He worked with Bernini for more than a decade (including work on the baldachin in Saint Peter's), applying his refined artistic technique and sensitivity to a variety of forms. He created the colossal statue *Sant'Andrea* (Saint Andrew), which stands with statues by Bernini, Bolgi, and Mochi in Saint Peter's Basilica, and the statue *Santa Suzanna* (Saint Suzanne) in Santa Maria di Loreto, Rome. A very fine relief of *Putti Musicanti* (1618) can be admired in the church of the Santi Apostoli in Naples.

Anthony Van Dyck
Portrait of François Duquesnoy, detail
c. 1622, oil on canvas. Brussels, Royal Museum of Fine Arts.

Leading Figures · *François Duquesnoy*

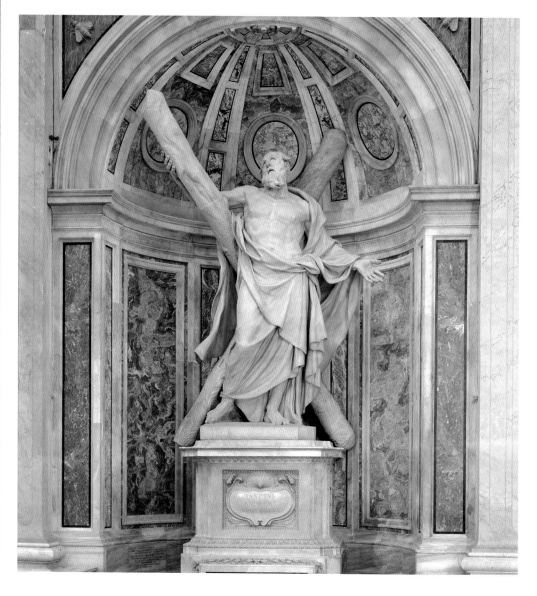

François Duquesnoy
Sant'Andrea
1629–33, marble.
Vatican City, Saint Peter's Basilica.

Artemisia Gentileschi
(b. Rome 1593, d. Naples c. 1652)

Artemisia Gentileschi
Self-Portrait, detail from *Allegory of Painting,* c. 1628, oil on canvas. Rome, National Gallery of Ancient Art in Barberini Palace.

The general public has learned something of the turbulent life of Artemisia Gentileschi through a number of novels and films, which have made her a very topical figure: a woman who had the courage and strength to take control of her own life without yielding to compromises with shallow morality or hypocrisy. Her life was overshadowed by the scandal generated by the court action she brought against Agostino Tassi (1566–1644), a painter from Perugia who raped her. The daughter of established painter Orazio Gentileschi (1563–1639), Artemisia absorbed the legacy of Caravaggio from her father, who had been among the first artists to follow Caravaggio's example in the early seventeenth century. Artemisia chose to underscore the realism of her compositions in an unflinching style that does not spare the viewer's feelings. She worked in the major Italian cities (Florence, Rome, Naples) and had a brief stay in England (1638–39). She died in Naples, her adopted city.

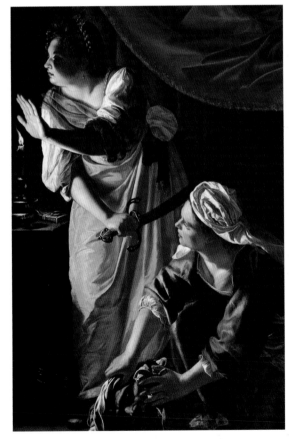

Above:
Artemisia Gentileschi
Judith and Her Maidservant with the Head of Holofernes
c. 1623–25, oil on canvas. Detroit, Institute of Arts.

Right:
Artemisia Gentileschi
Portrait of a Gonfaloniere
c. 1625, oil on canvas. Bologna, Communal Collection of Fine Arts.

Luca Giordano
(b. Naples 1634, d. 1705)

Luca Giordano, *Self-Portrait*
c. 1692, oil on canvas.
Naples, Pio Monte della
Misericordia.

Luca Giordano was the most versatile and prolific figure in the second generation of seventeenth-century Neapolitan painters, the generation that had already synthesized the work of Caravaggio and was moving on to engage with other artistic poetics. Son of Antonio Giordano, a copier, Luca served his apprenticeship under the elderly Jusepe de Ribera, during which time he became familiar with the dramatic intensity of Caravaggio's approach to light. He traveled across Italy in 1652 and discovered other painters and their works. He encountered the work of Correggio and the art of the Veneto, as well as Giovanni Lanfranco and the traditional art of Emilia Romagna; he also discovered Pietro ad Cortona and Rome's artistic circle. Between 1682 and 1685, he painted the vast fresco on the vaulted ceiling of the gallery in Medici Riccardi Palace in Florence, depicting the *Allegory of Justice*. He spent ten years in Spain (1692–1702) and the last years of his life in Naples, where he painted the frescoes of the chapel of the Tesoro di San Martino (1704).

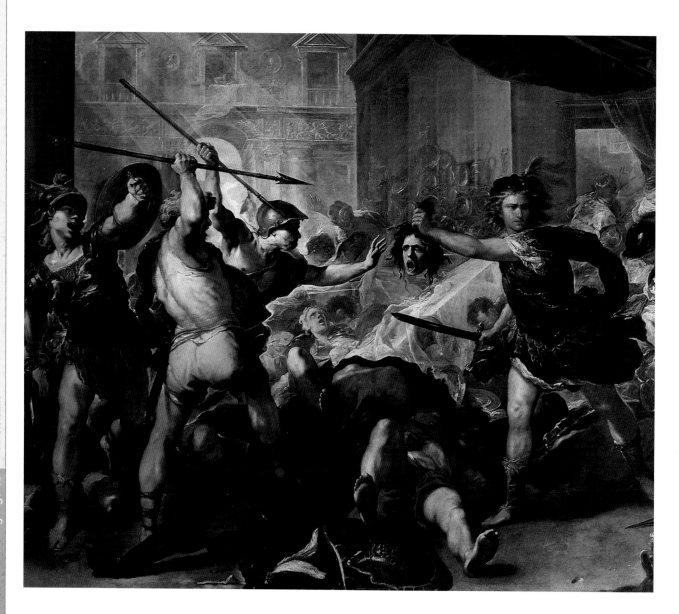

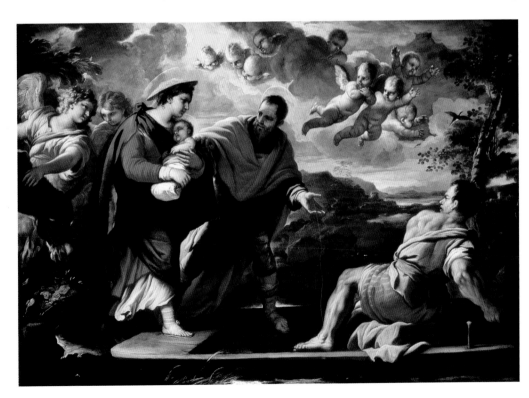

Luca Giordano
Allegory of Justice
1682–85, fresco.
Florence, Palazzo Medici
Riccardi.

Right:
Luca Giordano
Flight into Egypt
1684–85, oil on canvas.
Madrid, Santa Marca
Collection.

Facing page:
Luca Giordano
*Perseus Fighting Phineus
and His Companions* or
*Perseus Turning Phineus
and His Followers
to Stone*
1670, oil on canvas.
London, National
Gallery.

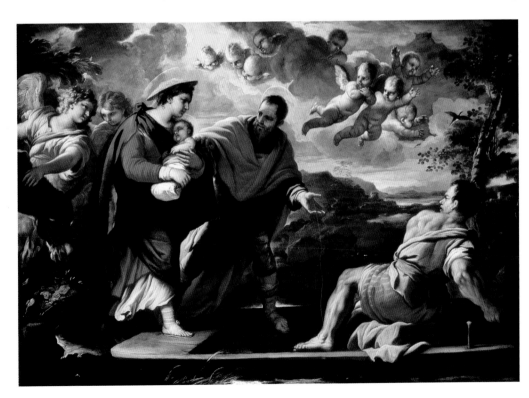

Guercino
Giovanni Francesco Barbieri
(b. Cento, Ferrara 1591, d. Bologna 1666)

Guercino's early work was self-taught before he served his apprenticeship under Benedetto Gennari. His work was also influenced by his contact with the Carracci family. He worked for Alessandro Ludovisi, archbishop of Bologna and later cardinal, executing four large canvases that are today housed in different museums. Opportunity smiled on Guercino when Cardinal Ludovisi became Pope Gregory XV in 1621. Guercino was summoned to Rome to decorate the palaces of local aristocrats, including Costaguti Palace and Lancellotti Palace. Some of his outstanding work can be seen in the Casino Ludovisi, where paintings like *Aurora* and *Fame* earned him immense acclaim, further assured by his *Burial of Saint Petronilla* (1622–1623, Pinacoteca Capitolina). He left Rome in 1623 and returned to his native town of Cento, where he went on to become one of the major figures in seventeenth-century painting from the Emilia region.

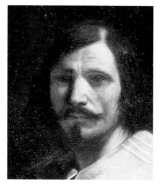

Guercino
Self-Portrait
c. 1630, oil on canvas.
United States, private collection.

Guercino
Aurora
1621–23, tempera
mural painting.
Rome, Casino Ludovisi.

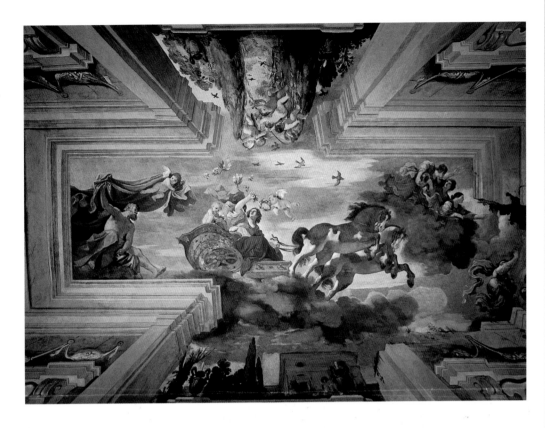

Guercino
Moonlight Landscape
1615–16, oil on canvas.
Stockholm, National
Museum.

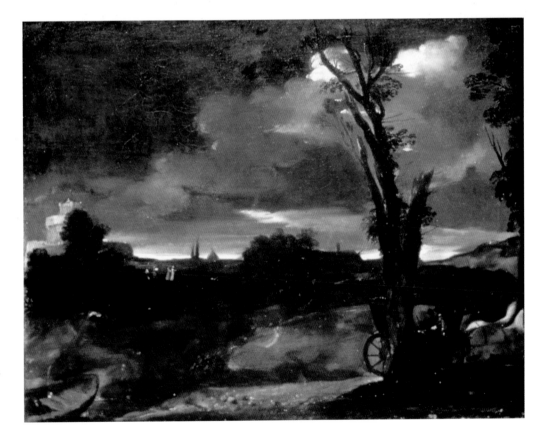

Facing page:
Guercino
Et in Arcadia Ego
1618–22, oil on canvas.
Rome, National Gallery
of Ancient Art in
Barberini Palace.

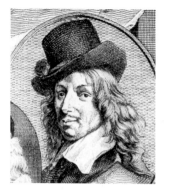

Jacobus Houbraken
Portrait of Frans Hals, engraving
by Arnold Houbraken
1718. De Groote Schouburgh,
Amsterdam.

Frans Hals
(b. Antwerp 1580, d. Haarlem 1666)

Our knowledge of this lively and prolific Dutch painter comes for the most part from his many surviving works (around 240), rather than the few documents and contemporary papers that refer to him. He was married twice and had six children. His turbulent career was closely tied to local commissions, and as a result he often had recourse to lawyers and the courts to force his debtors to pay. He was part of the local watch; according to records, from 1622 onward he was a regular member of the town militia (company of Saint George). He was thus familiar with local military circles, which explains a number of his commissions, including the well-known *Banquet of the Officers of the Civic Guard* (1616, Haarlem, Frans Hals Museum), and his many innovative group portraits, which were not well received at the time but were of fundamental importance for later artists including Courbet and Manet.

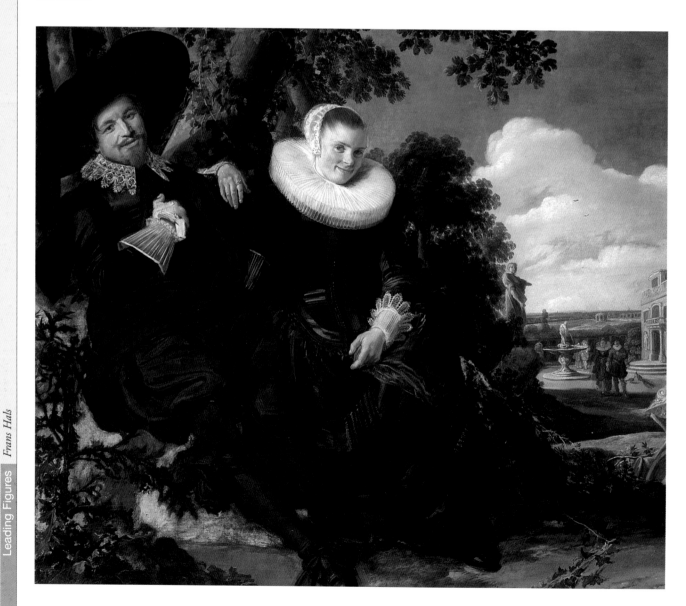

Gerrit van Honthorst
The Matchmaker, detail
1625, oil on panel.
Utrecht, Centraal Museum.

Gerrit van Honthorst
(b. Utrecht 1590, d. 1656)

The Dutch painter was known in Italy, where he stayed from 1610 to 1620, as Gherardo delle Notti. During his time in Rome, Honthorst became familiar with the work of Caravaggio and the Manfredi method, the style of Caravaggio developed by the Roman painter and *caravaggisto* Bartolomeo Manfredi. Honthorst shifted away from the Mannerist style he had learned in his apprenticeship with Bloemaert in Holland and concentrated on his experimentation with candlelight in nocturnal scenes, although his work continued to show the influence of Guido Reni and Bassano as well. Honthorst returned to the Low Countries after his enriching experience in Italy and found himself in the role of trailblazer, as he spread the "message of Caravaggio" across Europe. He was employed by the crowned heads of England and Denmark; he worked for the princes of Brandenburg and the stadtholder Frederick Henry of Orange. His works ranged from religious scenes to genre painting.

Right:
Gerrit van Honthorst
Flute Player
1623, oil on canvas.
Schwerin, State Museum.

Music is a recurring theme in the work of Gerrit van Honthorst, often lending an earthy, anecdotal tone to his paintings, a homage to the cheerful atmosphere of taverns where revelers drink and play music, or to the sly relationship between music and love, which was a staple of seventeenth-century painting. In this work, the artist delights in capturing the efforts of an old singer who refuses to accept that his voice is no longer what it used to be.

Facing page:
Frans Hals
Wedding Portrait
1622, oil on canvas.
Amsterdam, State Museum.

Jacob Jordaens
(b. Antwerp 1593, d. 1678)

Flemish in origin, Jordaens was admitted to the Antwerp painters' guild at the unusually early age of twenty-three, and by 1621 he had his own workshop. He was noticed by Rubens himself, who asked Jordaens to become his assistant. The influence of the great master can be seen in Jordaens's works; it was Rubens who helped Jordaens absorb the styles of Michelangelo and Caravaggio, which the younger artist interpreted in his own innovative way, making use of rich, vibrant colors that were the equal of the great Flemish master. With his sweeping, easy brushwork and distinctive style, he concentrated on scenes from ordinary life, which he occasionally set off with touches of mythological beauty, evident in his *Satyr in the Peasant's House*. He also painted a number of religious scenes and from 1640 onward received a growing number of important commissions.

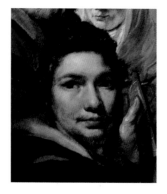

Jacob Jordaens, *The Artist with the Family of His Father-in-Law Adam van Noort*, detail 1615–16, oil on canvas. Kassel, Old Masters Picture Gallery.

Giovanni Lanfranco
(b. Terenzo 1582, d. Rome 1647)

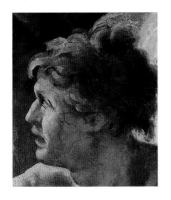

Giovanni Lanfranco
Assumption of the Virgin, detail
of *Male Figure* 1525–27, fresco.
Rome, Sant'Andrea della Valle.

A pupil of Agostino Carracci, Lanfranco acquired his master's love for Raphael's ideal, while from Annibale Carracci he acquired a sense for the monumental softened by the style of Correggio. The affinities with Annibale's technique can be seen in a series of drawings including *Apparition of Jove* (Paris, Louvre), which had long been attributed to Annibale Carracci. Lanfranco trained at first under Agostino, who involved him in the decorations for the Palazzo del Giardino in Parma, before joining the workshop of Annibale, involved in decorating the Farnese Gallery. His first major independent commission was for the decorations of the Camerino degli Eremiti, also in Farnese Gallery (c. 1604). In Rome, he worked with Guido Reni (frescoes for San Gregorio al Cielo, 1608–10) and on his own in decorations for San Carlo ai Catinari and Sant'Andrea Della Valle. He was active in Naples from 1634 to 1646.

Facing page:
Jacob Jordaens
Pan (Satyr Playing a Flute)
Mid-seventeenth century, oil on canvas.
Amsterdam, State Museum.

Above:
Giovanni Lanfranco
Council of the Gods
1624–25, fresco.
Rome, Borghese Gallery.

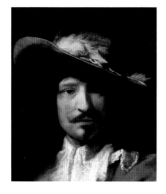

Charles Le Brun
Portrait of the Sculptor Nicolas Le Brun, detail
c. 1635, oil on canvas.
Salzburg, Residenz Gallery.

Charles Le Brun
(b. Paris 1619, d. 1690)

This French painter, born into a family of artists (his father, Nicolas, was a sculptor of a certain talent), served his apprenticeship under Simon Vouet, whose workshop he joined at the age of fourteen. He first encountered Italian art at Fontainebleau, where he had gone to study Mannerism and the works in the royal collection. Dazzled by the young man's talent, his patron Chancellor Séguier sent Le Brun with Poussin to Rome, where he lived from 1642 to 1646. While in Rome, Le Brun had ample opportunity to study classical sculpture firsthand as well as the works of the great Renaissance artists, including Raphael, and the Bolognese school of Guido Reni and the Carracci family. He also had the opportunity to strengthen his friendship with Poussin, who helped Le Brun develop as an artist. In 1663, he was appointed director of the Gobelins as well as chancellor for life of the French Royal Academy. He executed a number of works for some of the major patrons of his age, including Fouquet, Richelieu, and Colbert.

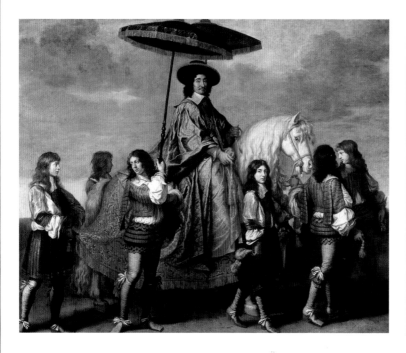

Charles Le Brun
Chancellor Séguier
c. 1656, oil on canvas.
Paris, Louvre.

Although the painting depicts a scene from contemporary life, Le Brun confers a certain sobriety on his subject that comes from using well-known classical models derived from bas-reliefs and sculpture.

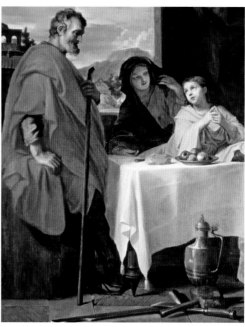

Charles Le Brun
Holy Family (The Grace)
Second half of the seventeenth century, oil on canvas.
Paris, Louvre.

Le Brun's great talent lay in his ability to convey the intimate atmosphere of this moment in the life of Jesus in such a way as to make the story accessible to everyone.

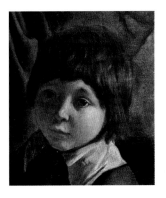

Louis Le Nain
Peasant Family in an
Interior, detail
1640–45, oil on canvas.
Paris, Louvre.

Louis Le Nain
(b. Laon c. 1593, d. Paris 1648)

The three Le Nain brothers left their mark on seventeenth-century France, offering a lively and very accessible image of their age. Although they were all members of the Royal Academy, they were strongly attracted to Caravaggio's realism and can rightly be considered the first "anti-academic" French painters. Their work, in a sense, constitutes the other side of the coin of official art, which at the time was the monopoly of highly acclaimed artists, including Simon Vouet and Charles Le Brun. Louis Le Nain produced works like *The Happy Family* as well as mythological and religious paintings, and is better known than his two brothers: Antoine (b. Laon c. 1588, d. Paris 1648) specialized in crafting small paintings on copper; Mathieu (b. Laon 1607, d. Paris 1677) lived the longest of the three and succeeded in gaining a certain position for himself in society, painting the portraits of leading figures of his time, including Cardinal Mazarin and Anne of France.

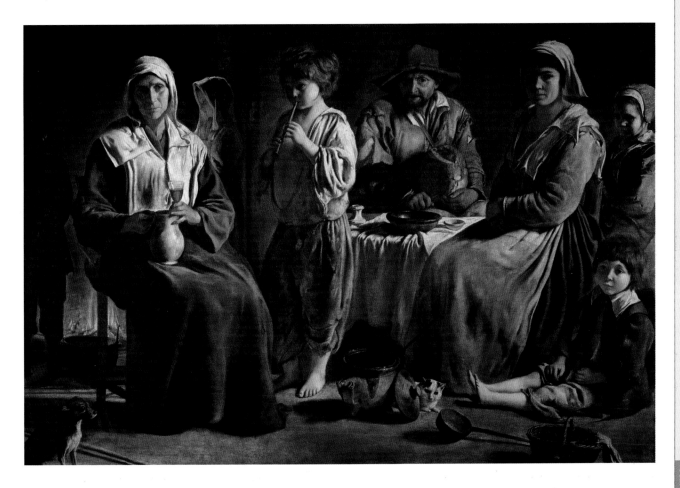

Louis Le Nain
Peasant Family in an
Interior
1640–45, oil on canvas.
Paris, Louvre.

One of the main features of seventeenth-century painting was the attention artists paid to the everyday lives of people of humble birth. In this work, Le Nain captures the elegant composure of a world where people, by necessity, have a taste for simple things and are unfamiliar with the excesses in food or clothes displayed by the aristocracy.

French school
Portrait of Louis Le Vau, detail
Eighteenth century, oil on
canvas. Versailles, Châteaux de
Versailles et de Trianon.

Louis Le Vau
(b. Paris 1612, d. 1670)

The fame of this French architect is without a doubt tied to the incredible undertaking represented by the Château de Versailles, when the king decided to transform Louis XIII's modest country home into a palace of unparalleled splendor. Le Vau was nominated first architect of the realm and was also called upon to create a number of buildings for some of the greatest names in France's aristocracy and for members of the elite upper classes. Cardinal Mazarin commissioned him to build the Collège des Quatre-Nations (1662, today the home of the Institut de France), while the finance minister Nicolas Fouquet commissioned him to build the majestic castle at Vaux-le-Viscomte (1656–61), which was so beautiful that, piqued by envy, the king orchestrated the arrest of Fouquet. Le Vau took the Mannerist inclinations of Hardouin-Mansart and guided them toward the free-flowing Baroque classicism influenced by the careful composure of Bernini's works.

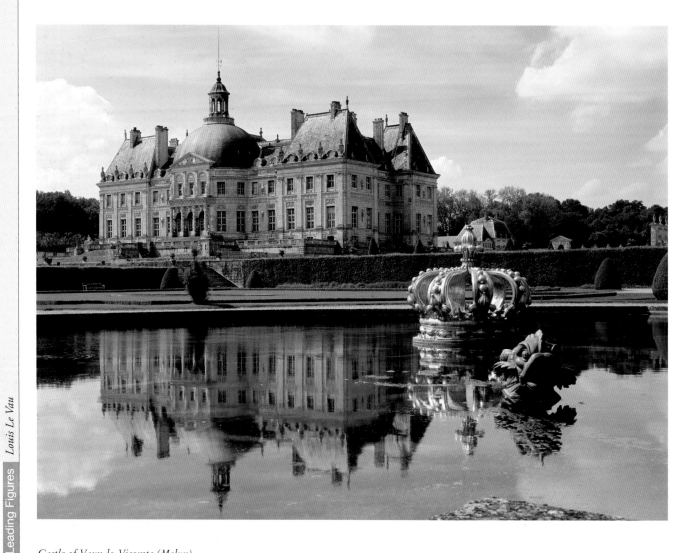

Castle of Vaux-le-Vicomte (Melun).

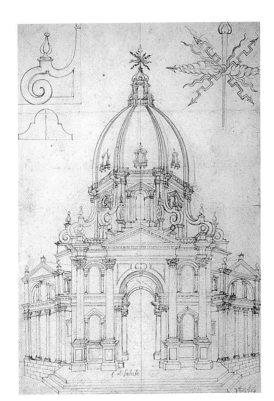

Baldassarre Longhena
(b. Venice 1597, d. 1682)

Defined by critics as the "only high-class alternative to the Baroque of Rome," Longhena's architecture was able to renew the Venetian tradition without betraying its principles. A former pupil of Vincenzo Scamozzi (1552–1616), Longhena's later work clearly shows the fine sensitivity he acquired during his apprenticeship as a sculptor. His first work was to finish the Procuratie Vecchie, begun by his teacher. He then built the church of the Scalzi (1660) and Santa Maria Della Salute (completed by Antonio Gaspari after Longhena's death in 1687). He also designed civilian buildings, including Ca' Pesaro (1660) and Ca' Rezzonico (1667).

Baldassarre Longhena (attr.)
Facade of the Church of Santa Maria della Salute in Venice
c. 1631, engraving.
Vienna, Albertina Museum, Collection of Graphic Arts.

Baldassarre Longhena
Santa Maria della Salute
1631–87.
Venice.

Generally considered by critics to be Longhena's masterpiece, the church of Santa Maria della Salute was built as a votive church dedicated to the Virgin to implore her to end the devastating plague of 1630. Completed by Antonio Gaspari in 1687, the church stands at the tip of the Dorsoduro, next to the Dogana, rebuilt between 1677 and 1683 by Giuseppe Benoni. The church has been rightly defined as a "prayer in marble," which blends religious devotion with civic piety. It has an octagonal layout and transversal apse and shows how Longhena paid homage to Palladio's architectural idiom while endowing it with Baroque sensitivity. This can be seen in the power and inventiveness of some of the building's features, such as the double cupola or the bridging volutes between the main building and the cupola base, as well as the multitude of statues.

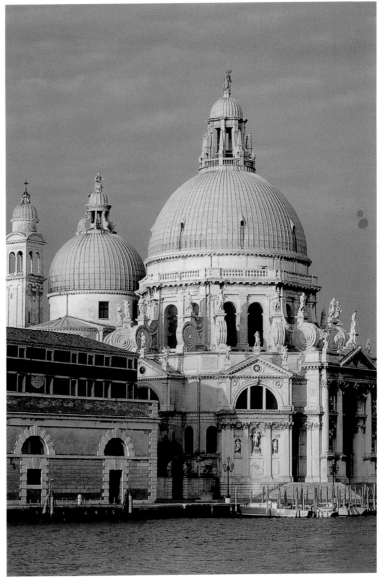

Claude Lorrain, in an engraving after the artist's Self-portrait.

Claude Lorrain
(b. Champagne 1600, d. Rome 1682)

Known as *le Lorrain* because of his native region, Claude arrived in Rome when he was just twenty, and he never left the Eternal City again, apart from a two-year stay in Naples (between 1619 and 1621) and a short period in Nancy, where he worked as an assistant in the workshop of Claude Deruet between 1625 and 1626. The artistic circle in Rome at the time was particularly lively and creative, still reeling from the impact of Caravaggio. Lorrain was also interested in Raphael, as can be seen in his relationship with the work of Poussin, who was also in Rome at the time. Beginning in the mid-1630s, Lorrain began to write *Liber Veritatis*, his book of the truth that was a kind of diary in which he recorded not only sketches of works he executed but also the names of all his patrons and clients, providing invaluable details about almost fifty years of artistic production.

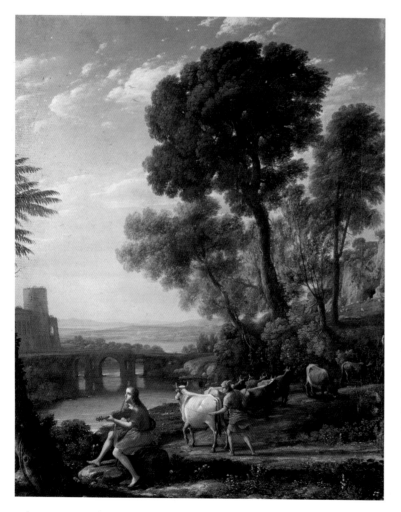

Claude Lorrain
Landscape with Apollo Guarding the Herds of Admetus
1645, oil on canvas.
Rome, Doria Pamphilj Gallery.

The complex interweaving of the many cultural strands of the seventeenth century cannot be reduced to the progression of a handful of stereotypes. It is thus hardly surprising that alongside the dominant movement of the *caravaggisti* painters, there was space for other approaches, such as those of Poussin or Lorrain, as well as for other subjects and themes. The landscape is transformed into a wide stage that becomes the setting for both profane and Christian scenes (Annibale Carracci's *Flight into Egypt*). Following Carracci and Poussin, in this work Lorrain gives his mythological subject a landscape setting. The central figure is Apollo, who for a period in his gilded life was also a shepherd in the service of Admetus. The scene depicts the episode of Hermes stealing from Apollo, but the story takes a very different turn. To reward Admetus for his hospitality, Apollo asks the Fates to grant the man immortality, provided someone offers to die in his place. Admetus's wife, Alcestes, offers to die for her husband (she is later freed from Hades by Hercules).

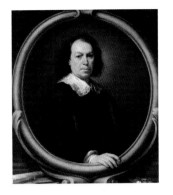

Bartolomé Esteban Murillo
Self-Portrait, detail
c. 1675, oil on canvas.
London, National Gallery.

Bartolomé Esteban Murillo
(b. Seville 1618, d. 1682)

Murillo is, alongside Velázquez, Ribera, and Zurbarán, one of the greatest figures of Spanish Baroque art. We know that until the age of twenty-one, he had been apprenticed in the workshop of Juan del Castillo, but little else is known about his early years for which very little documentation has reached us. Murillo's first important commissions were the paintings depicting the life of Saint Francis (1645–46) for the Franciscan monastery in Seville. Murillo was at first attracted to the style of Cano, Ribalta, and Ribera before coming under the influence of Zurbarán. His style reached maturity after his stay in Madrid in 1655, when he had the opportunity to study the royal collections. In 1660, he founded a painting academy in Seville with Juan Valdés Leal and Francisco Herrera the Younger, and became its president. He established his reputation and fame with his portraits and genre scenes.

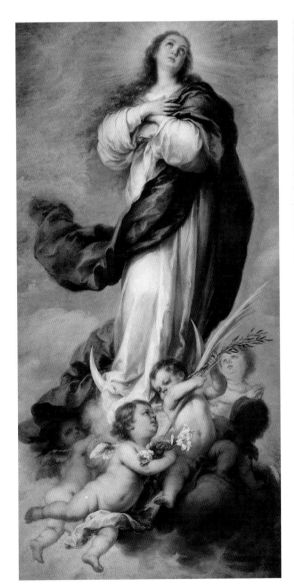

Left:
Bartolomé Esteban Murillo
Immaculate Conception of Aranjuez
1656–60, oil on canvas.
Madrid, Prado Museum.

The image of the Immaculate Conception derives from a passage in the Book of Revelation (12:1) that describes a woman clothed in the sun's rays.

Above:
Bartolomé Esteban Murillo
Children with Shell
(Ecce Agnus Dei)
c. 1670, oil on canvas.
Madrid, Prado Museum.

The evident tenderness, candor, and playfulness suggest that the mission of salvation of Christ and John the Baptist was revealed as soon as they were born.

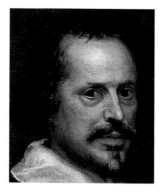

Pietro da Cortona
(b. Cortona 1596, d. Rome 1669)

Both a painter and an architect, da Cortona (also known as Pietro Berrettini) was a leading exponent in both disciplines of a "third way," compared with the approaches of Bernini and Borromini or Caravaggio and the Carracci family. His work resonated in the movement known as *cortonismo*. In 1612, he worked under Andrea Commodi in Rome. Pietro owed his rise to fame and fortune to his relationship with the powerful Barberini family, who commissioned major works from him, including *Allegory of Divine Providence* (1633–39), a fresco painted on the ceiling of the *piano nobile* of the family's palace in what was then the outskirts of Rome. He was elected a prince of the Academy of Saint Luke and designed its new home, which was then located in the Church of Santi Luca e Martina. Summoned to Florence, he painted the acclaimed decorations in the Sala Della Stufa in Palazzo Pitti depicting Venus, Jupiter, and Mars (1637–47). He also designed the churches of Santa Maria in Via Lata (1658–62) and Santa Maria Della Pace, both in Rome.

Pietro da Cortona
Self-Portrait, detail
c. 1630, oil on canvas.
Florence, Uffizi Gallery.

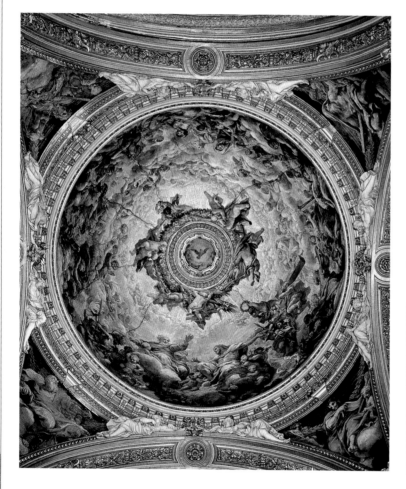

Pietro da Cortona
Trinity in Glory Among the Saints and Exaltation of the Instruments of the Passion
1648–51, fresco.
Rome, Santa Maria in Vallicella.

Pietro da Cortona
Santa Maria della Pace,
facade
1656–57.
Rome.

Leading Figures Pietro da Cortona

Nicolas Poussin
(b. Les Andelys 1594, d. Rome 1665)

Nicolas Poussin
Self-Portrait, detail
c. 1630, drawing.
London, Trustees of the
British Museum.

Poussin was born in Normandy, the son of Jean Nicolas, a fallen noble, and Marie Delaisement, the widow of a magistrate whose dowry had included a small estate. Nicolas's family had chosen a career in law for him, and to escape this fate and follow his own calling, he ran away from home and eventually reached Paris (perhaps after a time in Rouen). He could not bear the burden of hardship and returned to his parents. In 1621, he was back in Paris and received his first commissions, working alongside Philippe de Champaigne. In 1624, he decided to undertake the journey to Italy that had become so customary for artists. In 1625, he settled in Rome and six years later got married. Ten years later, he returned to Paris and was appointed "first painter in ordinary to the king" with a pension of one thousand ecus a year. Nevertheless, life at court did not suit Poussin, who was not fond of petty jealousies and intrigues, and despite the steady flow of important commissions he decided to return to Rome in 1642, where he died soon after the death of his wife.

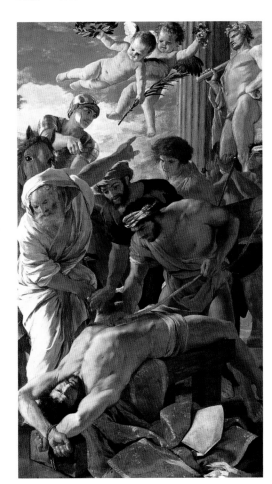

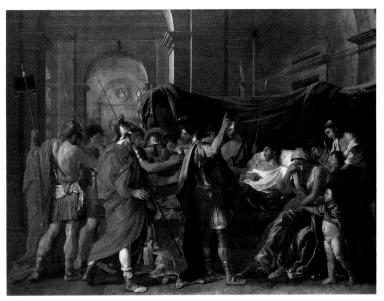

Left:
Nicolas Poussin
Martyrdom of Saint Erasmus
1628, oil on canvas.
Vatican City, Vatican Picture Gallery.

Above:
Nicolas Poussin
Death of Germanicus
1627, oil on canvas.
Minneapolis, Minneapolis Institute
of Arts.

Andrea Pozzo
Self-Portrait, detail
c. 1680, oil on canvas.
Florence, Uffizi Gallery.

Andrea Pozzo
Trompe l'oeil cupola
1691–94, fresco.
Rome, Sant'Ignazio.

Andrea Pozzo
(b. Trent 1642, d. Vienna 1709)

An architect, scene designer, and perspective theorist, Andrea Pozzo was among those Baroque artists who succeeded, through the force of their brushwork and the power of their imagination, in breaching the ceilings and roofs of churches to let Paradise through. Pozzo entered the Jesuits in 1665 and arrived in Rome in the early 1680s. His most well-known work is his masterpiece, *Apotheosis of Saint Ignatius* (1691–94), executed for the church of Sant'Ignazio in Rome. Looking up from the right spot, observers can admire the saints in their glory. Pozzo also decorated the refectory in the convent of Trinità dei Monti (1694). In 1703, he arrived in Vienna, where his work on the Liechtenstein palace, the university, and the college of the Jesuits brought him to prominence and made him an influential figure for eighteenth-century German painters. He was also an accomplished mathematician and wrote a treatise on perspective, *Perspectiva pictorum et architectorum* (1693–1702).

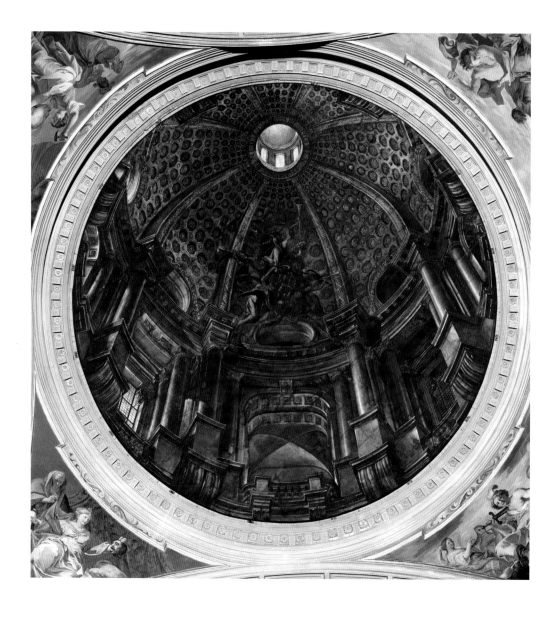

Mattia Preti
(b. Catanzaro 1613, d. Valletta 1699)

At the time, Preti's nomination as a Knight of Malta at the scandalously early age of twenty-nine (1642) caused such a controversy that a new nickname was coined for him, the "Calabrese Knight," which combined both his origin and his new title. The nomination was well deserved, however, as Preti had already established quite a reputation, thanks to his work in Naples (1630), where he had quickly adopted the Manfredi method, as Caravaggism was then called. He had also been acclaimed for his work in Rome, where he had been elected to the Virtuosi al Pantheon; he painted frescoes in the churches of San Carlo ai Catinari (1642) and Sant'Andrea Della Valle (1650–51). He moved between Modena and Naples before settling in Valletta (Malta), where he remained for the rest of his life, except for occasional trips. He was appointed official painter to the Order of the Knights of Malta and painted a number of decorative cycles, including *Glory of the Order* (Valletta, San Giovanni).

Mattia Preti
Self-Portrait, detail
1660, oil on canvas.
Florence, Uffizi Gallery.

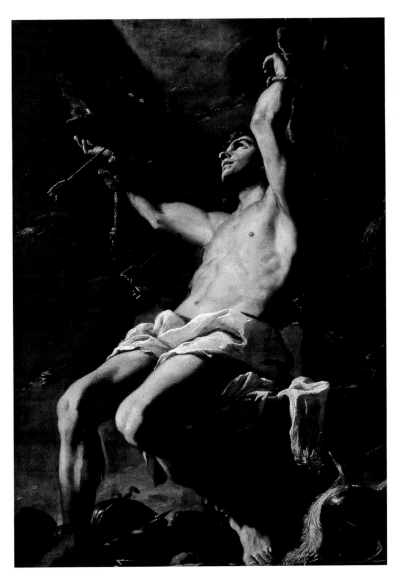

Mattia Preti
Saint Sebastian
1657, oil on canvas.
Naples, Santa Maria dei
Sette Dolori.

Mattia Preti
Vanity
c. 1660–70, oil on canvas.
Florence, Uffizi Gallery.

Rembrandt
Self-Portrait of the Young Artist,
detail
c. 1634, oil on canvas.
Florence, Uffizi Gallery.

Rembrandt
(b. Leiden 1606, d. Amsterdam 1669)

The eighth of nine children, Rembrandt Harmenszoon van Rijn was the penultimate child of a reasonably prosperous miller who owned a mill on the banks of the River Rhine (hence the "van Rijn" part of the family name). Rembrandt's father enrolled him in Leiden University in 1620 with the idea that his son would go on to a brilliant literary career. The son of Harmen had other ideas, and at the age of fourteen he joined the workshop of Isaaks Jacob van Swanenburgh, who introduced him to Italian art, and then the workshop of Pieter Lastman. Despite his passion for painting, Rembrandt never undertook the customary journey to Italy. Instead, he began his career in Leiden, where Lastman embraced Caravaggio's style as practiced by the artists of Utrecht. Rembrandt proved to be an exceptional, indeed unparalleled, interpreter of Caravaggio's message, expressing his talent in paintings (*The Night Watch*, 1642) and etchings (*The Hundred Guilders Print*, 1642–45).

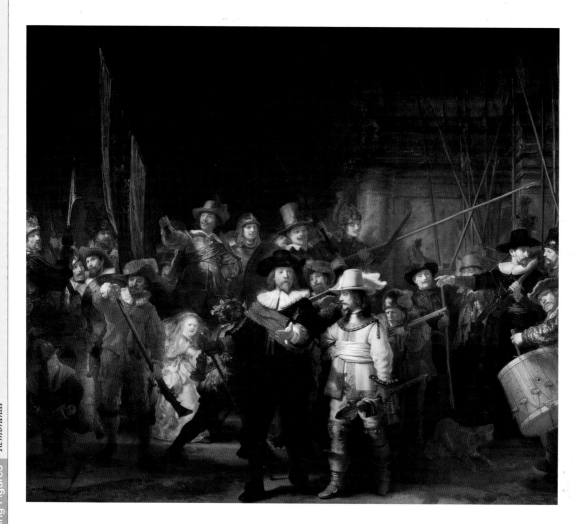

Rembrandt
The Company of Frans Banning Cocq and Willem van Ruytenburch (The Night Watch)
1642, oil on canvas.
Amsterdam, State Museum.

Rembrandt
A Woman in Bed
c. 1648, oil on canvas.
Edinburgh, National Gallery of Scotland.

Above:
Rembrandt
*Diana Bathing with Her
Nymphs, with Stories of
Acteon and Callisto*
1634, oil on panel.
Anholt, Museum
Wasserburg.

Right:
Rembrandt
*Two Studies for Birds
of Paradise*
c. 1640, drawing.
Paris, Louvre.

Facing page:
Rembrandt
Seated Woman
1632, oil on canvas.
Vienna, Academy of
Fine Arts.

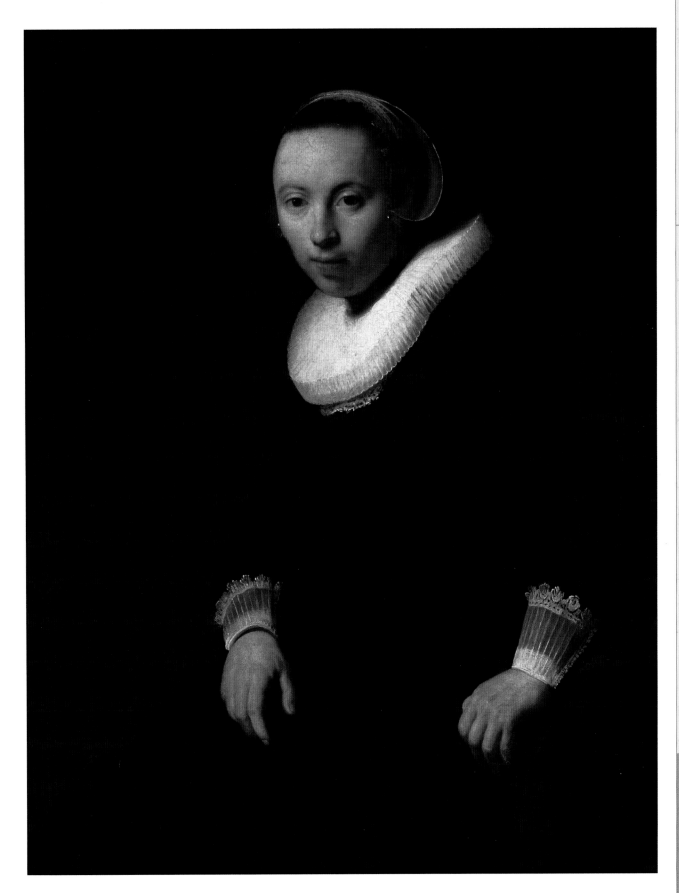

Guido Reni
(b. Bologna 1575, d. 1642)

The young Guido Reni in all likelihood was destined to become a musician, as his father, Daniele, had made him start studying for that profession. Guido's father's choice was to some extent understandable, as Daniele, through his work as a musician in the employ of the town council, had gained the respect of his fellow citizens as well as a certain financial independence. Guido's passion for painting and art was so strong that he abandoned his music studies and entered apprenticeship in the workshop of Flemish painter Denijs Calvaert (1540–1619), whose pupils included the like of Domenichino and Francesco Albani. Reni devoted himself to studying the work of Raphael, who remained his artistic ideal throughout his life (he did a number of copies of Raphael's *The Ecstasy of Saint Cecilia*).

Guido Reni
Self-Portrait, detail
c. 1630, oil on canvas.
Florence, Uffizi Gallery.

Guido Reni
*Crucifixion of
Saint Peter*
1604–5, oil on canvas.
Vatican City, Vatican
Picture Gallery.

Guido Reni
*Slaughter of the
Innocents*
1611–12, oil on canvas.
Bologna, National
Picture Gallery.

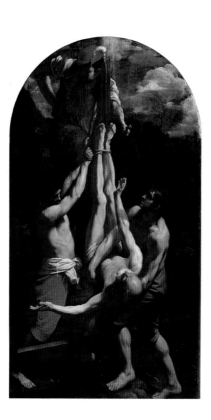

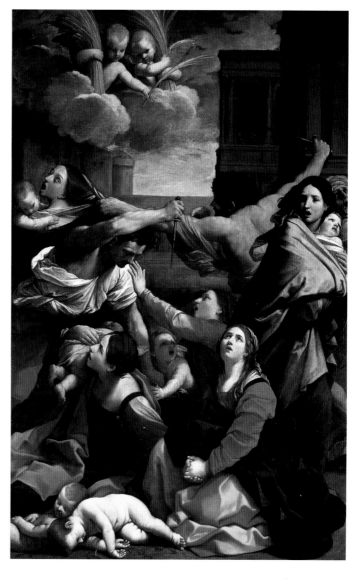

Guido's aspirations were not completely satisfied by his time with Calvaert, and at the age of twenty he decided to join the Carracci academy. He was part of the academy for three years (1595–98), and there he tempered the classical tendencies of the style of his adored Raphael with his studies of realistic representation. Rather than winning him new friends, Guido's talent was the source of conflict and clashes within the academy. He joined the Confraternity of Painters in 1599, and between that year and 1602 he made his first visits to Rome before settling there in 1608. He established his reputation with his depiction of the *Crucifixion of Saint Peter*, today housed in the Vatican Picture Gallery, which he painted for Cardinal Aldobrandini between 1604 and 1605. This large altarpiece shows the influence of Caravaggio, whose style was to become a fundamental part of Guido's own painterly language. From this point, he began to receive more important commissions. Pope Paul V summoned him to work on the pope's palace in Montecavallo and the basilica of Santa Maria Maggiore. He returned to Bologna in 1614, where he remained for the rest of his life, except for a trip to Naples in 1622 (the frescoes for the Tesoro di San Gennaro) and Rome in 1627.

Left:
Guido Reni
Atalanta and Hippomenes
1615–25, oil on canvas.
Madrid, Prado Museum.

A signed version of this canvas is in the collection of the National Museum of Capodimonte in Naples; the painting was thought not to have been by Reni until restoration work in the 1960s proved that it was original and confirmed entries in Spanish inventories. The painting is one of Reni's masterpieces, showing his skill in blending the legacies of Raphael and Caravaggio.

Below:
Guido Reni
The Rape of Helen
1629, oil on canvas.
Paris, Louvre.

José Maea
Portrait of Ribera, engraving by
Manuel Alegre
Late eighteenth century.
Madrid, Calcografia Nacional.

Jusepe de Ribera
(b. Játiva 1591, d. Naples 1652)

Known in Italy as "lo Spagnoletto" because of his Spanish origins, Ribera served his apprenticeship under Francisco Ribalta in Valencia. There is little documentary evidence, but according to some reports, he arrived in Italy when he was around twenty years old. In all likelihood, he spent time traveling around Lombardy and Emilia in 1611; there is evidence that he was in Rome between 1613 and 1615. He settled in Naples the following year, perhaps summoned by the viceroy, the duke of Osuna, and he remained in Naples for most of his life. Ribera's palette and approach to color had for some time been influenced by Caravaggio before his encounter with Velázquez, who also exerted considerable influence on the artist's technique; after his stay in Rome, his colors became lighter. This evolution continued over the course of the next decade, as the Venetian painting style become more familiar in Rome and later in southern Italy. Ribera was a major influence on Neapolitan painters and painting; one of his pupils, for example, was Luca Giordano.

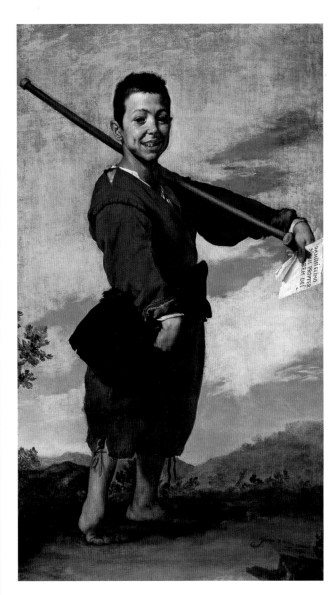

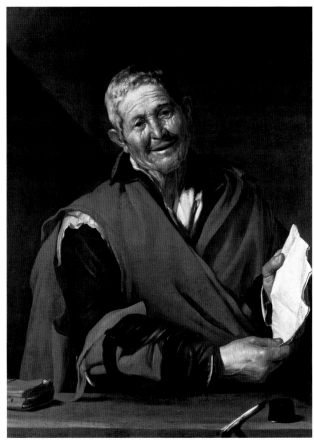

Left:
Jusepe de Ribera
The Clubfoot
c. 1614, oil on canvas.
Paris, Louvre.

Jusepe de Ribera
Democritus
Oil on canvas.
New York, formerly in
the Piero Corsini
collection.

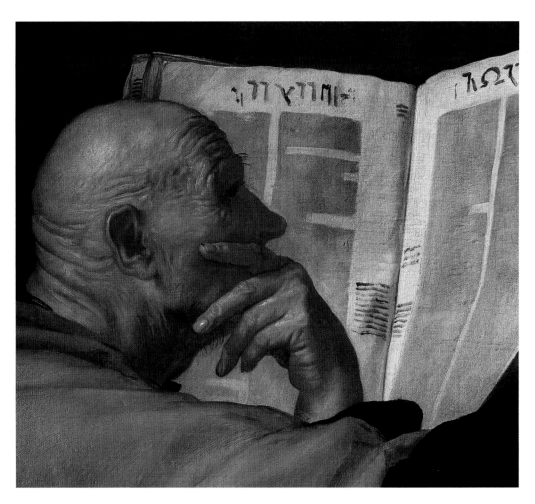

Jusepe de Ribera
Joel, detail
1638, oil on canvas.
Naples, Certosa di San
Martino.

The careful attention
paid to compositional
volumes and light is one
of the hallmarks of
Ribera's work,
considered among the
finest works of homage
to Caravaggio. Here, the
use of oblique, almost
cruel lighting takes on a
moral dimension as it
underlines and decries
the fragility of the
human condition.

Jusepe de Ribera
Landscape with Fort
Work signed and dated
1639, oil on canvas.
Collection of the
Duchess of Alba.

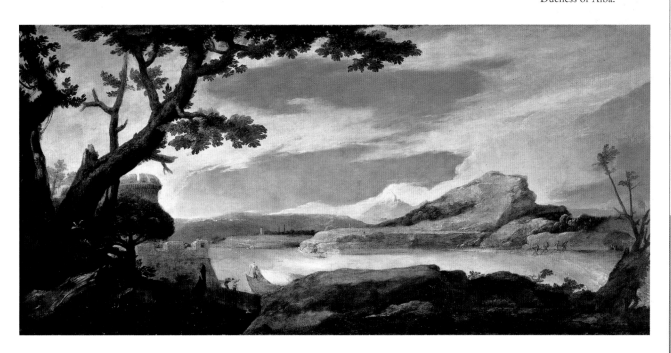

Peter Paul Rubens
Self-Portrait, detail
1628, oil on canvas.
Florence, Uffizi Gallery.

Peter Paul Rubens
(b. Siegen 1577, d. Antwerp 1640)

This fascinating and widely praised Flemish painter stands among those artists who, more than others, defined the Baroque style in painting. The son of a middle-class, Calvinist father who had fled to Cologne to avoid persecution, Rubens began his artistic training and practice in that city before settling in Antwerp. When, at the age of twenty-three, Rubens undertook the customary journey to Italy, he had already established himself as an artist in his homeland. He spent eight years in Italy (1600–8), traveling among Venice, Mantua, Genoa, and Rome, and had ample opportunity to study Italian Renaissance art firsthand, discovering the works of Titian, Veronese, Tintoretto, Michelangelo, the Carracci family, and Caravaggio. He also developed his own personal, complex, and grandiose style (*Adoration of the Shepherds*, 1608), which appealed to Europe's aristocrats and crowned heads, ensuring he was sought after by the leading courts of the age.

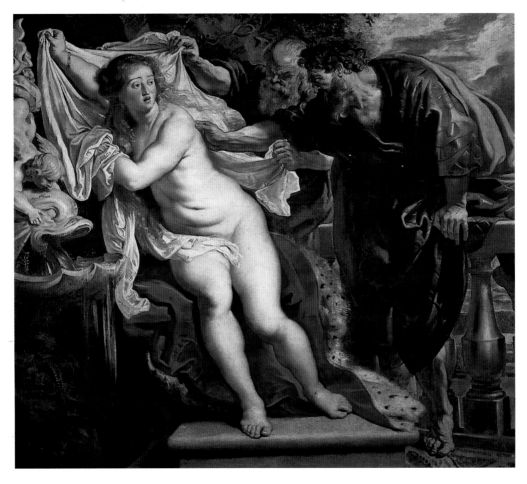

Facing page:
Peter Paul Rubens
Love and Psyche
1612–15, oil on canvas.
Hamburg, Rolf Stoedter
Collection.

Peter Paul Rubens
Susanna and the Elders
1609–10, oil on panel.
Madrid, Royal Academy of
Fine Arts of San Fernando.

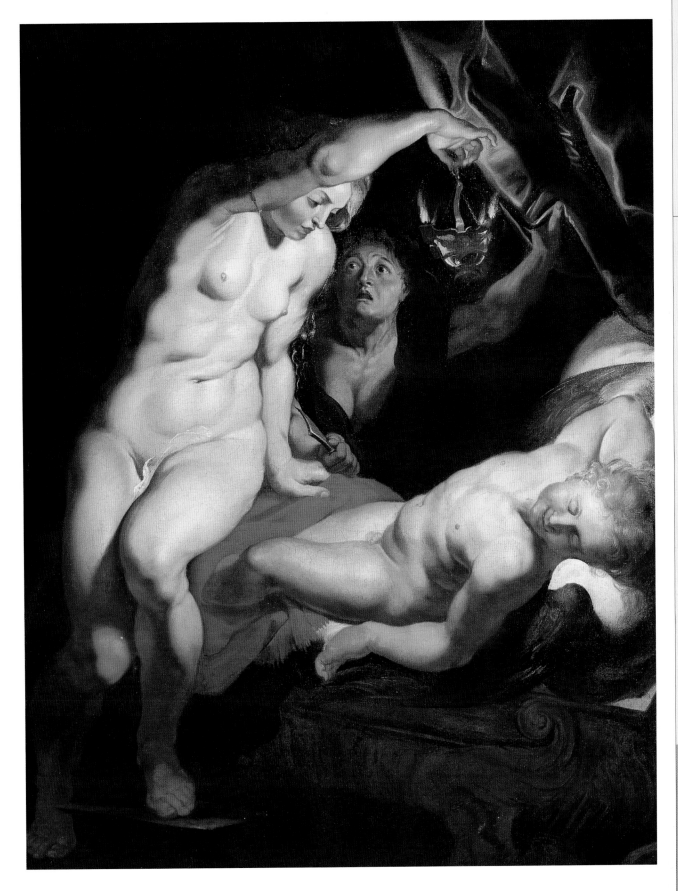

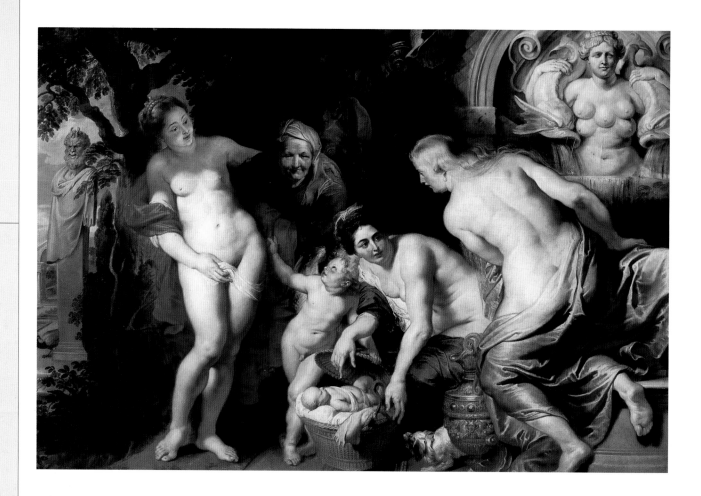

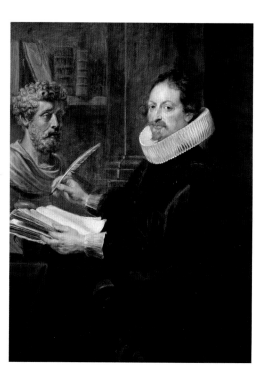

Above:
Peter Paul Rubens
The Discovery of the Child Erichthonius
1615–16, oil on canvas.
Vaduz, Collections of the Prince of Liechtenstein.

Right:
Peter Paul Rubens
Jan Caspar Gevaert
c. 1627, oil on panel.
Anversa, Museum of Fine Arts, Kunsten.

Facing page:
Peter Paul Rubens
*Rubens, His Wife, Helena Fourment, and One of
Their Children*
c. 1634–35, oil on panel.
New York, Metropolitan Museum of Art.

Anthony van Dyck

(b. Antwerp 1599, d. London 1666)

The son of a rich silk merchant, Van Dyck was considered a child prodigy and joined the workshop of Hendrik van Balen in 1609. He opened his own workshop at the age of fifteen. At eighteen, he was recorded as a member of the Antwerp painters' guild and worked alongside Rubens. He moved to England in 1620 and then to Italy in 1621. He stayed in Italy until 1627, settling in Genoa, a strategic spot for the Flemish artist, as he traded in tapestries and works of art. He also traveled to other cities in Italy (Venice, Florence, Rome, and Palermo) and elsewhere in Europe (Marseille, Aix-en-Provence), where he was well received and obtained a number of commissions. He returned to Antwerp and was appointed court painter to Archduchess Isabella. Appointed court painter by Charles I, Van Dyck settled in England, where he married and lived for the rest of his life after a stay in Paris in 1640.

Anthony van Dyck
Self-Portrait, detail
1623, oil on canvas.
Saint Petersburg, Hermitage.

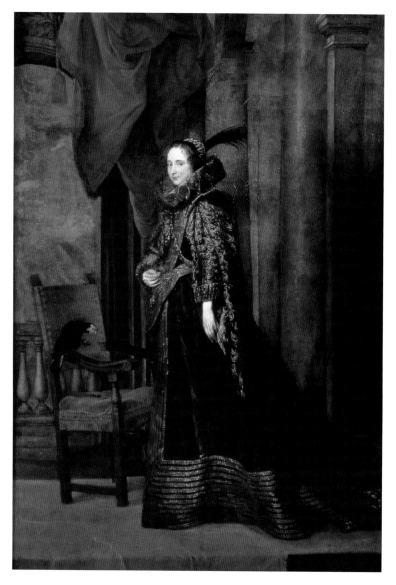

Anthony van Dyck
Paolina Brignole
1600, oil on canvas.
Genoa, Palazzo Rosso
Gallery.

Anthony van Dyck
*A Genoese Noblewoman
with Her Child*
c. 1623–25, oil on canvas.
Cleveland Museum.

Facing page:
**Anthony van Dyck and
assistants**
*Portrait of Charles V on
Horseback*
c. 1620, oil on canvas.
Florence, Uffizi Gallery.

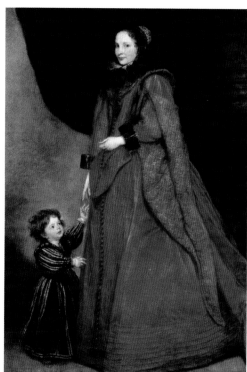

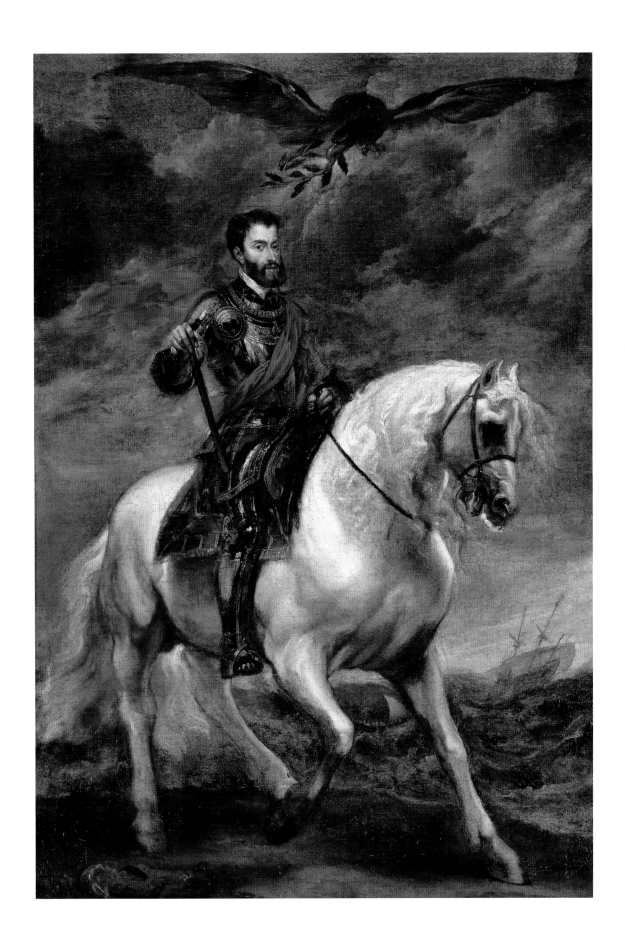

Diego Velázquez
(b. Seville 1599, d. Madrid 1660)

Seventeenth-century Spanish painting reached new heights of excellence in the art of Diego Rodríguez de Silva y Velázquez. This exceptionally talented artist was apprenticed to Francisco de Herrara at the age of eleven and a year later to Francisco Pacheco, with whom he worked until the age of eighteen, before working independently. A cultural fulcrum for the whole of Spanish painting, Velázquez introduced the innovative naturalism of Caravaggio to his homeland while also adopting the Venetian style of Titian. Thanks in part to the patronage of the Count of Olivares, he was appointed court painter at the early age of twenty-four and even served as a diplomat on occasion, helped by his affable nature and striking presence. In 1649, twenty years after his first journey to study in Italy, Velázquez painted the portrait of Pope Innocent X (today in Rome, Galleria Doria Pamphilj). Most of his career was spent in the service of the powerful Spanish court (*Las Meninas* [*The Maids of Honor*]) and *The Spinners*, Madrid, Prado Museum).

Diego Velázquez
Self-Portrait, detail
c. 1640, oil on canvas.
Florence, Uffizi Gallery.

Diego Velázquez
Venus at Her Mirror
1650, oil on canvas.
London, National
Gallery.

Facing page:
Diego Velázquez
Portrait of the Infant Margarita at Age Eight
1659, oil on canvas.
Vienna, Kunsthistorisches Museum.

Jan Vermeer
Johannes Vermeer
(b. Delft 1632, d. 1675)

The son of Reyner Vermeer, a small merchant who traded in fabrics, catering, and artwork, and Digna Baltens, Jan inherited his father's business upon the latter's death in 1652. He married Catherina Bolnes in 1653 and joined the Guild of Saint Luke as a master painter. We know very little about his early years and initial training, although in a poem he stated he had been a pupil of Carel Fabritius. In the early stages of his career, he painted religious themes before shifting his attention to interiors (this change coincided with the presence of Pieter de Hooch in Delft; the two artists may have influenced each other's work). Some fine examples of interiors are *Girl Reading a Letter at an Open Window* (Dresden, Old Masters Picture Gallery) and *Girl Interrupted at Her Music* (New York, Frick Collection).

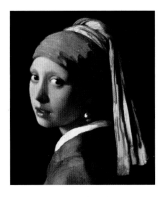

Jan Vermeer
Girl with a Pearl Earring
c. 1665–66, oil on canvas.
Hague, Mauritshuis.

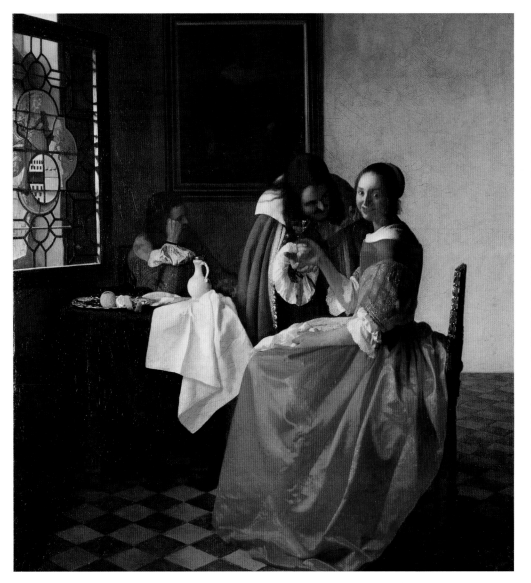

Jan Vermeer
Interior Scene
c. 1659–60, oil on canvas.
Brunswick, Herzog
Anton Ulrich-Museum.

It is not always easy to understand the subject of Vermeer's paintings. Here, the heraldic significance of the crest is unclear, and the portrait in the background is also obscure. Behind the crest in the window is a female figure holding a bridle in her left hand. Ever since Raphael painted the lunette depicting the three theological virtues in the Stanza della Segnatura in the Vatican, the bridle had been seen as an allegory of temperance. The motif was carefully reprised by Cesare Ripa, and Vermeer makes use of it in this painting, where it seems to stand as a warning to the main figures.

Simon Vouet
(b. Paris 1590, d. 1649)

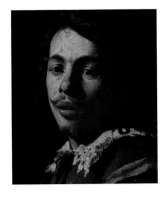

Simon Vouet
Self-Portrait
c. 1615, oil on canvas.
Arles, Musée Réattu.

The son of an artist, and a precocious talent, Simon Vouet became one of the most important French painters of the Baroque age. He was sent to England at the age of fourteen to paint the portrait of an aristocratic lady. Six years later, he went to Istanbul to paint the portrait of the sultan. On his journey back to France, Vouet stopped in Venice. He stayed in Italy from 1612 to 1627. He received a very warm welcome at the court of Pope Urban VIII in Rome and experienced all the fervent creativity of the zenith of the Baroque age, which led him to be acclaimed a prince of the Academy of St. Luke. Louis XIII summoned him to Paris and appointed him first painter to the king. With a keen flair for business and much sought after by collectors, Vouet—and his workshop—spread the Italian Baroque style throughout France and was one of the major forces behind the style's international success. Vouet was actually expelled from San Luca by his own students, so he reorganized the old community and modernized its teaching methods.

Simon Vouet
The Last Supper
1636, oil on canvas.
Lyons, Museum of
Fine Arts.

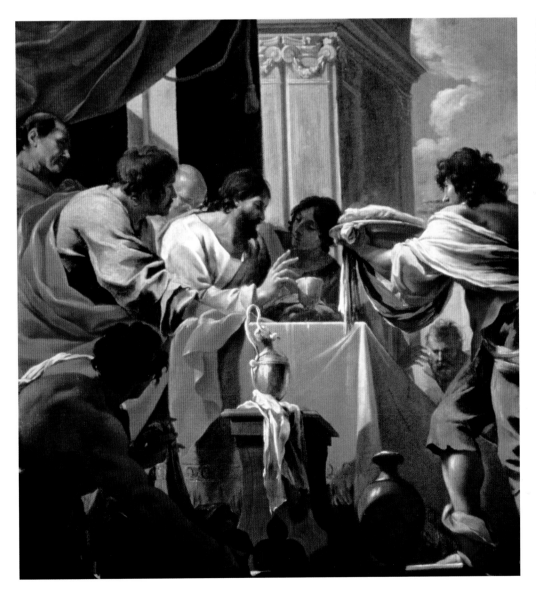

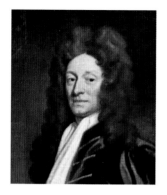

Godfrey Kneller
Portrait of Christopher Wren
1711, oil on canvas.
London, National Portrait
Gallery.

Christopher Wren
Saint Paul's Cathedral
1675–1710.
London.

Christopher Wren
(b. East Knoyle 1632, d. Hampton Court 1723)

Wren was an English architect and an accomplished scholar of mathematics and astronomy; he received his master of arts from Oxford University at the young age of twenty-one. He taught at London's Gresham College from 1657 and at Oxford from 1661. He was one of the founding members of the Royal Society and its president from 1681 to 1683. His first architectural work was the Sheldonian Theater in Oxford (1664), inspired by the Theater of Marcellus in Rome. He spent some time in France between 1665 and 1666, studying architecture. His great opportunity, as it were, came in the wake of the Great Fire of London (1666); he was appointed Surveyor General of the king's works and charged with supervising the rebuilding of the capital, including Crown buildings, government offices, and the enormous undertaking of Saint Paul's Cathedral (1675–1710). He retired from the Surveyor General's office in 1718.

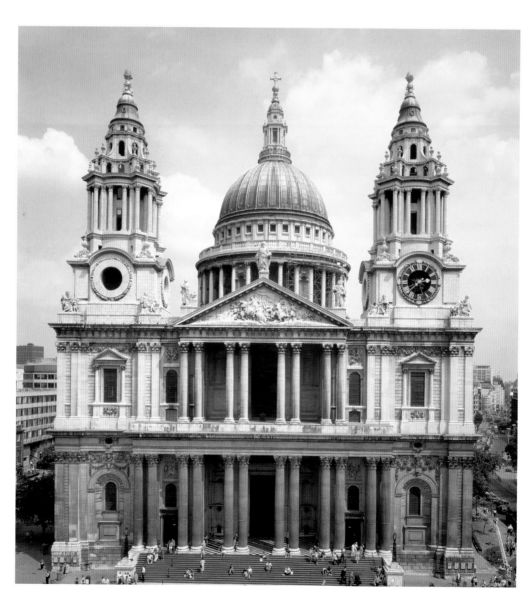

Francisco de Zurbarán
(b. Fuente de Cantos 1598, d. Madrid 1664)

Along with Ribera and Velázquez, Zurbarán helped to shape Baroque sentiment and sensitivities through his depictions of Spanish religious life, which are not so much narratives as portraits of a spiritual condition. Zurbarán began to work as a painter at the age of sixteen when he joined the workshop of Pedro Diaz de Villanueva in Seville. Three years later he opened and managed his own flourishing workshop in Llerena. In 1629, the people of Seville, who greatly admired his work, urged him to return. In 1634, he went to Madrid and worked under Velázquez on the decoration of the Salon de Reinos in the new Buen Retiro Palace. He returned to Seville in 1635 and concentrated on painting large cycles; he received commissions from as far away as Mexico. In 1658, he moved to Madrid, near the end of a turbulent life during which he married three times and had nine children.

Francisco de Zurbarán
Christ Crucified with Saint Luke
(thought to be a self-portrait),
detail. 1635–40, oil on canvas.
Madrid, Prado Museum.

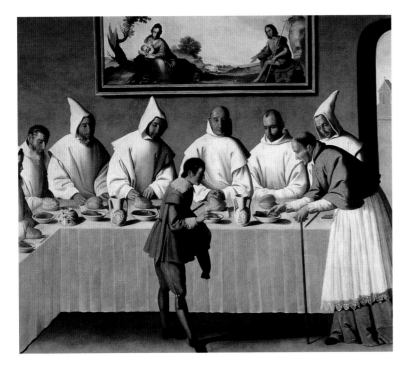

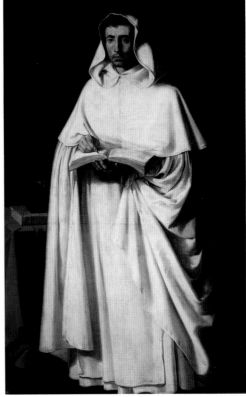

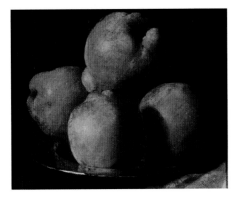

Francisco de Zurbarán
Still Life with Apples
1633, oil on canvas.
Barcelona, Museo de
Bellas Artes de Cataluña.

Top left:
Francisco de Zurbarán
*Saint Hugo in the
Refectory of the
Chartusian Monks*
1630–35, oil on canvas.
Seville, Museo Provincial
de Bellas Artes.

Above:
Francisco de Zurbarán
Fra Jerónimo Pérez
After 1630, oil on canvas.
Madrid, Academia de
Bellas Artes de San
Fernando.

Rococo

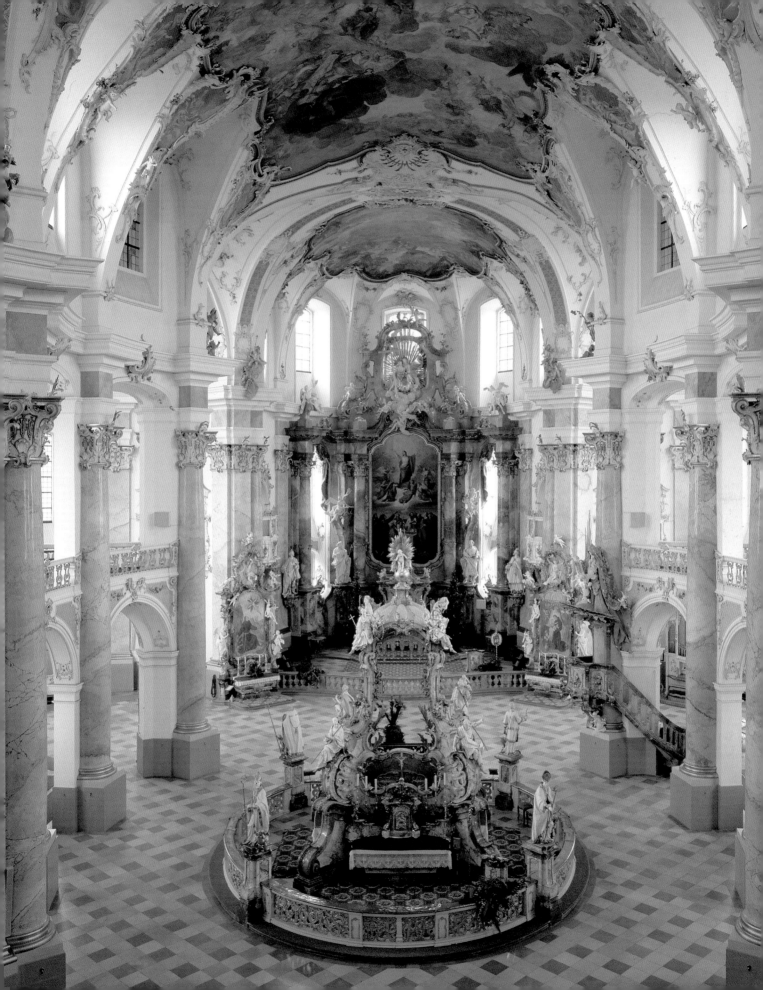

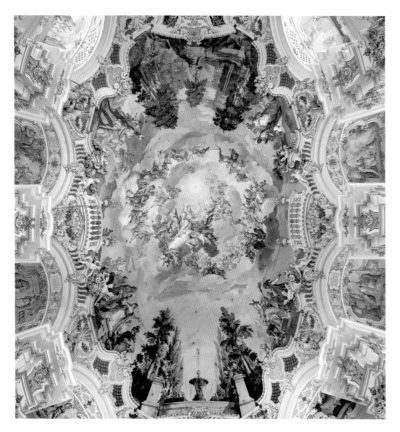

Above:
Johann Baptist Zimmermann (architecture and moldings) and **Giambattista Tiepolo** (frescoes) *The Four Continents Pay Homage to the Virgin Mary* 1731, stucco ceiling with frescoes. Steinhausen, Pilgrimage Church.

Previous page:
Johann Balthasar Neumann *Central Nave of the Sanctuary of the Fourteen Saints* (circular altar in the center designed in 1763 by Joseph Anton Feichtmayr and Johann Georg Übelherr) 1742–44. Vierzehnheiligen.

When we think of the figurative and architectural styles of the eighteenth century, we immediately picture the pure lines of Neoclassicism. Yet more than half of the eighteenth century saw the development of a new style, conventionally defined as *barocchetto* or *Rococo*.

From a Shell to Rococo

The term *Rococo* seems to derive from the word *rocaille*, the name of a type of shell used to decorate gardens or country homes. The French etymology of the word reflects the nation that would lead the way in the evolution of this new tendency, which contemporaries referred to as style nouveau. The style was not invented in the eighteenth century, however, since the Romans used shells to decorate the walls of grottoes and nymphaea (grottoes or shrines dedicated to nymphs), giving these spaces the blend of mystery and nature that so enthralled the people of

the imperial age. In the wake of the sixteenth century's passion to rediscover the past through archeology, the use of shells as decorative motifs was reintroduced to Rome (for instance, the roof of the Elephant Fountain in Villa Madama, designed by Giovanni da Udine) and Florence at the time of the grand dukes, as seen in the celebrated ceiling of the Tribune designed by Bernardo Buontalenti (Bernardo Delle Ghirandole, c. 1536–1608). The style was later introduced to courts around Europe. The shell had also played an important role in Baroque architecture while retaining its distinctive and easily recognizable nature. The eighteenth century was less interested in the volumes and flowing forms that were so typical of the Baroque age, and gradually the shell was flattened onto the surface it was used to decorate. At the same time, the motif had begun to be used more frequently and to encrust flat surfaces that essentially disappeared under the intricate decoration.

This is the essence of the Rococo poetics; it reflected the contemporary change in mind-set and sensitivities. It should not be forgotten, however, that the origin of this new taste and style can be found in the

Hall of Mirrors (*Galerie des Glaces*) in Versailles, considered to be the quintessence of the Baroque age.

Historical Background

The connection between Rococo and the palace of Versailles is useful in helping to dispel a number of the misunderstandings that grew out of hasty and ill-considered historical interpretations. A number of scholars have rightly pointed out how the sprawling apparatus of the court of Louis XIV, the "Sun King," had been dismantled by the regent Philippe d'Orléans (during the Regency, 1715–30) and his immediate successor, Louis XV. The regent transferred the court from Versailles to Paris, and although the court was not dismantled as a result, it was significantly reduced in size (if only for practical reasons of space). Louis XV took advantage of this new situation, which favored smaller gatherings and groups, to replace the etiquette of the Sun King's sumptuous court with a less rigid, more accessible, more familiar, even more intimate atmosphere. The

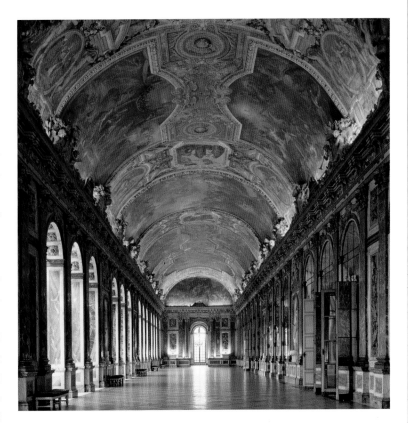

paintings of Chardin or Liotard clearly reflect the new arrangement. These choices may seem to be tied closely to personal taste, but were also dictated by political developments that would eventually lead to the definitive decline of the aristocracy; in this light, the French Revolution may be seen as the natural consequence of the ongoing process that saw the steady marginalization of Europe's noble caste, the seeds of which were already being sown.

It would seem that while Louis XIV had surrounded himself with the cream of France's aristocracy, his successors on the throne, up to Louis XVI, tended to sideline the nobility to give greater scope and space to the middle class. In truth, it was the Sun King who had first deprived the aristocracy of any real political role in favor of the bourgeoisie. Starting with his own first minister, Colbert, Louis XIV bestowed roles of financial and governmental power upon members of the middle class that had previously been the reserve and privilege of the aristocracy. In compensation, the nobles were offered the chance to belong to the exclusive circle of the

Above:
Louis Le Vau and Jules Hardouin-Mansart
Hall of Mirrors
1646–1708.
Versailles, Musée National du Château.

Left:
Joseph Saint-Pierre
Rocaille lintel of a window in the central pavilion of the palace of Wilhelmina, sister of Frederick II of Prussia
1749–53.
Bayreuth, Hermitage.

ROCOCO

Versailles court, and it can be said that the nobles buzzed around the Sun King as worker bees buzz around the queen. Insulated by a seemingly unending flow of wealth that sheltered the nobles from any real worry or preoccupation, the aristocrats busied themselves with the king's clothes and costumes, hairstyles, banquets and fine wines, and the pomp and ceremony of balls—in fact, everything connected with the sovereign. Meanwhile, the middle class took care of the economy, trade, and the destiny of the nation, which was still headed by the king, who had deftly achieved a triple result by his actions: he had neutralized the potential threat posed by the nobles, created a middle class devoted to their sovereign, and dazzled the world with the splendor of the court of Versailles.

So, the rise of the new middle class in the eighteenth century had its roots in the magnificence of Baroque aristocracy. It does not follow that late Baroque (or *barocchetto*, as some scholars call the style with barely disguised disparaging overtones) should be considered as just the tired continuation of mature Baroque. The new style played a fundamental role in the slow demolition of the basic concepts that were so characteristic of the Baroque age; the period's sense of monumentality and stolid classical apparatus was crumbling away, like the notion of absolute monarchy that was the bedrock of the Sun King's era.

Defining Rococo

The characteristics of French Rococo, which was poised to become an international style in the wake of widespread Baroque success, were defined in the final years of the reign of Louis XIV. There were four distinct stages in the development of French Rococo. The first stage (1675–1715) coincided with the reorganization of the Académie de France (1699), when Pierre Lepautre more or less "invented" the *style nouveau*. The second stage took place during the Regency (1715–30) when Jean-Antoine Watteau was at the height of his power and the *style nouveau* absorbed decorative elements from Borromini and his followers. The third stage (1730–45) saw the rise of the rocaille style and the consolidated prominence of François Boucher, who returned from Italy in 1731 and was accepted into the Académie three years later as a "prince." Rococo reached its fourth and final stage

Francesco Suardi
Rococo decorations,
detail of the top of
the facade
1735.
Rome, Santa Maria
Maddalena.

with the so-called Pompadour style (named after the king's favorite), which developed between 1745 and 1764. It was at this time that public taste seemed to shift toward the kind of simplicity that heralded Neoclassicism.

In architecture, Rococo did not really represent a significant departure from the norms of mature Baroque. Change was evident in decoration and the spread of intertwining motifs in C and S shapes that, in visual terms and compared with the turgid plasticity of the Baroque (whether in Bernini's Classical or Borromini's Gothic style), tended to undermine and eclipse the structure of the surfaces they were supposed to decorate. The facade of the Roman church of Santa Maria Maddalena—designed in 1735 by Francesco Suardi—is a fine example of this phenomenon. Clearly modeled on the structure of San Carlino alle Quattro Fontane, with its distinctive Borromini lines, Suardi's church softens the earlier church's aggressive bulk and instead employs a much more discrete chiaroscuro arrangement, set off by a reserved yet effective decorative scheme that catches the warm sunlight of Rome. Italy was by no means the only country where such choices emerged. Designed by Fischer von Erlach in 1710,

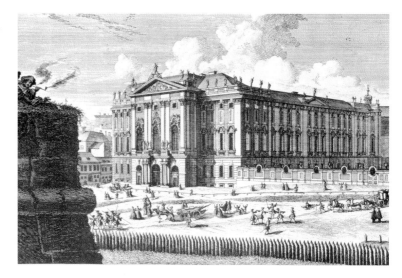

the Trautson palace in Vienna already exhibited similar characteristics. Unlike a church, the purpose of the palace causes it to spread horizontally, one floor seeming to flow into another instead of being clearly distinct. On the facade of the central block, especially around the windows of the main floor, we can see evidence of the same experimentation in decoration present in the Italian building. Other examples are the Daun-Kinsky mansion in Vienna, built in 1713 by Johann Lukas von Hildebrandt (1668–1745), or the elegant Pommersfelden castle in Bamberg, completed in 1718.

Above:
Johann August Corvinus
Trautson Palace
Before 1738, engraving.

Johann Lukas von Hildebrandt and Johann Dientzenhofer
Weissenstein Castle
1711–18.
Pommersfelden, Bamberg.

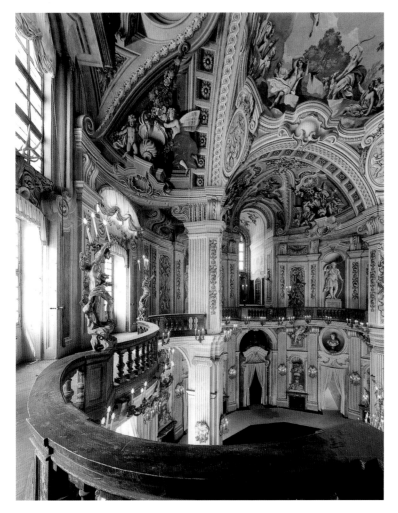

In Rococo architecture, structural features (real or decorative), including orders, columns, and pillars, are brought closer to the surfaces of the walls themselves, which become the canvas, so to speak, for an explosion of florid decoration. An especially noteworthy example is to be found in Braga, Portugal, where the Rococo decoration of the facade of the Palacete de Raio (the "king's palace," today a museum) is rendered all the more dense and intricate through the use of majolica. This is one of the most striking examples of Rococo decoration, which plays on the contrast achieved between traditional Portuguese blue majolica tiling and the blossoming decorative carvings that spread across the palace facade.

The Rococo style is most evident in interiors, where the decorative elements seem to spread over the walls like a form of dazzling incrustation, as seen in the splendid stucco moldings in the Cistercian monastery of Osek in the Czech Republic and in the sumptuously decorated nave of the Vierzehnheiligen church, near Bamberg, Germany, designed by Johann Balthasar Neumann (1687–1753), one of the greatest German architects of all time.

The Rococo was also marked by an enduring taste for complex layouts, undulating walls, and bulky shapes. One of the most significant examples is the royal hunting lodge at Stupinigi, near Turin, a favorite retreat of Vittorio Amedeo II of Savoia. Built between 1729 and 1733 by Filippo Juvarra, an architect from Messina, the immense building succeeds in blending harmoniously with the surrounding garden and grounds; it is considered by many to be Juvarra's masterpiece. The palatial lodge presents an elliptical central layout and is organized along diagonal lines, while the wings of the building seem to stretch out to embrace the surrounding countryside. Here, what seem to be typically Baroque features are transformed into something more airy, more regular. The lodge established Juvarra's reputation, and he was summoned to Spain in 1735 by Philip V to design the facade of La Granja in San Ildefonso, near Segovia, and the new royal palace in Madrid, both buildings bearing all the hallmarks of the late Baroque. The architect's sudden death in 1736 prevented him from carrying out the projects.

Another noteworthy development in Spain at the time was the exaggerated excesses in form, including the facade of Santiago de Compostela (begun in 1738) and the superbly ornate portal of the Dos Aguas Palace in Valencia (shown on page 104). Divided in two distinct registers, the portal gives a new interpretation to the very Michelangelesque figures of the *ignudi*, which here seem to be "drowning" under teeming, albeit restrained, decorative motifs that make the surface crackle with light. Spanish creativity also produced another highly distinctive decorative and structural feature of Rococo churches, known as *el transparente*. Liturgical rules at the time did not allow the faithful to cross the ambulatory behind the Eucharist, so it was placed in a glass-fronted receptacle (hence the name, "the transparent"), which allowed the faithful to worship from the ambulatory as well as the nave. The first example of this device

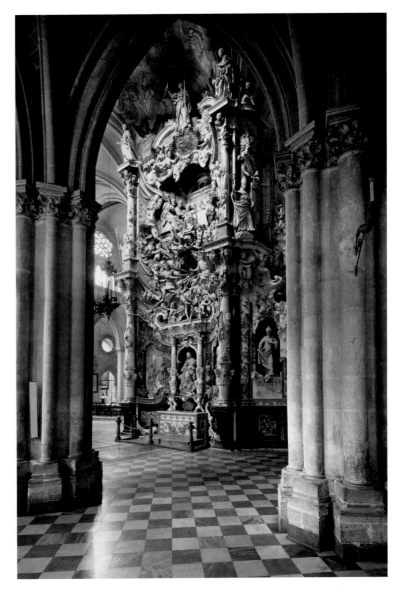

was built in Toledo Cathedral between 1721 and 1732, and in doing so the architect Narciso Tomé created one of the age's most visually astonishing and awe-inspiring works of art. Other artists followed Tomé's example, including the supremely talented Ventura Rodriguez (1717–85), who created a *transparente* for Cuenca Cathedral in 1753. Any overview of Spanish eighteenth-century architecture would be incomplete without reference to the Churrigueresque style that stemmed from the creative genius of the Churriguera family of architects, who combined the techniques of traditional Catalan wooden sculpture with Roman

Above:
The Trasparente
c. 1730.
Cathedral of Toledo.

Facing page, from top:
Palacete de Raio, detail of the facade with majolica decorations Eighteenth century. Braga, Portugal.

Filippo Juvarra
Grand Salon
1729–31.
Stupinigi Hunting Lodge, Turin.

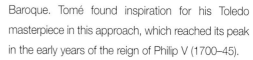

Above:

Johann Michael Rottmayr
Good Conscience Triumphs over Vice
1717, frescoes on stucco ceiling.
Pommersfelden, Weissenstein Castle, Marble Salon.

Right:

Telamon, detail of the main portal decorations 1740–44.
Valencia, Dos Aguas Palace, Museo Nazionale della Ceramica.

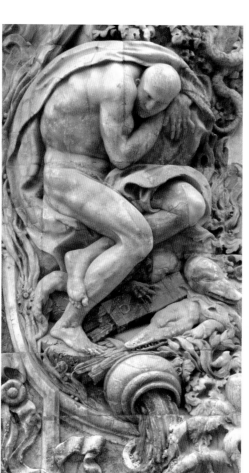

Baroque. Tomé found inspiration for his Toledo masterpiece in this approach, which reached its peak in the early years of the reign of Philip V (1700–45).

Britain at the time was still dazzled by Andrea Palladio (1508–80) and had to deal with a revisited Classicism that also had a strong impact on American architecture. The sober composure of neo-Palladianism in Britain and North America, countries as yet untouched by Rococo, reflected their ambitions to transform London and Washington into the new Athens or the new Republican Rome. In this light, what happened in Britain at the time helped pave the way, to some extent, for the rise of Neoclassicism.

Sculpture and Painting

The diminished sense of the monumental and the proliferation of overhanging decorative motifs shifted Rococo sculpture toward the ornamental. In other words, Rococo sculpture became subordinate

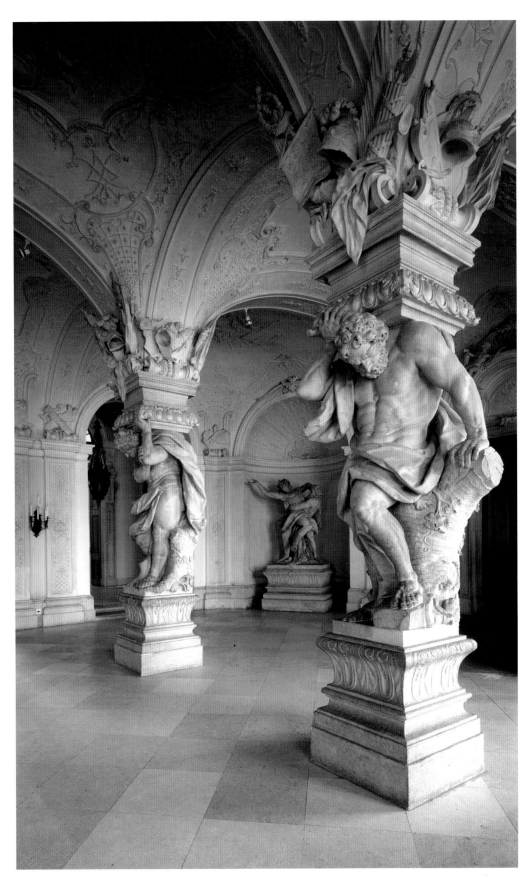

Johann Lukas von Hildebrandt
Caryatids Atrium, detail
1721–23.
Upper Belvedere,
Vienna.

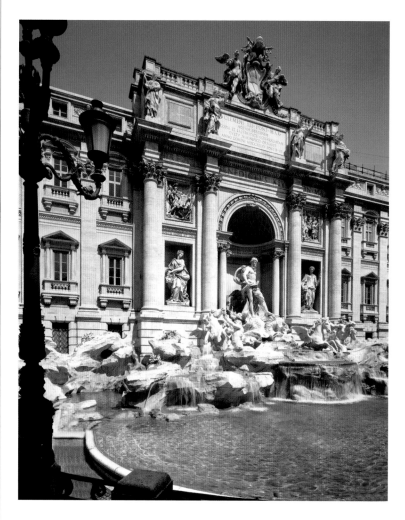

Nicolò Salvi
Fontana di Trevi (Trevi Fountain)
1732–62.
Rome.

The list of significant examples goes on: the troubled figure in the *Immaculate Conception* by Joseph Anton Feichtmayr (1696–1770), the interior decoration of the church of Wies, the delicate stucco group known as the *Baptism* crafted by Joseph Christian for the Benedictine church of Ottobeuren (1757–66), and the innumerable examples of stucco molding made by Italian craftsmen in churches across Europe. Rococo sculpture was also used on exteriors, including the Trevi Fountain in Rome (completed in 1762); the statues are, as it were, grafted onto an architectural frame and thus once again serve a decorative rather than structural purpose. This is also the case with the statues created by Antonio Bonazza (1698–c. 1767) for the grounds of Villa Wildman in Padua, and with the marble groups of mythological figures sculpted by Luigi Vanvitelli for the grounds of the Royal Palace at Caserta.

In the sphere of the figurative arts (to which most of this book is dedicated), the eighteenth century also marked the victory of Poussin over Caravaggio. The palette became lighter, and there was a return to mellow pastel shades that lent gentle tones to the pleasant, easy brushwork. The great frescoes of artists including Baciccio and Andrea Pozzo can, in a sense, be viewed as the legacy of another outstanding Italian artist, Giambattista Tiepolo, who worked for the most important courts in Europe, from Venice to Würzburg and Madrid. Tiepolo's work served as a model that inspired the decoration of Weissenstein Castle in Pommersfelden and the Pilgrimage Church in Steinhausen, where the vaulted ceilings open onto skies teeming with historical or religious figures and which were conceived as veritable scenic devices seamlessly integrated with the structure of the buildings.

The Baroque legacy was thus interpreted according to the requirements of new prevailing taste, which can be clearly seen in approaches to still lifes. Some artists chose to take a more *intimiste* approach, including Chardin, whose works depict objects from his studio; others, like Jean-Baptiste

to painting and architecture, deprived of the monumental autonomy the discipline enjoyed during the Baroque period. In such a context, it is no surprise that wood and stucco are the materials most frequently used by sculptors, rather than marble. One example is the work of Ignaz Günther (1725–75). With his polychrome wooden sculptures, including *Saint Cunegond*, today conserved in the church of the Benedictines in Rott am Inn, Günther took the Mannerist idiom and interpreted it in a highly decorative, distinctly Rococo way. The Rococo preference for the spiral can also be seen in more overtly monumental works, such as the trio of caryatids in the Belvedere in Vienna, produced by Hildebrandt. Here, Michelangelo's *Prigioni* theme is transformed into yet another astonishing Rococo masterpiece.

Oudry, who specialized in hunting scenes, are by turns triumphal and ironic.

The most striking new feature of Rococo painting comes in the form of the pastoral themes depicted in the many *fêtes galantes*, which bring together that desire for simplicity later found in the myth of the "noble savage" theorized by Rousseau and the natural impulse of the aristocracy—French aristocrats in particular—to seek out elegance. Thus, if the world is indeed as Watteau describes it (as we can see his works)—an ideal place where Nature is "well mannered," where the "savage" has been replaced by the "authentic"—then it is also an idyll played out in a setting where Olympus has been moved to Versailles, where shepherdesses look like courtiers and sheep like lapdogs. Alongside this pursuit of the elegant, Rococo painting concentrated on female beauty as an end in itself: the ideal here is of a sensual earthly paradise inhabited by maidens kissed by eternal youth.

As the pages that follow will show, this is the art of Boucher and Fragonard, the art that swathed the *petites maisons* and secret chambers in a discrete yet intense eroticism.

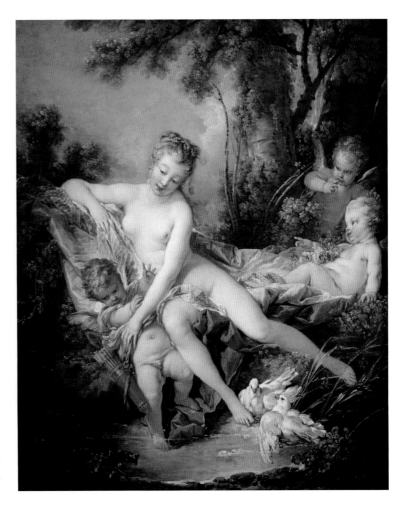

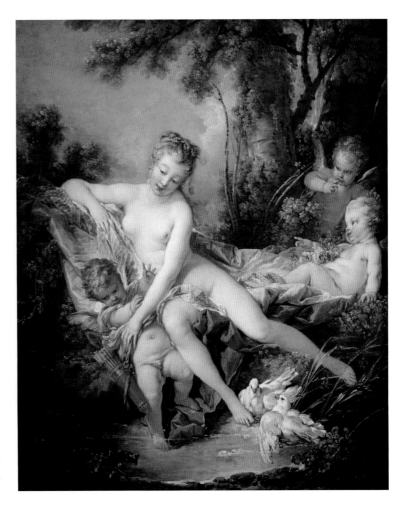

François Boucher
Venus Consoling Love
1751, oil on canvas.
Chester Dale Collection.

Jean-Baptiste-Siméon Chardin
The Attributes of the Arts and the Rewards Bestowed upon Them
1766, oil on canvas.
Minneapolis,
Minneapolis Institute
of Art.

Sanctuaries and Faith

When we think of popular devotion and of churches built by popular demand from the faithful, our mind's eye usually conjures up images of the Middle Ages and the spirituality of the great mystics such as Saint Benedict or Saint Francis. Nevertheless, the eighteenth century is not only the age of the Enlightenment, it is also the period when Pope Benedict XIV called for the renewal (or relaunch, as we might say today) of the Holy Year and brought thousands of pilgrims to Rome by mid-century. According to reports, the Trinità dei Pellegrini alone housed up to 135,000 pilgrims. The great European centers of faith, including Santiago de Compostela (which had been an unfaltering attraction for pilgrims since the early Middle Ages), were renovated and restored during the eighteenth century, testifying to unfailing popular devotion. A monumental double staircase designed by Fernando de Casas y Novoa in 1738 was built that led to the main facade of the cathedral. The structure was so magnificent that it was dubbed El Obradorio, "the golden work." The celebrated *Puerta del Paradiso*, one of the greatest Spanish Rococo masterpieces, was constructed nineteen years later.

While it might be the most famous pilgrimage destination in Europe, Santiago was by no means the only center to be built on a wave of popular devotion. Another example is the sanctuary church of Wies, in Bavaria, which received a steady flow of pilgrims from 1738 who came to worship and admire the wooden statue of Jesus scourged at the pillar (the statue is said to have shed tears). The small wooden church in this tiny town was soon swamped by the flow of pilgrims, and a new church had to be built. The new sanctuary, erected between 1745 and 1754, was a distinctly Rococo construction thanks in part to the advice of Hyazinth Gassner, the erudite abbot who called in the Zimmerman brothers, two of the most talented purveyors of Bavarian Rococo. Dominikus was an architect, stucco sculptor, and marble craftsman; his brother, Johann Baptist, was a painter and stucco sculptor. The result of their labors was the magnificent new church of Wies, a felicitous blend of Borromini's legacy and local Bavarian tradition. Its most striking feature is the sumptuous interior decoration, with its splendid ceiling frescoes and elaborate altar made all the more vibrant by energetic decorations and sculptures.

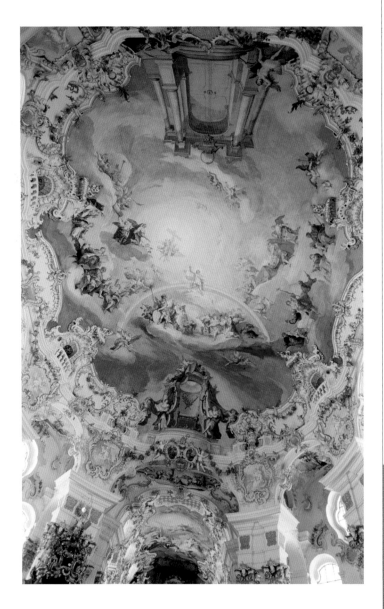

Facing page:
Main Facade of the Sanctuary
Eighteenth century.
Santiago de Compostela.

This page:
Johann Baptist Zimmermann and Dominikus Zimmermann
Pilgrimage Church of Wies
1745–54, altar and frescoed ceiling.
Wies, Bavaria, Germany.

The Capriccio

The term *capriccio* had already been in common usage for more than a century, referring in music and painting to a powerfully evocative composition where "the force of the imagination prevails over the observation of the conventions of art," in the words of the very apt definition provided by French scholar Antoine Furetère in 1690. In the sphere of the figurative arts, the grotesques that provided the original inspiration for the capriccio were transformed into Rococo arabesques decorating princely mansions, occasion-

ally given exotic forms, as was the case with chinoiserie. Optical illusions continued to be popular. The anamorphic or distorted projections invented in the sixteenth century and further developed in the seventeenth became a kind of optical whimsy in the eighteenth. A silver cone or cylinder was placed over a distorted drawing or painting, and the image was recomposed as a genre scene—hunting, mythological, erotic—or a face.

A variation of the capriccio as analyzed above took the form of the pictorial views created by the Venetian *vedutisti,* (such as the painting by Canaletto shown here), where architecture takes center

stage. Although it may have been based on a real detail, in this variation of the capriccio, the view was the result of the artist's (seemingly arbitrary) invention. One example is the *Capriccio with Gothic Building and Obelisk* by Michele Marieschi (1710–43), where the very real Ducal Palace in Venice is transformed into a gothic ruin in a scene already tinged with Romanticism. Other artists, including Bernardo Bellotto, envisaged the capriccio as an assembly of real scenes; in a sense, to borrow an anachronism, the painter created very atmospheric photomontages. Other examples are the capriccios created by Giambattista Piranesi in his highly imaginative *Prisons* series.

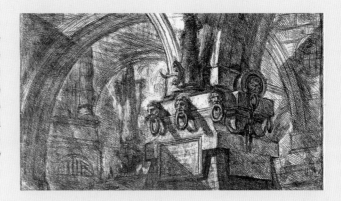

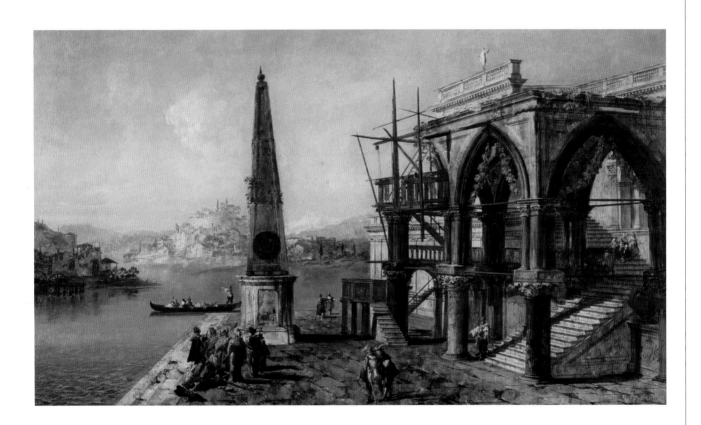

Facing page, from top left:
English school
Portrait of Charles I
c. 1711.

Bernardo Bellotto and Francesco Zuccarelli
Roman Capriccio with the Pyramid of Caius Cestius, Saint Peter's Basilica, and Castel Sant'Angelo
1742–47, oil on canvas.
Parma, National Gallery.

Canaletto
Capriccio with Colonnade and Courtyard
Work signed and dated 1765, oil on canvas.
Venice, Gallerie dell'Accademia.

Above:
Michele Marieschi
Capriccio with Gothic Building and Obelisk
1741, oil on canvas.
Venice, Gallerie dell'Accademia.

Top:
Giambattista Piranesi
Imaginary Prisons, Plate XV, The Pier with a Lamp
End of eighteenth century, etching (first draft).

Rococo

The Nude and Eroticism

Among eighteenth-century France's contributions to the development of contemporary culture (in addition to the ideas of liberty, fraternity, and equality for each citizen, or *citoyen*, a word the Revolution made its own), there was also the creation of the modern nude. Until that time, it had been practically impossible to depict nude figures in official art without appropriate justification. A visit to any brothel would doubtless have uncovered naked figures and bodies in decidedly erotic positions, and these were common from the time of Marcantonio Raimondi, who had made burin copies of drawings by Giulio Romano, who previously had made illustrations for Pietro Aretino's famous *Modi*, a collection of licentious sonnets that earned quite a lot of money for their author. Nevertheless, until the rise of Rococo, it would have been unthinkable for official art to represent a nude or even partially undressed woman who was not Delilah, Mary Magdalene, a bathing Venus, Susanna among the Elders, or a nymph of the woods. In other

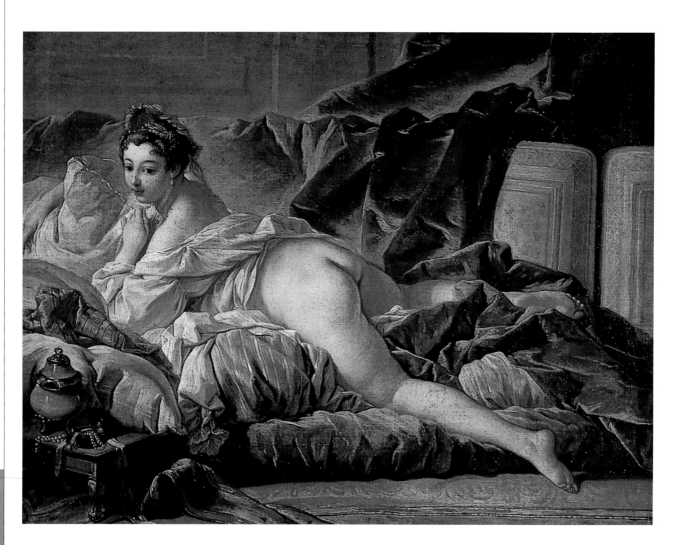

words, the painter needed a narrative pretext linked to religion or mythology.

For the Rococo eighteenth century, which saw the arrival of the *peinture des seins et des culs* that so delighted the French aristocracy and middle class, official art, which was already in a sense somewhat sly and coquettish, officially accepted the representation of the female nude. If a high-ranking cleric such as the bishopbaron of Saint-Julien, treasurer of the French church, was able to commission a painting like *The Swing* from Jean-Honoré

Fragonard (in which the motion of the swing is no more than a pretext to admire, however fleetingly, the lady's charms), then it is easy to understand how such works as *The Brunette Odalisque* (shown opposite) and *Blonde Odalisque* (shown on page 130) by Boucher could be offered to the gaze of covetous collectors without any narrative justification at all. The artists of the period went even further, furtively introducing themselves into the secluded intimacy of the boudoir to catch a glimpse of a lady undressing or playing with her dog on a bed.

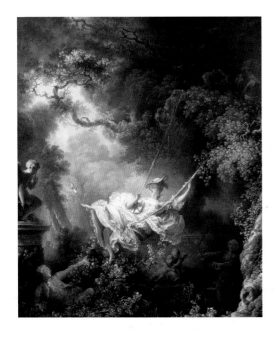

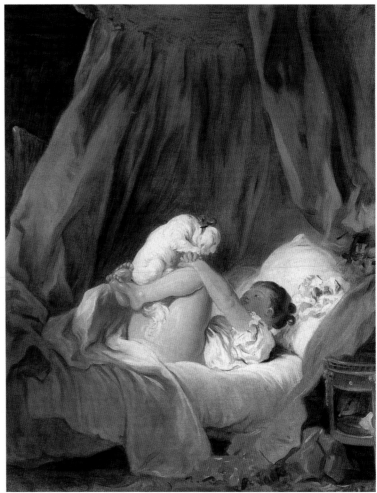

Jean-Honoré Fragonard
The Swing
1767, oil on canvas. London, Wallace Collection.

Facing page:
François Boucher
The Brunette Odalisque
1745, oil on canvas. Paris, Louvre.

Right:
Jean-Honoré Fragonard
La Gimblette (Girl with Dog)
c. 1768, oil on canvas. Munich, Old Pinacotheca.

The Portrait

If there is a painting that distills the shift from the Baroque seventeenth century to the Rococo eighteenth century, that would be *Portrait of Marquise de Pompadour*, which shows the lady on the grounds of Bellevue castle. The work is part of the endless series of portraits that François Boucher painted for Louis XIV's favorite. This particular opus differs from the others because of its natural woodland setting, which in turn suggests the *fêtes galantes* that Boucher himself often attended and depicted in a number of masterpieces. On the left, in the background, we can see the group of statues sculpted by Jean-Baptiste Pigalle (1714–85)

known as *Love and Friendship*, today in the Louvre. The sculptor, who dedicated many portraits to the lady, here gives rein to Baroque inspiration tempered by mature Rococo style.

The issues and climate that dominated the Rococo portrait were substantially the same that shaped portraiture in the seventeenth century, although the genre did become more widespread thanks to the use of pastels, which made the art form more accessible. Swift, easy to apply, and inexpensive, albeit delicate and perishable, pastels were favored by the Venetian portraitist Rosalba Carriera, whose work was much sought after by Europe's middle class and aristocracy. Carriera was also a friend of Jean-Antoine Watteau, of whom she painted a very intense portrait.

Above:
Gilbert Stuart
Peter Gansevoort
c. 1794, oil on canvas.
Utica, New York,
Munson-Williams-
Proctor Arts Institute.

Left:
François Boucher
Portrait of Marquise de Pompadour
1759, oil on canvas.
London, Wallace
Collection.

Facing page, top right:
Gilbert Stuart
*George Washington
(The Athenaeum Portrait)*
1796, oil on canvas.
Washington, D.C.,
National Portrait Gallery,
Smithsonian Institution.

Angelica Kauffmann (1741–1807) also made use of pastels, and in a sense, she could be seen as continuing the work of Carriera. An artist of the caliber of Chardin also used pastels in his series of self-portraits, developing an "intimate" portraiture technique that derived from his knowledge of the work of the Flemish painters Vermeer and de Hooch. Although they were developed in a different way, we encounter similar influences in the work of Thomas Gainsborough, who was also a keen observer of humanity.

Painting in the eighteenth-century English-speaking world followed other directions too, as can be seen in the official portraits of Sir Joshua Reynolds (1723–92) and American Gilbert Stuart

(1755–1828). After his initial training in Scotland, Stuart made a career of painting George Washington's portrait; of the many portraits Stuart painted of Washington, the most well known is doubtless the image found on U.S. banknotes.

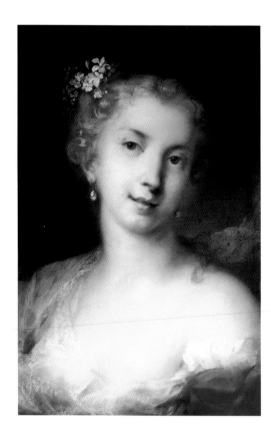

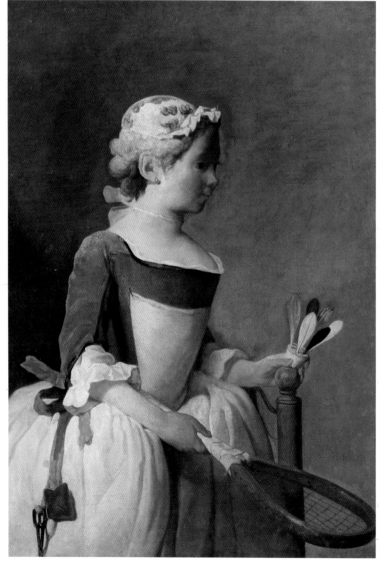

Rosalba Carriera
Flora
First half of the eighteenth century, chalk on paper.
Florence, Uffizi Gallery.

Right:
Jean-Baptiste-Siméon Chardin
Girl with Shuttlecock
c. 1741, oil on canvas.
Florence, Uffizi Gallery.

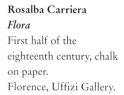

Rococo

The *Veduta*

In the course of the eighteenth century, the passion for traveling gave shape to the so-called Grand Tour. It became a custom—indeed, a requirement—for northern Europe's educated classes, especially in Britain, to tour other countries in Europe, particularly Italy, in search of beauty and thus complete their education. These elite travelers therefore discovered the roots of antiquity while elevating their spirits and opening their minds. It is hardly surprising, then, that sizable communities of foreign intellectuals would live for decades in Rome and other favorite destinations including Venice, Florence, and Naples. After having traveled around the Low Countries, Spain, and France, they would traditionally come to Italy for the last leg of their tour and, spurred to indulge in a radical lifestyle change, they might set up home on the banks of the Arno or Tiber.

More often, though, these affluent British travelers returned to their homeland and were usually inclined to take some form of souvenir of their travels with them, such as the *vedute*, or "views." One of the more fortunate collectors of these early "holiday post-cards" was Joseph Smith, the British consul in Venice. Smith was a knowledgeable art connoisseur who was instrumental in making Canaletto known to the British public. He also partly financed Canaletto's stay in England.

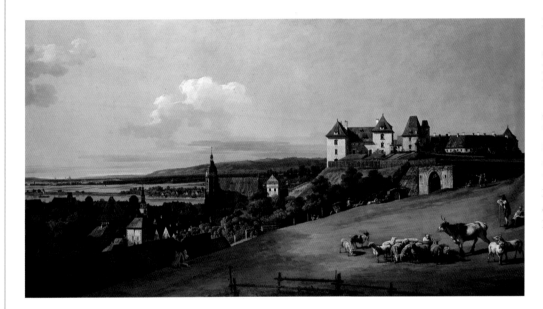

Bernardo Bellotto
View of Sonn Castle
c. 1750, oil on canvas.
Dresden, Old Masters
Picture Gallery.

Gaspar van Wittel
*View of Piazza
Quirinale and Monte
Cavallo Palace*
1684, oil on canvas.
Rome, National Gallery
of Ancient Art in
Barberini Palace.

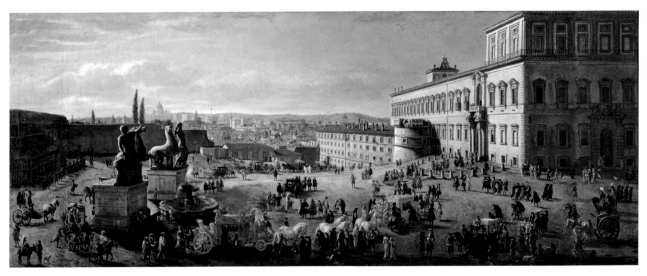

Unlike the landscape, the *veduta* was dedicated to depictions of the city and urban settings. The aim of these works was to capture the atmosphere of streets and squares, the sound of people, and the busy flow of everyday life, rather like a modern-day snapshot. Indeed, artists including Canaletto and Bellotto made use of a fixed or mobile camera obscura. A great many artists executed this kind of view, including Luca Carlevarijs (1663–1730) from Friuli, who published more than one hundred views of Venice; the Dutch painter Gaspar van Wittel (1653–1736), who settled in Rome from 1674 to his death; Giovanni Paolo Pannini (1692–1764); Michele Marieschi (1711–43), creator of stage settings as well as a painter and *vedutista*; and Francesco Guardi (1712–93), whose misty views of Venice brought the century to a close.

Canaletto
The Thames Seen from Sommerset House, Looking Toward Saint Paul's Cathedral
c. 1750, oil on canvas.
New Haven, Yale Center.

Giovanni Paolo Pannini
The Archeologist (Study of Roman Ruins)
c. 1740, oil on canvas.

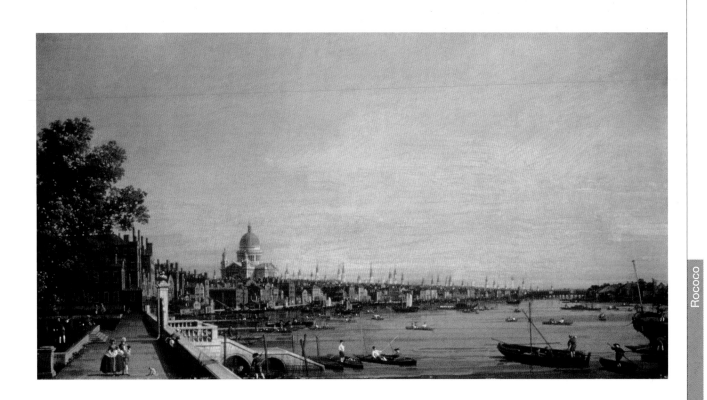

Fashion

Fashion in the eighteenth century is probably synonymous with images of that long stretch of the century that saw the rise of Rococo wigs and married ladies with gallant escorts, a time when France was the undisputed leader that other European nations sought to imitate. In fact, the eighteenth century was the period of the advent of the modern concept of fashion, linked on one hand to the definition of genres and on the other to the definition of the "aesthetic," and thus to the ability to judge theorized by Kant and by the intellectuals of the Enlightenment who came after him.

Basically, the concept was a reflection of the desire to follow a model that on one day could be the style of Madame de Pompadour and the next the extravagant hairstyles of Marie Antoinette. The desire to be *à la page*, or trendy as we would say today, to be fully informed and in touch with the pace of change, was satirized by the likes of Hogarth (who dedicated his acclaimed *Marriage à la Mode* series to this very theme).

The eighteenth century was a time of unparalleled importance for fashion, especially for women's clothing, which played a far more prominent role than men's. One of the legacies of the seventeenth century was the panniered dress, which evolved from a

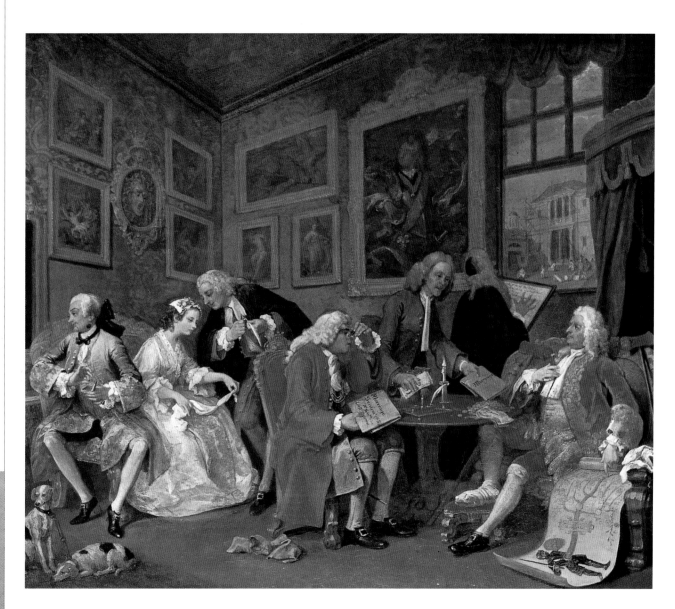

garment for occasional use to something women wore all the time; the effect was of voluminous petticoats and a waist made unnaturally narrow by deliberately tight bodices that were no longer simple undergarments but that coquettishly showed drawstrings that drew attention to the bust. The contrast was underlined further by flounces on the sides that made the petticoats seem even fuller and more flowing. The effect was enhanced with the addition of rich fabrics, bows, and shawls, and the whole was crowned, in every sense, by a large wig or hairpiece, which could tower several inches above the forehead and be embellished by flowers, strings of pearls, and ostrich feathers, transforming the wearer into a kind of walking sculpture. Men's clothes, on the other hand, became less sophisticated than their seventeenth-century counterparts: the cut of trousers changed; jackets were wider and open at the front; and men usually wore a vest, stockings, and the typical three-cornered hat (see page 145).

Facing page:
William Hogarth
The Marriage Contract
1743, oil on canvas.
London, National
Gallery.

Top right:
Pierre Thomas Le Clerc
Lady at the Hairdresser's, plate 31
from *Galerie des Modes et Costumes Français (Gallery of French Styles and Costumes)*
1778, colored etching.

Right:
Pierre Thomas Le Clerc
Elegant Woman in English Dress Drinking Coffee, plate 183 from *Galerie des Modes et Costumes Français (Gallery of French Styles and Costumes)*
1778, colored etching.

Below:
Pietro Longhi
The Pot Game
1760, oil on canvas.
Vicenza, Leoni
Montanari Palace.

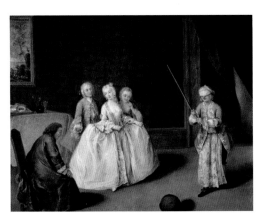

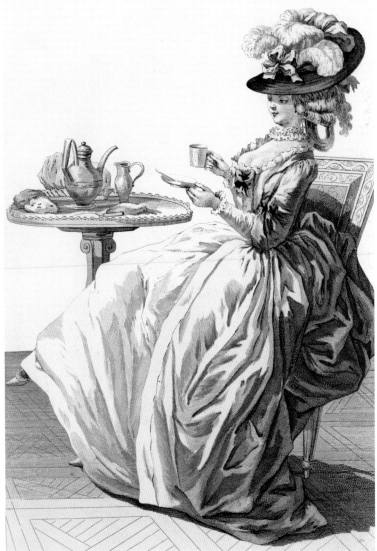

Porcelain and Chinoiserie

Porcelain is a kind of pottery made from a smooth paste of translucent whiteness, which is composed mainly of kaolin clay, baked clay, and quartz silica, fired at temperatures from 2,112 to 2,732 degrees Fahrenheit. In the West, porcelain was created in an effort to imitate the items made in China from the third century AD. After various experiments, the German scientist Ehrenfried Walther von Tschirnhausen and alchemist Johann Friedrich Böttger succeeded for the first time in Dresden, at some point between 1708 and 1709. They managed to produce a hard paste, unlike the soft paste produced by the Florentine factories set up by the Medici grand dukes 150 years before. Germany was of course one of the first countries to produce this valuable material, and in 1710 the Meissen factory started to make it under the supervision of Böttger, who was in the employ of Augustus II the Strong, king of Poland. Another factory opened in Vienna in 1719 and another in Venice in 1720. After a number of attempts that had yielded a soft, translucent porcelain in 1678, a factory opened in France at Chantilly in 1725, followed by further sites in Paris, Niderville, and Limoges, which opened between 1753 and 1771.

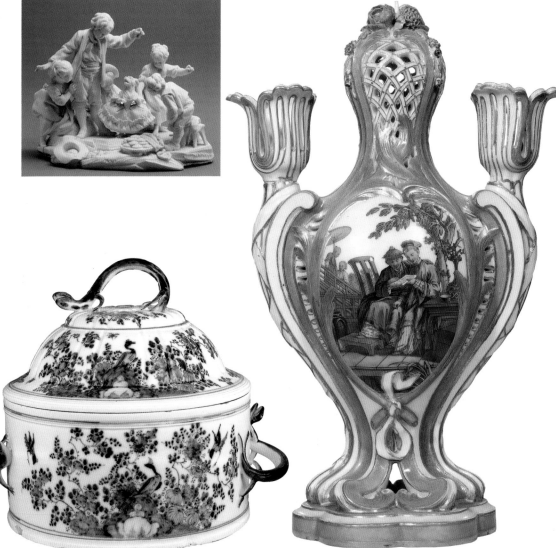

Clockwise from above:
Manufacture Nationale de Sèvres
Group with Dancing Dog Dressed as a Woman
1759, biscuit porcelain. Manufacture Nationale de Sèvres.

Charles-Nicolas Dodin
Candleholder,
Manufacture Nationale de Sèvres, semi-porcelain.
Paris, Dépôt des Objets d'Art.

Meissen Porcelain Factory
Soup dish for fish, with handles and lid in the form of salamanders
1725, porcelain.
Dresden State Art Collections.

Porcelain is a characteristically Rococo material, and the style influenced not only how it was used but also the subject matter of the artifacts. It is hardly surprising that Boucher's little shepherdesses were given shape in the ceramic figurines made at Sèvres: groups of figurines where young couples in love, having more or less forgotten about their flock, embrace and kiss passionately, perhaps in the shade of a tree under the vacant gaze of a sheepdog. The bright colors, the elegant gilding, and the translucent sheen of the material complete the charming effect.

The enduring admiration for China and its exotic appeal prompted the production of Chinese-style porcelain objects.

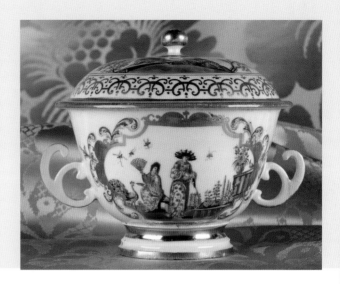

Above:
Meissen Porcelain Factory
Soup dish with lid and chinoiserie in a gilded frame with peacocks and flower beds
1730, porcelain.
Mannheim, Städtisches Reiss-Museum.

Left:
Meissen Porcelain Factory
Chinese musician with guitar
1740, porcelain.

Meissen Porcelain Factory
Coffeepot, detail of handles (with girl's head), attached to lid by a chain
1740, porcelain.
Hamburg, Museum of Art and Design.

Rococo

Arcadia

Guercino's famous painting *Et in Arcadia Ego* (shown on page 60) contains all those aspects later theorized and developed by the poetics named after mythical Arcadia, the bucolic region of Greece where shepherds went to live a life of happy simplicity after overcoming the harshness of earthly existence. Guercino's painting, however, offers another reading in contrast with this idyll, evident in the skull upon which a fly is resting, both symbols of decay that may be traced to the Latin verse that states "I [death] am also in Arcadia." At the same time, the artist is also implying that he

aspires to that ideal of simplicity and beauty, so far from death's decay, that Arcadia once represented.

Poets and writers tried to recapture this condition in the Accademia dell'Arcadia, founded in Rome in 1690 by the same intellectuals (including Leonio, Gravina, and Crescimbeni) who used to meet together in the gardens of the Via della Lungara palazzo where Cristina, the former queen of Sweden, went to live in 1668 after her triumphant reception in Rome in 1656. From that moment on, every Thursday, scholars and intellectuals, including Pietro Metastasio, Antonio Muratori, and Vincenzo Monti, met in the Bosco Parrasio, on the side of the Gianicolo Hill, in a setting

Below and right:
François Boucher
Summer Pastoral
1749, oil on canvas.
London, Wallace
Collection.

François Boucher
Autumn Pastoral
1749, oil on canvas.
London, Wallace
Collection.

Facing page, top right:
Grotto
Late seventeenth/early
eighteenth century.
Viry-Châtillon, France.

Facing page, right:
Jean-Antoine Watteau
*Merry Company in the
Open Air*
1717–18, oil on canvas.
Dresden, Old Masters
Picture Gallery.

designed by architect Antonio Canevari (1681–1750). They would converse and recite with a single goal in mind: to affirm the return to classical beauty. These ideals of bucolic Greek Classicism soon spread out from Rome to reach the rest of Europe, starting with France, where Arcadia became the poetic lifeblood of Watteau's painting. Watteau invented the theme called the *fêtes galantes*, rural and mythological settings populated by shepherds dressed in silk who try to woo shepherdesses dressed in brocade. The genre was revisited by Boucher and Fragonard, who took up the underlying poetic principle and shifted it gently toward discrete eroticism blended with the Arcadian ideal of the Golden Age.

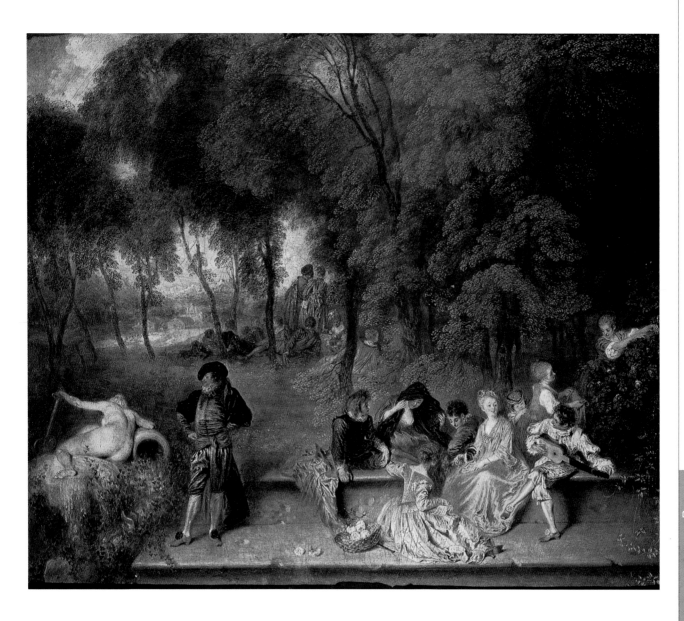

Furniture

As had been the case with architecture, the quintessentially Baroque style of Louis XIV furniture and furnishings did not find favor in England, where taste leaned more to the simple, sober lines of Thomas Chippendale (1718–70). The acclaimed furniture maker invented new forms that have since become classics, such as cabriole, legs for his chairs in the shape of a goat's leg or of an S; the French designation once again shows the extent to which that nation led the way in fashionable furniture. Chippendale published a collection of designs in 1754, which ensured that his models survived and went on to become what is universally known as Chippendale. The new ornamental motifs that thus arose showed a pronounced taste for the exotic, especially for all things Chinese, brought together in an eclectic style that used Louis XIV designs alongside Gothic elements.

The opulence of Rococo was better received in Holland, at the time one of the richest nations in Europe and the point of entry for goods traded by East and West Indies companies. An idea of the style's success in Holland can be garnered from a visit to the fine Haarlem home of Abraham van der Hart at number 17 on the bank of the River Spaarne, especially the "blue room." The effect is

Right and far right:
Thomas Chippendale
Chairs
c. 1760, mahogany.
London, Victoria and
Albert Museum.

Below, left:
Charles Cressent (attr.)
Louis XV chest
Eighteenth century,
polished wood with
marble top.

Below, right:
**Real Fabbrica di
Capodimonte
(Capodimonte Factory)**
*Porcelain cabinet in
Palazzo di Portici*, detail
1757–59, painted and
gilded porcelain mounted
on wood.
Naples, National
Museum of
Capodimonte.

Facing page, left:
Piedmontese production
*Fireplace, hearth screen,
and mirror*
Late eighteenth century.
Turin, Royal Palace,
Music Room.

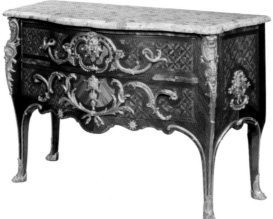

rather like walking into a sumptuous treasure chest, embellished by enormous cameos used to decorate the lunettes of the doors and walls; the walls, in turn, are decorated with blue and white Ionic pilasters.

France remained the leading producer of furniture and furnishings. Rococo reached the height of its popularity during the reign of Louis XV. Every piece of furniture took on sinuous, captivating curves; inlaid marquetry was applied wherever possible, making use of a multitude of motifs. Many different types of materials were used, including silver. The legs of chairs and tables were transformed into hooves and claws, caryatids and telamons. The offshoots of Rococo could also be found in the emerging United States of America, where by the mid-nineteenth century the style represented the ostentatious status symbol of wealth finally achieved.

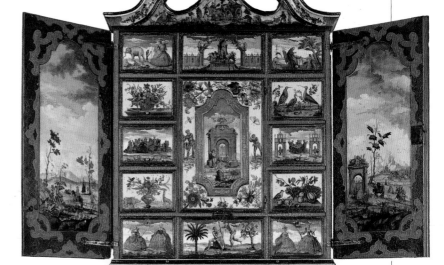

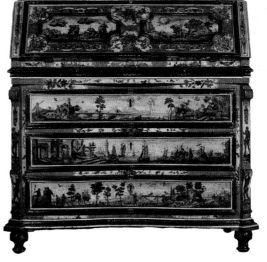

Above:

Venetian production
Dressing table mirror with chinoiserie decoration
Mid-eighteenth century, lacquered wood.

Right:

Venetian production
Writing desk/dresser with three drawers, fold-down flap, and shutters
Early eighteenth century, poplar and fir.
Milan, Sforzesco Castle, Collection of Decorative Arts.

Rococo

Etchings

In the eighteenth century, Holland lost its role as the major center for etchings and engravings (an art that had propelled the growth of a flourishing book-publishing and map-making industry) to France. Although there were no great master etchers in France at the time, the market had to meet the needs of leading figures such as the learned antiques dealer Pierre-Jean Mariette (1694–1744). Mariette was also a keen collector of drawings and used the printed reproductions for his own art dealings. The presses were used principally to reproduce masterpieces or objets d'art with the aim of making them more familiar to the wider public. It is no surprise, then, that a great deal of effort was invested in finding new techniques, such as the aquatint, which allowed for softer tonal variations and was invented in France by François-Phillippe Charpentier. It was at this time that the first attempts were made to produce color prints, first by using multiple matrices and then using aquatints (Debucourt, 1775–1832).

The engraver's art was also highly valued in England where, for example, Sir Joshua Reynolds made use of engraving to produce

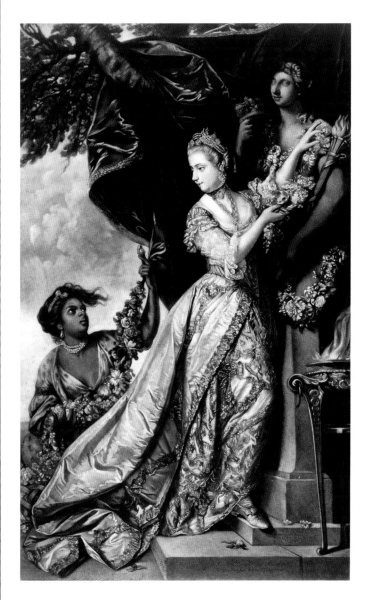

Edward Fisher (after
Joshua Reynolds)
Lady Elisabeth Keppel
1761, halftone.

Giambattista Tiepolo
*Oriental Peasant
with Family*
c. 1778, etching.

Facing page:
William Hogarth
The Courtroom
Etching.

tonal effects and where artists favored soft passages, calling upon the talents of master engravers including James Watson (1740–90). Engraving was recognized as an art in itself, an autonomous form of expression, and was used by Thomas Gainsborough. Very late in his career, the elderly Gainsborough produced some very moving soft-wax etchings. The converse of this ideal situation came in the work of William Hogarth, who used engravings to give vent to his talent for caricature and satire, which was also evident in his prolific work as a painter. Eighteenth-century Italy could also boast the talents of some exceptional master engravers, including Giambattista Tiepolo, Canaletto, and Giambattista Piranesi. Piranesi succeeded in diversifying his output, ranging from his closely observed views of Rome, with glosses and captions related to the different monuments, to his famous series of imaginary prisons, whose atmospheres seem to herald Romanticism.

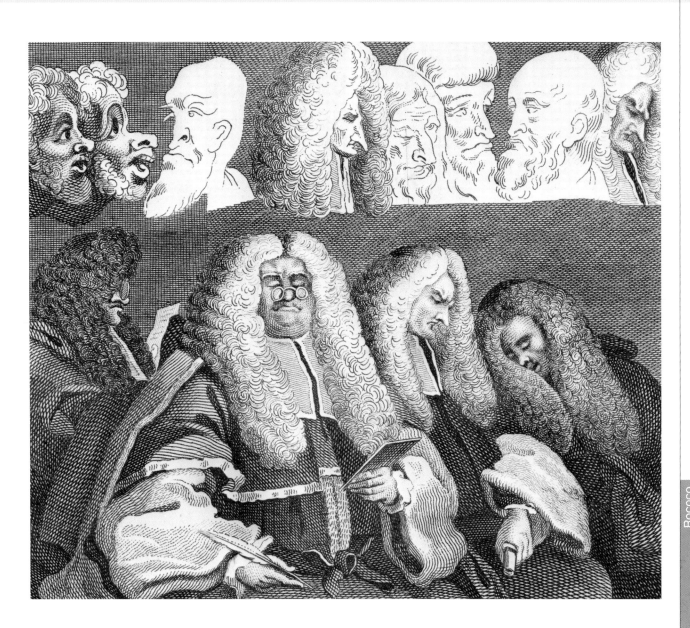

Pompeo Girolamo Batoni
(b. Lucca 1708, d. Rome 1787)

Pompeo Batoni
Self-Portrait, detail
1773–87, oil on canvas.
Florence, Uffizi Gallery.

Batoni learned draftsmanship from his goldsmith father. He was in Rome in 1727 and received financial help from patrons from Lucca. While in Rome, he executed drawings of ancient statues, which he sold to foreigners, and studied Raphael and the great classical painters of the seventeenth century. From his studies, he developed a feel for a carefully composed Naturalism. He worked at first as an assistant to established landscape painters before moving on to figures. By the mid-eighteenth century, Batoni had become one of the most respected artists in Rome. He was equal in prestige to Anton Raphael Mengs, his rival for the title of leading artist of the Neoclassical school. He painted religious and mythological scenes and was an internationally acclaimed portrait artist much sought after by foreign visitors to Rome. He was erudite though never dogmatic. His paintings combine a sensual irony with the pursuit of unencumbered elegance, as well as a keen observation of his model with mildly nostalgic commemoration of the mythical.

Pompeo Batoni
Achilles and the Centaur Chiron
1746, oil on canvas.
Florence, Uffizi Gallery.

The work shows close reading and energetic understanding of the sixteenth century's grand mythological tradition. For every detail in the painting, a reference can be found, a source identified: the Veronese-style bust, the leafy oaks that could be by Gaspard Dughet, the fair skin typical of Domenichino, the intense expressions that might be by Reni. Of course, there would be very little value in depicting a catalog of historical precedents. Batoni's repertoire is reinterpreted with new verve and sensitivity; in engaging with the great Classical-Renaissance tradition, the artist shows the delicacy of an archeologist and restorer.

Bernardo Bellotto
(b. Venice 1721, d. Warsaw 1780)

Pupil and nephew of Canaletto (Bellotto was the son of Fiorenza Canal, the acclaimed painter's sister), he was in Rome between 1741 and 1742 and in Dresden in 1747. Dubbed Florence on the Elba because of its airy, imaginative Baroque buildings, Dresden at the time was at the height of its splendor. Bellotto executed a number of views of the city, applying the conventions of Canaletto's views. He was appointed court painter by Augustus III. During the Seven Years' War, Bellotto was in Vienna, working for Empress Maria Theresa of Austria, and Munich. He painted a number of views of the two cities (*Vienna from the Belvedere*, *Moat of the Old Tower*), depicting, in response to his patrons' demands, the riches of the recently built palaces. From 1764, he taught painting in Dresden's recently founded Academy of Fine Arts. He was appointed court painter in Warsaw in 1767.

Bernardo Bellotto
Dresden Seen from the Right Bank of the Elba, detail
c. 1748, oil on canvas. Dublin, National Gallery of Ireland.

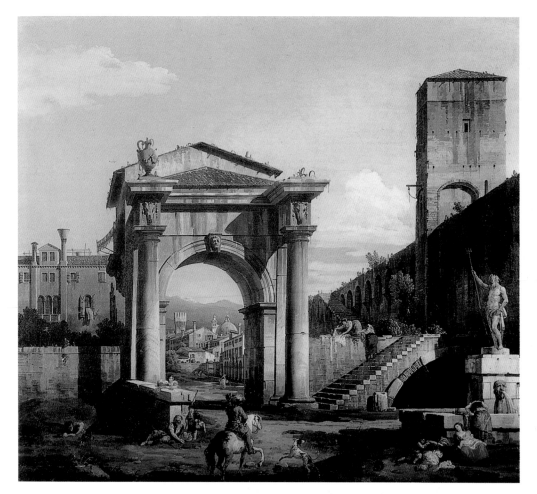

Bernardo Bellotto and Francesco Zuccarelli
Capriccio
c. 1746, oil on canvas. Parma, National Gallery.

A capriccio is an imaginary view that carefully simulates constructed topographical details. The tower we can glimpse through the arch recalls the Palace of Ezzelino in Padua, while the church dome, as white as the mountain peaks in the far background, evokes Saint Mark's Basilica. The house on the left resembles Venetian buildings painted by Canaletto; the sculptural friezes and the arch itself are fruit of the artist's imagination. In his capriccio pieces, Bellotto combines figurative elements from a range of origins in diverse and voluble compositions.

Leading Figures *Bernardo Bellotto*

Gustav Lundberg
Portrait of Boucher, detail
1742, oil on canvas.
Paris, Louvre.

François Boucher
(b. Paris 1703, d. 1770)

In his lifetime, Boucher was greatly admired for his pastoral and mythological scenes. His paintings captured the desire for sensuality, grace, and artifice that were hallmarks of French art in the Rococo period. The son of a lace designer, he studied under François LeMoyne. He discovered the work of Watteau and was struck by the refinement of Watteau's themes and the delicate elegance of the artist's atmospheric effects. He won the Prix de Rome in 1723 and stayed in the Eternal City between 1727 and 1731. Upon his return to France, he embarked on a versatile and highly prolific career. He painted and designed tapestries, costumes, and stage settings; he also designed furniture for Versailles and Fontainebleau. He was admitted to the Royal Academy in 1734 and appointed director of the factories at Beauvais and the Gobelins. He was appointed first painter to the king in 1765 and became director of the academy. He also designed decorations and models for Sèvres porcelain.

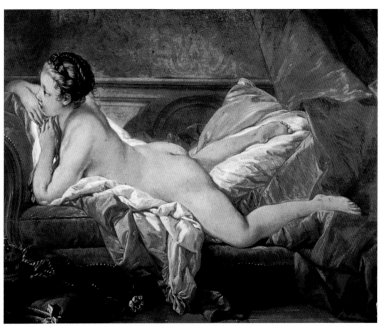

Above:
François Boucher
Blonde Odalisque
1752, oil on canvas.
Munich, Old
Pinacotheca.

Left:
François Boucher
*Rocaille drawing for
screen*
c. 1738, black pencil on
brown paper.

Facing page:
François Boucher
Portrait of Marquise de Pompadour
Work signed and dated 1756, oil on canvas.
Munich, Bayerische Hypotheken-und Wechsel-Bank,
deposited with the Old Pinacotheca.

Boucher executed a number of paintings of Louis XV's mistress; she was an admirer and collector of Boucher's work, and he was her drawing and etching teacher. Boucher's fame declined toward the end of his career when the new connoisseurs and intellectuals distanced themselves from the artist's world of escapism and illusion.

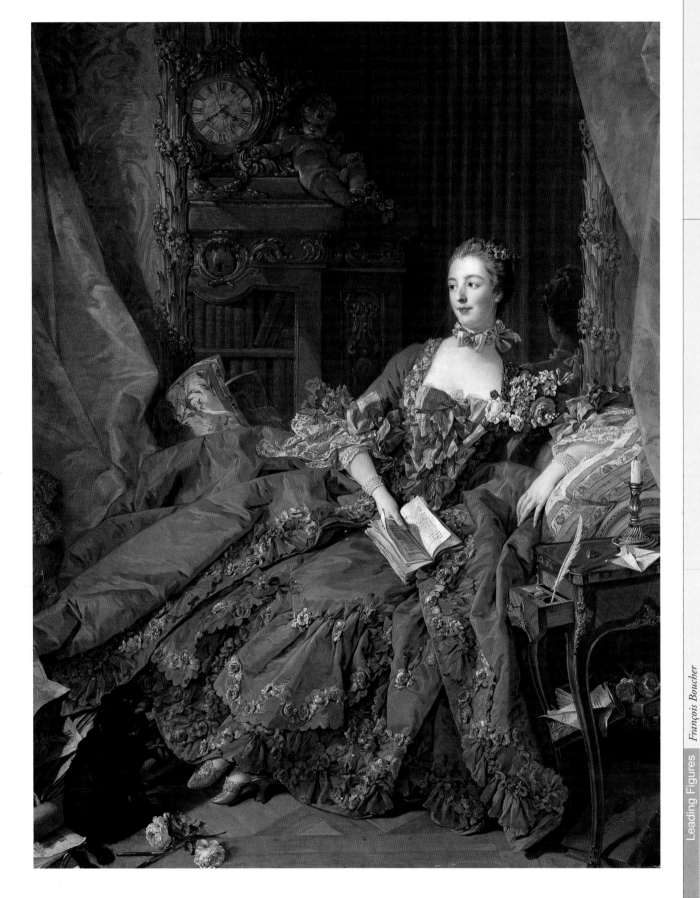

Canaletto

Giovanni Antonio Canal
(b. Venice 1697, d. 1768)

Antonio Visentini
Portrait of Canaletto, etching by
Giovanni Battista Piazzetta for the
frontispiece of *Prospectus Magni
Canalis Venetarium*, which contains
Visentini's etchings of Canaletto's
works. Before 1735.

Canaletto did more than any other artist to establish the importance of the *veduta* as an art form. His father, Bernardo, was a theater scene painter, and Canaletto trained in the same profession. However, in 1719, "bored with the indiscretions of dramatic poets," as his contemporary the historian Antonio Maria Zanetti wrote, "he solemnly disavowed the theater and left for Rome." He lived in the city for a year or two. There he became familiar with the work of the Flemish *vedutisti* and returned to Venice, where he worked as a painter of views from 1720. He preferred to use Venice's well-known monumental spaces, such as Saint Mark's Square or the Grand Canal, in his compositions, but he did not neglect to record the everyday life of the city as well. His work was much sought after by British collectors, and he traveled to London in 1746. Apart from sporadic visits to Venice, he remained in London for almost a decade. He was admitted to the Venice Academy in 1763.

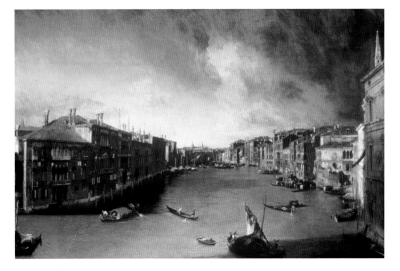

Left:
Canaletto
***The Grand Canal from
Palazzo Balbi Toward
Rialto***
c. 1730, oil on canvas.
Venice, Ca' Rezzonico.

Facing page:
Canaletto
***The Grand Canal with
the Church of San
Simeone Piccolo Toward
Fondamenta della Croce,***
detail
c. 1729–34, oil on canvas.
London, National
Gallery.

Below:
Canaletto
***View from Ca' Bon
Toward Ca' Foscari,
from Quaderno
di Disegni***
c. 1730, drawing
on paper.
Venice, Gallerie
dell'Accademia.

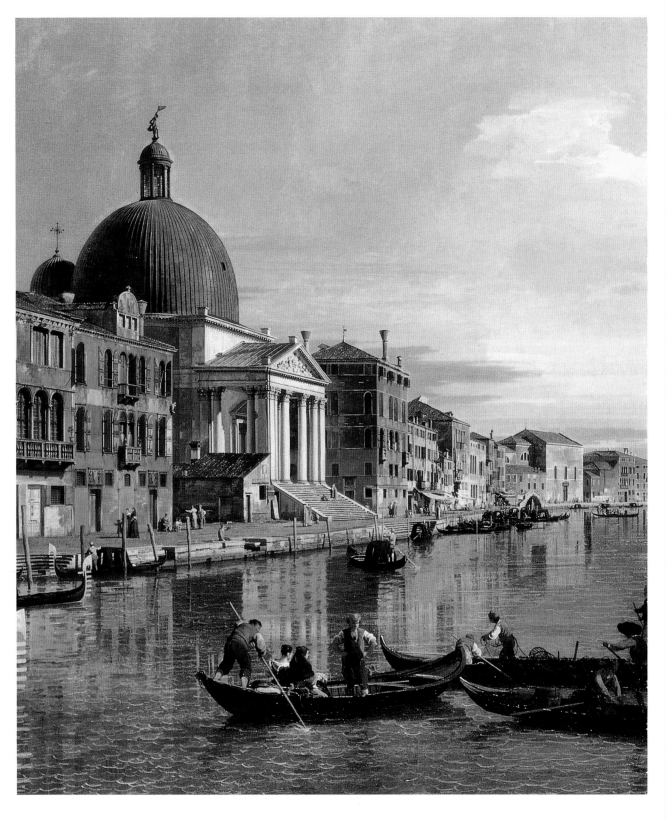

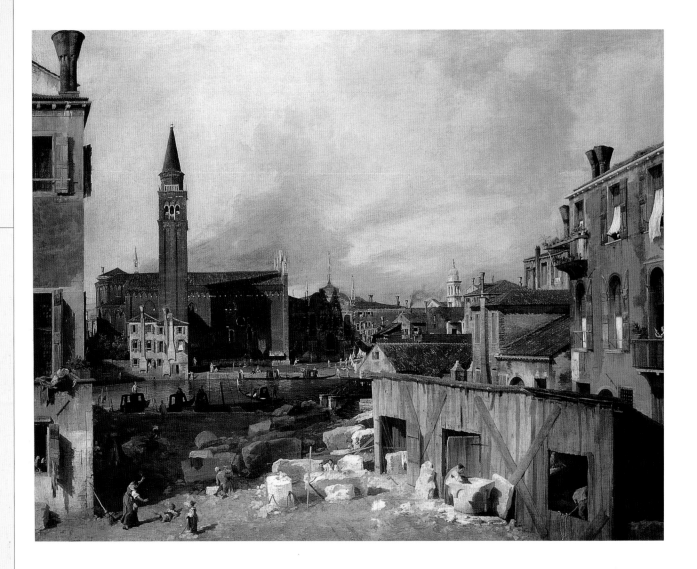

Canaletto
The Stonemason's Yard
1727–28, oil on canvas.
London, National Gallery.

In this scene, Canaletto chooses to depict not one of the city's elegant thoroughfares or squares, but rather a much less well-known and rarely visited place. Huddled around this space are a number of humble craftsmen's homes and a handful of marble carvers' workshops; in all likelihood, the workers are engaged in the reconstruction of the Church of San Vitale. The bright light of this early morning Venetian scene picks out the fronts of the dwellings, the wooden beams that the workers are preparing, the clothes left out to dry, the bell towers, and the marble. The genre details are particularly lively. The gondoliers are waiting for customers, the women bustle about the balconies or lean out of windows, the children play in the courtyard below, and the stonemasons have been captured as they chisel and chip at blocks of stone. In the background, a few idle figures are sitting or almost lying down as they rest on the steps that lead to the wharf.

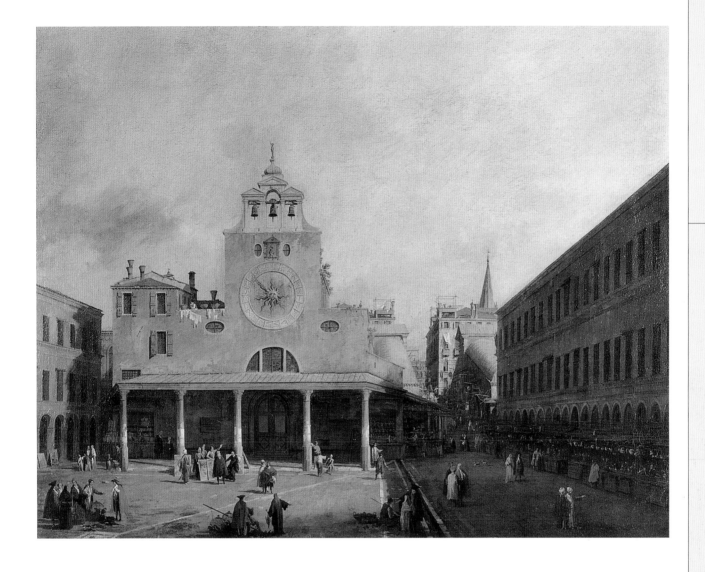

Canaletto
San Giacomo di Rialto
c. 1730, canvas.
Dresden, Old Masters Picture Gallery.

In executing his views, Canaletto made use of a camera obscura, the "black box" that was the precursor to the modern photographic camera. It worked by using mirrors that projected a succession of reflected images onto paper and allowed the artist to "copy" the subject in real time. It is astounding how such a simple optical device could lead to the execution of images suffused with an intense, radiant light, brighter than in nature. As one of his contemporary admirers pointed out, "In this country, Canaletto astounds everyone who looks upon his works, which is of the order of Carlevarijs."

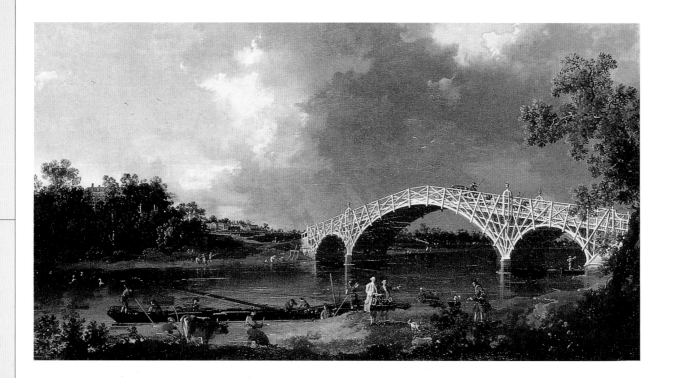

Canaletto
Capriccio with Triumphal Roman Arch and Ruins
After 1748, pencil, pen, ink, and watercolor on paper.
New York, Metropolitan Museum of Art.

The triumphal arch depicted here is from Pola, the archeological site found on the Istria peninsula in modern-day Croatia. Canaletto never went to Pola and may have copied the arch from an engraving by Piranesi. Minutely executed, the drawing shows the ruins of other columns and arches set out around a much larger arch; a seated artist is intent on drawing while in the background, on the right, we can make out the sea and a ship's mast.

Canaletto
Old Walton Bridge
1754, oil on canvas.
London, Dulwich Picture Gallery.

"Executed in 1754 for the first and last time, with every attention to detail," as Canaletto wrote on the back of the canvas, the painting—the property of a friend of the consul Joseph Smith—depicts a wooden bridge that once crossed the Thames about twenty-five miles from Westminster. Supported by three arches, the Old Walton Bridge was a light structure made from painted wood; here, it seems to vibrate in the luminous country setting that stretches out as far as the eye can see, bathed in light that falls from above.

Facing page:
Canaletto
Interior of Saint Mark's with Choristers
1766, pencil, pen, and watercolor on paper.
Hamburg, Hamburger Kunsthalle.

Executed "without eyeglasses," as the elderly artist took pains to write in his note, the drawing depicts a partial view of the interior of Saint Mark's Basilica and shows the diverse crowd that gathered in the church; the choir, the praying faithful, and the old beggar woman enchanted by the hymns of devotion. The Byzantine mosaics, the sixteenth-century altars, and the large skylights have their own place in the composition, as the Christian church embraces vestiges and remains of every era.

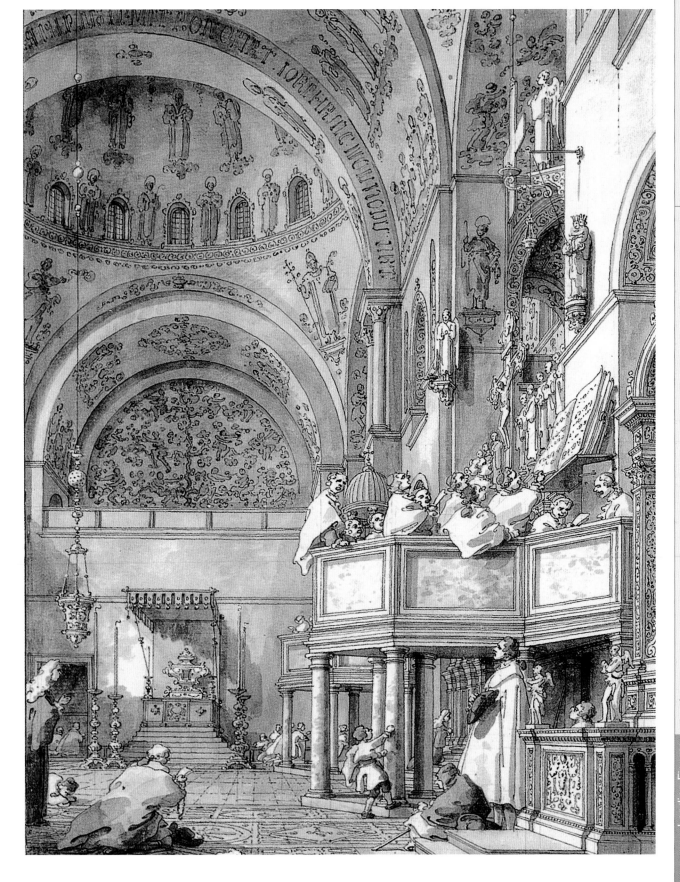

Bartolomeo Nazzari
Portrait of Luca Carlevarijs,
detail
Oil on canvas.
Oxford, Ashmolean Museum.

Luca Carlevarijs
(b. Udine 1663, d. Venice 1730)

The orphaned Luca is recorded in Venice as early as 1679. In all likelihood he traveled to Rome in 1690 (the journey is first mentioned by his nineteenth-century biographers). His work was deeply influenced by his encounter with the paintings of Gaspar van Wittel. In contact with a number of *vedutisti* from northern Europe working in Venice (including Eisman, who may have been his teacher, and Stom), Carlevarijs was among the first artists in Venice to move away from the imaginary compositions typical of the views. In 1703, he published his first signed and dated collection of etchings, which included "104 buildings and views of Venice, designed in perspective and engraved." Carlevarijs's works showed exceptional, almost documentary clarity of topographical detail and he proved to be no less talented in the distribution of light and shade. The striking atmospheres he achieved through his use of chiaroscuro in a number of his compositions revealed his close study of the work of Claude Lorrain, as well as the use of a camera obscura.

Luca Carlevarijs
Piazza San Marco
c. 1720, oil on canvas.
Madrid, Thyssen-
Bornemisza Collection.

Sometimes executed using a camera obscura, the hallmarks of Carlevarijs's views are the artist's painstaking meticulousness in his depiction of buildings and the multitude of types and "theatrical" characters. In the Piazza San Marco, the foreground teems with very elegantly dressed, masked ladies and gentlemen. A gentleman dressed in red and beige, wearing a huge wig, turns toward us, while a poor woman enters the scene from the right. Dappled light streaks across the scene, as if suddenly breaking through the clouds at the end of a storm; in the background we can see a performance of a *commedia dell'arte* play.

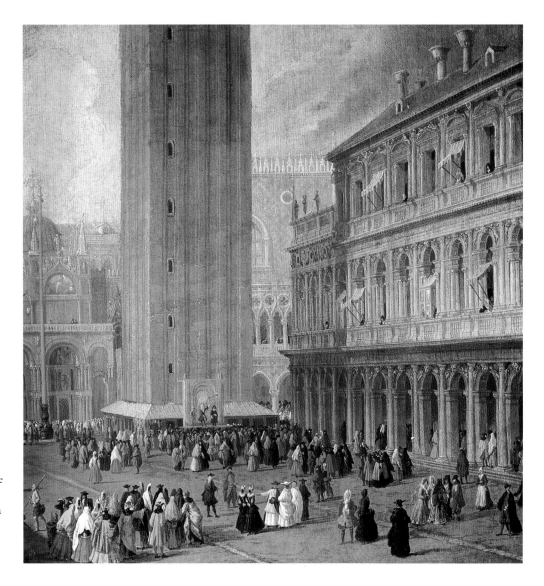

Rosalba Carriera
(b. Venice 1675, d. 1757)

Rosalba Carriera
Girl with Parrot, detail
c. 1720, oil on canvas.
Chicago, Art Institute.

Carriera's early training may have been in designing patterns for her mother, who traded in lace, but her reputation was established by her pastel portraits. With the support of Joseph Smith, British consul to Venice, and much sought after by aristocrats all over Europe and by foreign visitors to Venice, Rosalba, together with Sebastiano Ricci, became the interpreter of the new trend in painting emerging in Venice. A skilled painter of miniatures (she often painted portraits on snuffboxes and ivory), Carriera endowed her subjects with grace, delicacy, and gentleness. During her stay in Paris between 1720 and 1721, she met Jean-Antoine Watteau. In 1720, she was admitted to the Bologna academy of painting and the Académie Royale de la Peinture in Paris. She traveled to Modena in 1723 and Vienna in 1730. She started her own workshop and had a number of assistants to help execute the many commissions she received. She also left a large collection of letters upon her death.

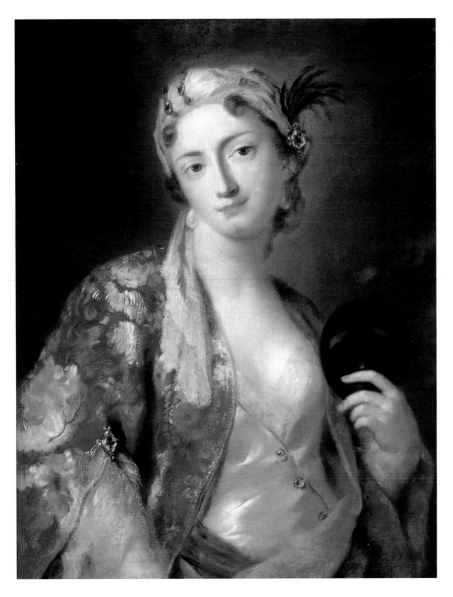

Rosalba Carriera
Portrait of Felicita Sartori in Turkish Dress
c. 1730–40, chalk on paper.
Florence, Uffizi Gallery.

Felicita Sartori herself made a miniature copy of the work, today housed in Dresden. Born in Gorizia, Felicita was a pupil of Rosalba Carriera, and although not as famous as her teacher, she was a refined and cosmopolitan portrait artist. Like Carriera, Sartori was also on friendly terms with famous collectors such as Pierre Crozat and artists like Watteau. We know that Sartori was a guest of Carriera in Venice between 1728 and 1741, the year in which she married in Dresden, and in all likelihood it was during this period that her teacher and friend executed this enchanting pastel.

Giacomo Antonio Melchiorre Ceruti
(b. Milan 1698, d. 1767)

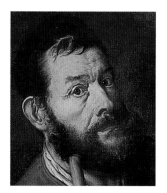

Giacomo Ceruti
Self-Portrait as a Pilgrim, detail
1737, oil on canvas.
Abano Terme, Palazzo del
Comune.

Ceruti was recorded as working in Brescia early in his career, and then in Venice in 1736. He then moved to Piacenza, Brescia again, and then Milan. An established portrait artist, Ceruti also painted religious scenes and still lifes. His reputation is founded on his paintings of the poor—beggars, pilgrims, peasants, laborers—as they go about their daily lives or caught in moments of rest. With close affinities to seventeenth-century painters like Le Nain and Murillo, Ceruti's style was carefully affected (his compositions tended invariably to be monochromatic). He was an attentive observer of the realities of his social context; during the decades that the artist spent painting them, the peasants and poor of the city were in fact afflicted by the hardships and privations that he depicted so many of his figures as suffering. Ceruti had many aristocratic patrons. His images of poverty were edifying, and to commission them was an act of philanthropy; some of them, in keeping with the tradition founded by the Carracci family, may even move us to laughter.

Giacomo Ceruti
Boy with Dog
Oil on canvas.
Belfast, Ulster Museum.

This is more an allegory than a portrait. The painting refers to hunting—there is a reference to this in the horn in the dog's mouth, which is used by the painter as a kind of attribute.

Jean-Baptiste-Siméon Chardin
(b. Paris 1699, d. 1779)

The son of a cabinetmaker, Chardin trained under Pierre-Jacques Cazes, a painter of historical scenes, and Noël-Nicolas Coypel. In 1728, he was admitted to the Royal Academy as a painter of fruit and animals. From the start, he concentrated his efforts on still lifes and everyday objects in the seventeenth-century Dutch and Flemish tradition. In 1731, he joined the team working on the restoration of the frescoes in the gallery of François I in Fontainebleau under the supervision of Jean-Baptiste Van Loo. From 1733 he painted domestic scenes and figures. He received admiring encouragement from a number of intellectuals and *encyclopédistes*, who commented on the distance between his art and the sensual and affected art of the Rococo painters. In a moralizing note taking painting to task, Diderot wrote of Chardin, "One stops before one of his works as the weary traveler stops in the glade that offers silence, water, shade and a refreshing breeze." In the last years of his career, Chardin turned to using pastels.

Jean-Baptiste-Siméon Chardin
Self-Portrait, detail
1775, crayon.
Paris, Louvre.

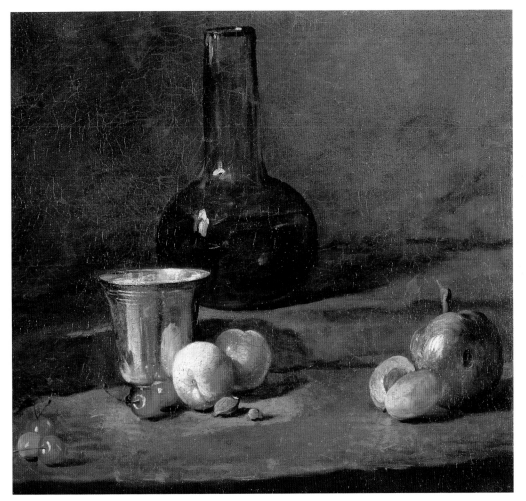

Jean-Baptiste-Siméon Chardin
Still Life
c. 1728, oil on canvas.
Saint Louis, Saint Louis Art Museum.

During the second half of the 1720s, Chardin shifted his attention to still life compositions, and in these works fruit had the same central role as animals (among his favorite subjects). Intensely colored cherries, peaches, and apricots are sometimes complemented by a glass or silver goblet, as in the work shown here, or by a bottle.

This page, clockwise:
Jean-Baptiste-Siméon Chardin
Still Life
c. 1750, oil on canvas.
Paris, Musée de la Chasse
et de la Nature.

Jean-Baptiste-Siméon Chardin
The Apricot Jar
1756, oil on canvas.
Toronto, Art Gallery
of Ontario.

Jean-Baptiste-Siméon Chardin
The Buffet
1728, oil on canvas.
Paris, Louvre.

Facing page:
Jean-Baptiste-Siméon Chardin
Soap Bubbles
c. 1733, oil on canvas.
Washington, D.C.,
National Gallery of Art.

Leading Figures | Jean-Baptiste-Siméon Chardin

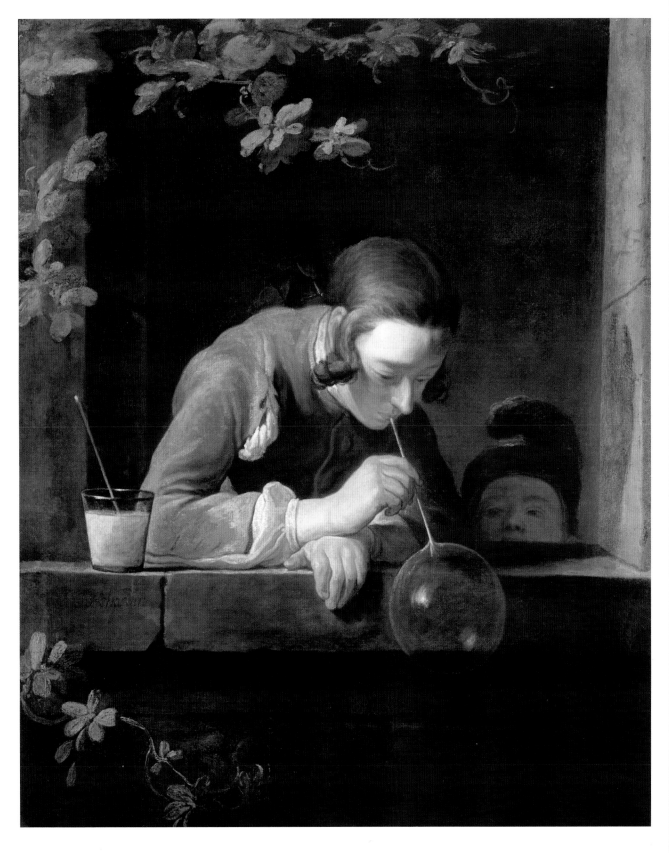

Giuseppe Maria Crespi
(b. Bologna 1665, d. 1747)

Giuseppe Maria Crespi
Self-Portrait, detail
1708, oil on canvas.
Florence, Uffizi Gallery.

An erudite artist who underwent lengthy and varied training (he traveled to Parma, Urbino, and Venice and was called to Florence by Grand Duke Ferdinando between 1708 and 1709), Crespi earned his unusual nickname *lo Spagnolo*, "the Spaniard," because of the clothes he liked to wear as a young man. One of the leading Italian painters of his age, Crespi was especially praised for his genre scenes (*The Fair at Poggio a Caino*, 1709, Uffizi Gallery), which variously reflected his knowledge of sixteenth-century Venetian tradition and the work of the Carracci family, Guercino, and Flemish artists. His compositions combine unusual points of view, elaborate and bizarre details, refined tonal harmonies, and warming chiaroscuro effects, and they are all the more striking because of the concealed finesse behind their apparent simplicity. He also worked as a painter of historical and mythological subjects. His sons were artists, and he was the owner of a successful school of painting.

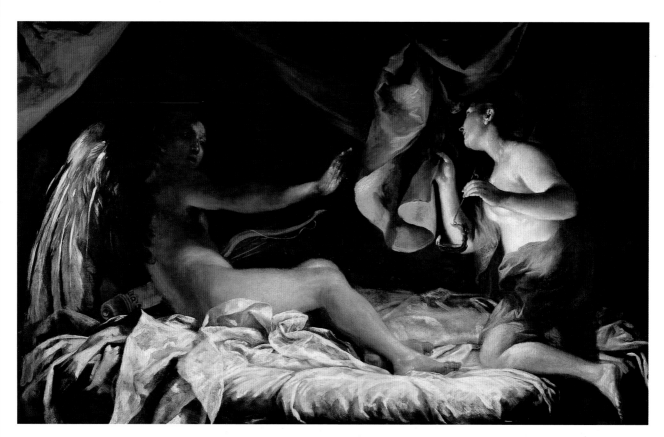

Giuseppe Maria Crespi
Cupid and Psyche
1707–9, oil on canvas.
Florence, Uffizi Gallery.

The subject is taken from Apuleius: in an attempt to see the unknown countenance of her mysterious lover, Psyche brings a lamp close to his face. In doing so, she breaks a rule and loses Love/Cupid. The nocturnal scene is one of the neo-Mannerist artist's supreme challenges: long, slender, nude adolescent forms depicted as they slowly twist their bodies, with rapt expressions, golden hair, and fair skin. The consummate fluidity and flexibility of the composition lend the softness and volatile movement of downy feathers to fabrics and draperies. Cupid's raised wing, half in light, becomes the emblematic fulcrum of a painting where the close study of natural appearance is carried to completion in the realm of magic and stylization. Recent restoration work on what is one of the Bolognese master's most intense paintings has uncovered Psyche's naked breast, which had previously been hidden by a veil.

Fra Galgario
Giuseppe Vittore Ghislandi
(b. Bergamo 1655, d. 1743)

Fra Galgario
Self-Portrait, detail
1732, oil on canvas.
Bergamo, Accademia Carrara.

The son and pupil of a painter of trompe l'oeil and views, Ghislandi served his apprenticeship first in Bergamo and then in Venice, where he arrived in 1675 to become a lay member of the Society of Saint Vincent de Paul. He returned to Bergamo and then traveled to Milan, where he worked under the German painter Salomon Adler before returning once more to Bergamo, now a friar in the Order of Minims in the monastery of San Galgario, the saint from whom his nickname was derived. Along with Ceruti, he was particularly acclaimed by twentieth-century historians and critics (he was numbered among those "Lombard painters who depict reality"); Fra Galgario revisited Bergamo's grand sixteenth-century portrait tradition (his model was above all Giovanni Battista Moroni), displaying a fine grasp of psychology as well as the moralist's eye. Taken together, his portraits make up a fine gallery of characters: the gentleman, the cleric, the courtier, and the scholar, all depicted with acumen and sobriety (*Portrait of a Knight of the Constantinian Order*, Milan, Poldi Pezzoli Museum).

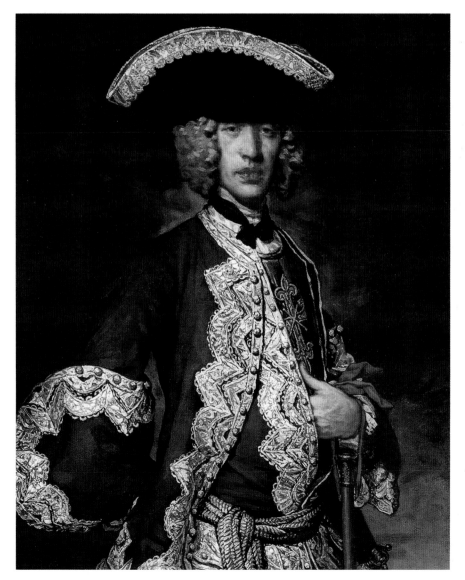

Fra Galgario
Portrait of a Knight of the Constantinian Order
c. 1737, oil on canvas.
Milan, Poldi Pezzoli Museum.

This portrait of a knight of the Order of Constantine (we learn as much from the emblem printed on the metal chest piece) is interesting for the play of hues that contrast with the dominant pallet of green and blue; for the precise rendering of the silver coins decorating, lacelike, the gentleman's hat and jerkin; and for the pungent irony with which the artist, anticipating the satirical talent of Goya, has captured the vacuous arrogance of the unknown cavalier.

Jean-Honoré Fragonard
Self-Portrait, Facing Forward,
detail
c. 1790, black pencil with crayon
additions. Paris, Louvre.

Jean-Honoré Fragonard
(b. Grasse 1732, d. Paris 1806)

A pupil of both Chardin and Boucher, Fragonard won the Prix de Rome in 1752. He worked in the studio of Charles Van Loo for three years and then traveled to Italy to study the classics. He was particularly attracted to the works of Giambattista Tiepolo. He was made a member of the Royal Academy in 1765, and his historical scenes were widely acclaimed. After his appointment to the academy, he began to paint amorous scenes and audacious nudes. He stopped exhibiting at the Salon in 1767, preferring to devote his time to painting commissions for prosperous patrons, including Jeanne Bécu, countess du Barry, mistress of Louis XV. Nor was he interested in an official career. He returned to Italy between 1773 and 1774, he moved to Grasse for health reasons in 1790, and returned to Paris in 1791. He made an attempt to adapt his style to the new taste of the day and received the support of Jean-Louis David, who obtained an administrative position for him at the Musée des Arts (as the Louvre was known). Once the prevailing cultural ideology had changed and his clients had disappeared, Fragonard died in anonymous poverty.

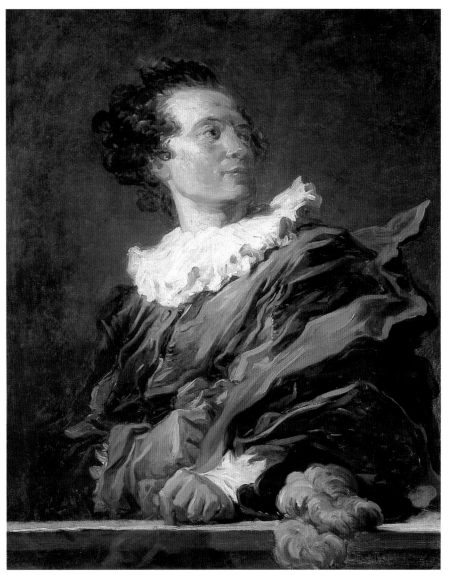

Left:
Jean-Honoré Fragonard
Portrait of the Abbot of Saint-Non
Work signed and dated 1769, oil
on canvas.
Paris, Louvre.

Facing page:
Jean-Honoré Fragonard
A Young Girl Reading
c. 1776, oil on canvas.
Washington, D.C., National Gallery
of Art.

In an earlier version, instead of the
young girl reading, Fragonard had
painted a man's head that looked toward
the viewer with an ironic expression.
The reasons for the change are
unknown, and in all likelihood the girl's
face is not a portrait from real life; the
painting is usually classified among
the *figures de fantaisie* painted from
1769 onward.

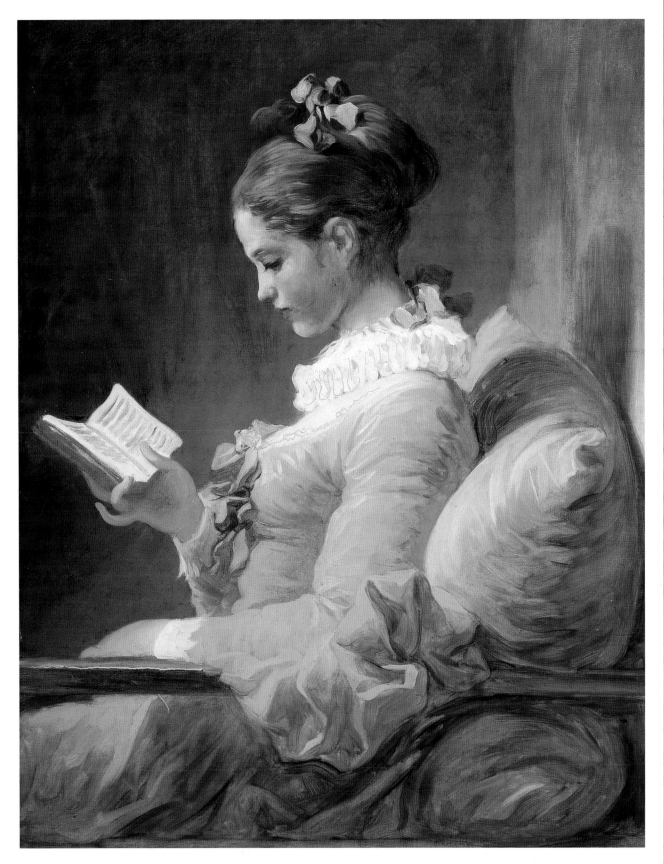

Jean-Honoré Fragonard
Le feu aux poudres
Before 1778, oil on canvas.
Paris, Louvre.

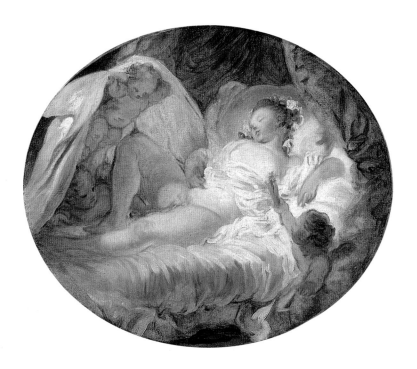

Left:
Jean-Honoré Fragonard
Little Mischievous One
1765–70, oil on canvas.

"A young girl, seated on a bench, pulls the hair on a statue of a magician on a little table." That was the description of the canvas when it was displayed at the 1860 Paris exhibition, held on Boulevard des Italiens. The event was a revelation for the public, whether they were from Paris or elsewhere, who had until then been unaware of the talent (and, for many, even the existence) of eighteenth-century French painters.

Facing page:
Jean-Honoré Fragonard
The Lover Crowned
1771–72, oil on canvas.
New York, Frick Collection.

The canvas was one of a series of four paintings depicting amorous scenes commissioned in 1771 from Fragonard by Louis XV's lover Jeanne Bécu, countess du Barry, for her pavilion in Louveciennes. Although the countess paid a fortune for the works, she gave them back to Fragonard two years later, because they went out of fashion.

Thomas Gainsborough
Self-Portrait, detail
1754, oil on canvas.
England, private collection.

Thomas Gainsborough
(b. Sudbury 1727, d. London 1788)

The son of a wool-maker, Gainsborough is the only eighteenth-century English painter to have consistently dedicated himself to painting landscapes. His early training took place in London under Hubert Gravelot, a French draftsman and engraver who introduced Gainsborough to the Rococo style. Then he studied with Francis Hayman, a genre painter and illustrator. His early models were the seventeenth-century Dutch landscape artists Wynants and Ruysdael. In 1752, he moved to Ipswich, drew landscapes, and visited the collections of leading families. He moved to Bath in 1759, where he was sought by the wealthy patrons who came to the spa on vacation. He drew inspiration from Rubens and Van Dyck. In 1768, he was among the founding members of the Royal Academy, where he was a regular exhibitor until 1784. He moved to London again in 1774 and attracted the attention of the court. George III preferred Gainsborough to Joshua Reynolds, and in 1781 Gainsborough was commissioned to paint a portrait of the king and queen. In the last years of his career, he painted seashores and idealized peasant girls.

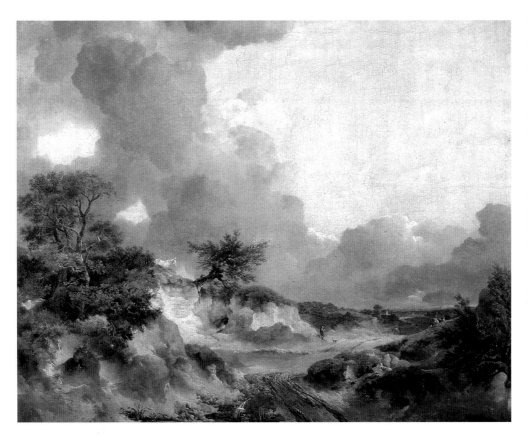

Thomas Gainsborough
Landscape with Sandbox
1746–47, oil on canvas.
Dublin, National
Gallery of Ireland.

The painting is an early work, when Gainsborough was experimenting with landscapes in the Dutch style. He may have been inspired by well-known Dutch models, but even in this early piece, Gainsborough applies his own very personal and highly refined style: colors are paler, light is softer, and the whole scene is executed with great skill.

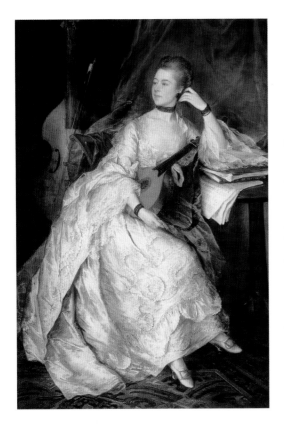

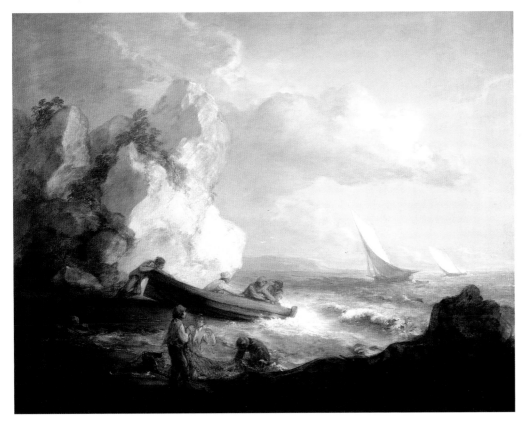

Top left:
Thomas Gainsborough
Portrait of Ann Ford
1760, oil on canvas.
Cincinnati, Cincinnati
Art Museum.

Thomas Gainsborough
The Painter's Daughters
Chasing a Butterfly
c. 1756, oil on canvas.
London, National
Gallery.

Thomas Gainsborough
Seashore with Fishermen
c. 1781, oil on canvas.
Washington, D.C.,
National Gallery of Art.

Jean-Baptiste Greuze
(b. Tournus 1725, d. Paris 1805)

Greuze first trained with Grandon, an established portrait artist, in Lyon. He later went to Paris in 1750 and continued his training at the royal academy in a sporadic way. He made his triumphal debut at the Salon in 1750, where he exhibited *The Father Explaining the Bible to His Children*. He immediately embarked on the execution of moralistic pieces that combined historical scenes and genre. His contemporaries considered his work to be an alternative to the facile, sensual motifs of Rococo, and prints of his works were widely circulated. Collectors also sought Greuze's red chalk drawings, especially his expressive heads. In 1769, he rejected the academy's judgment, which admitted Greuze only to the inferior category of genre painter. He had hoped to achieve recognition as a painter of historical scenes, so he decided that he would no longer exhibit at the official Salon. In the 1780s, in the wake of the consecration of the Neoclassical aesthetic, his popularity declined.

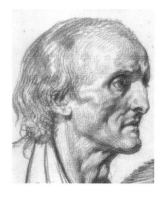

Jean-Baptiste Greuze
Study for a Paralytic, detail
Red chalk.
Paris, Louvre.

Below:
Jean-Baptiste Greuze
The Broken Jug
1772, oil on canvas.
Paris, Louvre.

Right:
Jean-Baptiste Greuze
Portrait of Claude-Henri-Watelet
1763, oil on canvas.
Paris, Louvre.

A taste for the theatrical and genuinely strong emotion are brought together by the need to give greater resonance to the present and its protagonists, claiming for them greatness and dignity on a level with the past. Here, Greuze found inspiration in the "grand manner" of Michelangelo's Sistine Chapel frescoes.

Francesco Guardi
Capriccio, detail
c. 1730–35, oil on canvas.

Francesco Guardi
(b. Venice 1712, d. 1793)

Specializing in painting figures for the compositions of his older brother Gianantonio, head of the family workshop, Francesco Guardi had a career as long as it was relatively obscure. It is not known for certain whether his career as a *vedutista* began before or after his brother's death in 1760, or if he served as an apprentice to Canaletto (although a number of Guardi's contemporaries referred to him as "a good pupil of the famous Canaletto"). It is more than likely, however, that those limpid and luminous views, executed with such scrupulous precision, were his first works and that Guardi later abandoned Canaletto's style. His reputation rests on vibrant and capriccio views where figures and buildings, depicted in imaginary arrangements, seem to dissolve into the air. His busy crowd scenes, feasts and celebrations, boat races, and concerts were among his most well-known and sought-after motifs.

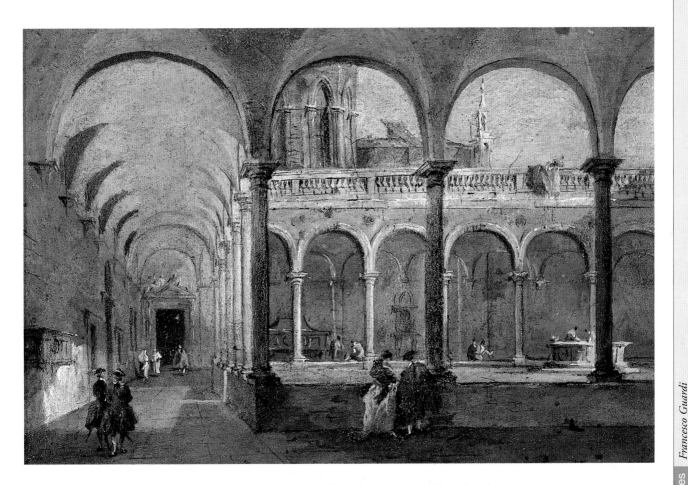

Francesco Guardi
Chiostro dei Frari a Venezia (Cloister of the Frari in Venice)
Oil on canvas.
Bergamo, Accademia Carrara.

Often interpreted as gloomy presages of decay, Francesco Guardi's *vedute* do not linger on psychological or literary readings. Instead they reflect the contemporary taste for picturesque themes and for the *macchiette*, those figures dressed in characteristic costumes that we find shown against a background of ancient ruins. Guardi displays a rare degree of excellence in these compositions, thanks to swift dabs of color vibrating in the bright sunlight.

William Hogarth
Self-Portrait with Trump, detail
1745, oil on canvas.
London, Tate Britain.

William Hogarth
(b. London 1697, d. 1764)

Hogarth's early training was as an engraver, and by 1720 he was already an established illustrator. He attended St. Martin's Lane Academy and the private school of Sir James Thornhill. He married Thornhill's daughter. He first made a name for himself with conversation pieces and family portraits. From 1731 he painted a number of morality paintings and regularly satirized foolhardy ambition, needless extravagance, indolence, and fatuousness. He saw his art in the same light as the work of the "dramatist," with images as his "theater." The prints made from his narrative cycles were hugely successful, but the publisher did not pay him his dues. Hogarth was a supporter of the campaign against plagiarism that eventually led to the passing of the law on copyrights. During the 1740s, he concentrated on painting portraits of the rich and famous. In 1753, he wrote *The Analysis of Beauty*, a polemical text directed at connoisseurs and pedants. Hogarth's theory of the serpentine line formed a cornerstone of the contemporary aesthetic.

Left:
William Hogarth
The Election, detail of
the banquet scene
1754–55, oil on canvas.
London, Sir John Soane's
Museum.

Facing page:
William Hogarth
Self-Portrait with Trump
1745, oil on canvas.
London, Tate Britain.

In this, his best-known self-portrait, a veritable manifesto for his theory of the serpentine line, Hogarth depicts himself with his faithful canine companion. The composition is also a very effective trompe l'oeil, as from within its oval frame the painter's image seems to project outside the canvas, simulating a living person surrounded by flamboyant Baroque taffeta draperies.

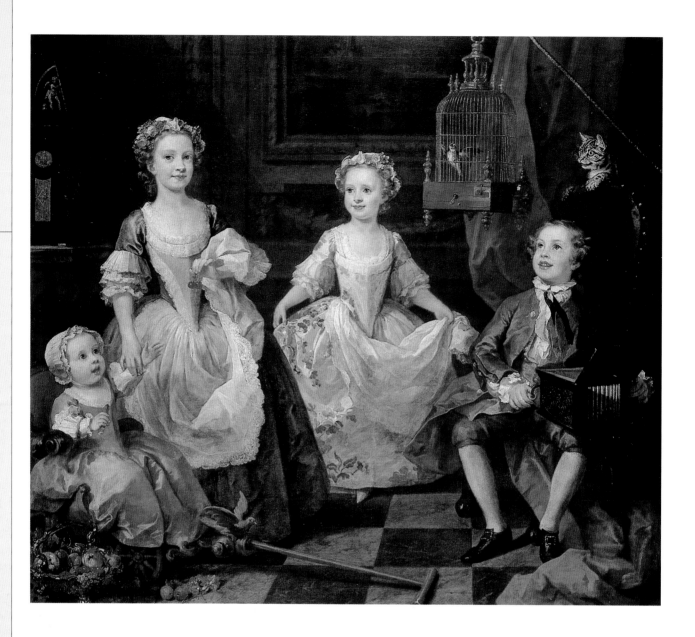

William Hogarth
The Graham Children
1742, oil on canvas.
London, Trustees of the National Gallery.

The painting shows the four children of Daniel Graham, pharmacist of Chelsea Hospital.
It is usually paired with *Children of Charles I* by Van Dyck, the great Flemish artist
whom Hogarth admired. Considered one of Hogarth's masterpieces because of the
striking immediacy of the subjects' expressions, this rare example of a life-size group
portrait is sprinkled with moralizing allusions. In contrast to the children's youth,
symbolized by the two cherries, other features of the painting refer to the fragile
transience of life: the sickle-bearing Cupid stands for *vanitas*; Orpheus hunting the beasts,
depicted on the organ, symbolizes the temporary harmony that art manages to impose on
savage *Nature*; and the *Tempest*, shown in the painting in the background.

Nicolas de Largillière
(b. Paris 1656, d. 1746)

Nicolas de Largillière spent his youth in Antwerp, where his father, a merchant, had taken the family for business reasons in 1658. In 1674, he traveled to England and worked as an assistant to Sir Peter Lely. Alarmed by the growing hostility in England toward Catholics, he returned to Paris in 1682 and was warmly welcomed by Le Brun and Van der Meulen. He was admitted to the Royal Academy in 1686 as a painter of historical scenes. The lower and upper middle classes of Paris adored his portraits, and while his rival Rigaud specialized in painting aristocrats, Largillière and his workshop were overwhelmed by requests from actresses, politicians, and religious figures. His success was founded on a skillful blend of fluid Flemish brushstrokes and vibrant hues, with an English meticulousness in arranging settings and poses. Largillière eventually became director of the academy in 1743. As well as portraits, he painted admirable still lifes and religious scenes.

Nicolas de Largillière
Self-Portrait, detail
Work signed and dated 1711, oil on canvas. Versailles, Musée National du Château.

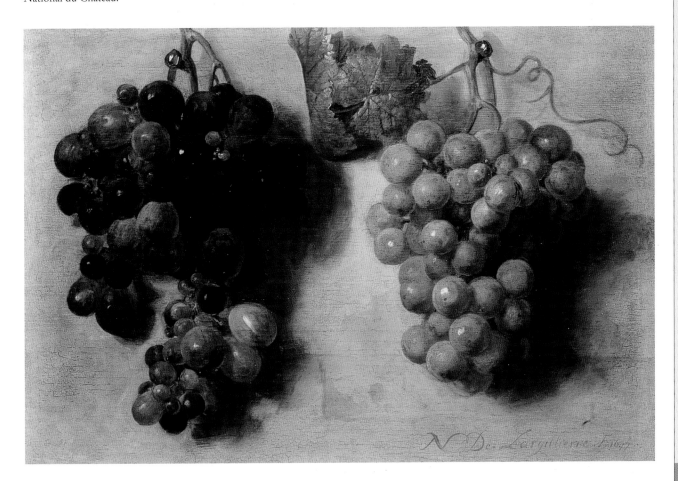

Nicolas de Largillière
Two Bunches of Grapes
1677, oil on canvas.
Paris, Lugt collection.

Page 158:
Nicolas de Largillière
The Artist in His Studio
c. 1686, oil on canvas.
Norfolk, Chrysler
Museum of Art.

Page 159:
Nicolas de Largillière
*Mlle Luclos in the Role
of Ariadne*
1712, oil on canvas.
Paris, Musée de la
Comédie-Française.

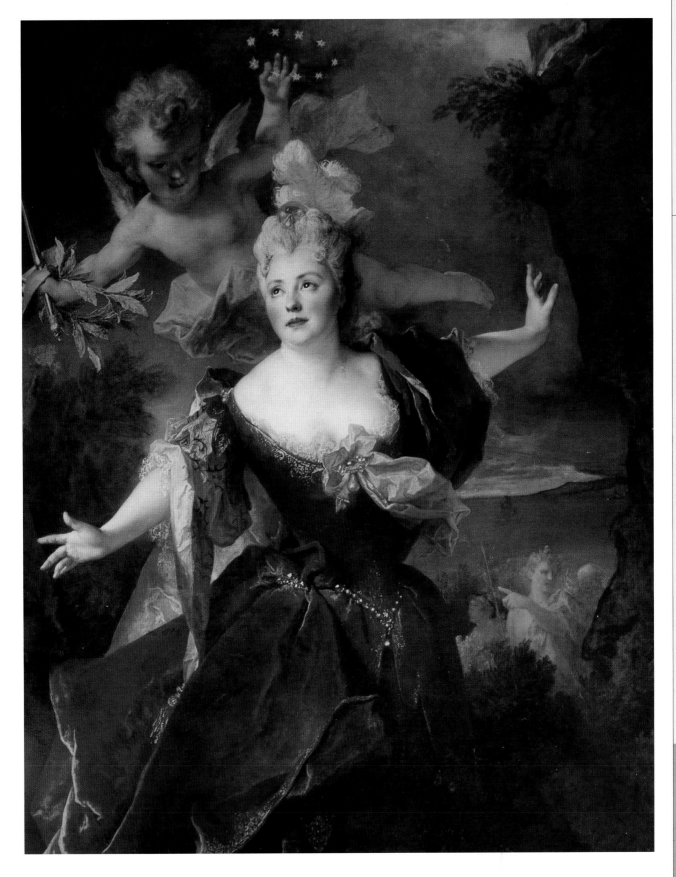

Jeanne-Étienne Liotard
(b. Geneva 1702, d. 1789)

Jeanne-Étienne Liotard
Self-Portrait in Turkish Dress,
detail
1744, crayon.
Formerly Bez, private collection.

Liotard began his training in Geneva, working on enamels and miniatures. He then moved to Paris and, following suggestions from Jean Baptiste Massé and François LeMoyne, he later traveled to Italy. He was a successful portrait artist whose work appealed to foreigners who were traveling on the Grand Tour. He accompanied Lord Ducannon and his family to Constantinople (Istanbul) and remained there from 1738 to 1742. He painted lifestyle scenes and portraits of Europeans from different nationalities, including Greeks, Armenians, and Jews, who were living in the cosmopolitan capital of the Ottoman Empire. Liotard wore a fez and let his beard grow long. He modeled his own style on the most refined Persian miniatures. He traveled to Vienna in 1742, 1755, and 1772. He stayed in London between 1772 and 1773. In the last years of his career he began to neglect the pastels that had made him famous and instead turned to painting in oils while sipping coffee and tea, drinks that had become very fashionable among both the aristocracy and middle class. In Geneva, he began writing his treatise on painting in 1776, and it was published in 1781.

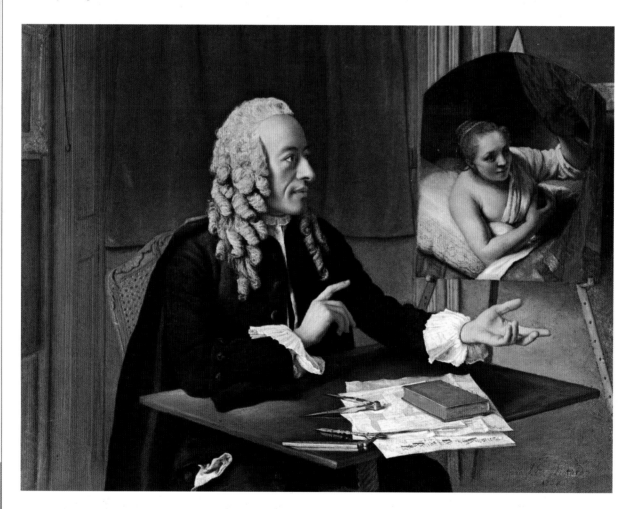

Jeanne-Étienne Liotard
Portrait of François Trouchin with Rembrandt's "A Woman in Bed"
1757, crayon on parchment.
Geneva, collection of L. Giraudon.

Facing page:
Jeanne-Étienne Liotard
Self-Portrait with Beard
1749, crayon on paper.
Geneva, Musée d'art et d'histoire.

Anonymous engraver, *Portrait of Pietro Longhi.*

Pietro Longhi
(b. Venice 1702, d. 1785)

After training as a painter of historical and religious themes, Pietro Falca (or Pietro Longhi, as he decided to call himself) shifted away from these traditional styles following a trip to Bologna where he encountered the work of Crespi, and in 1732 he abandoned the "grand manner." His son Alessandro explained that his father "changed his mind and, being possessed of a brilliant and bizarre nature, set himself to painting . . . conversations, whimsies [and] jealousies of love." He established his reputation as a brilliant figurative chronicler of the life of the city (he depicted the aristocracy and bourgeoisie of Venice with a keen sense of observation and vivid irony). He applied a great deal of care to painting scenes of contemporary life (*The Dentist, The Dance Lesson*, his series of the *Sacraments*), which contributed to his renown. He executed a great many preparatory drawings, constantly pursuing the right nuance while employing a host of atmospheric effects. He also was familiar with the work of Watteau, perhaps through Rosalba Carriera.

Pietro Longhi
Duck Hunting on the Lagoon
c. 1755, oil on canvas.
Venice, Pinacoteca
Querini Stampalia.

This duck-hunting scene provides the pretext for some rather subtle moral and social observation. In the damp silence of the early morning fog on the lagoon, the carefully groomed archer is about to let loose his arrow, while the rowers wait, poised to judge the hunter's skill, as though they were locked in some kind of silent rivalry. The artist lavished remarkable attention on little details: the cushions on the floor of the boat, the dead birds slung over the crossbeams.

Facing page:
Pietro Longhi
The Hairdresser and the Lady
c. 1755–60, oil on canvas.
Venice, Musei Civici.

A skillfully executed ensemble of chromatic variations, the painting depicts a lady during the hairdressing ritual. She is seated at her dressing table, and while the hairdresser busies himself with the lady's hair, the wet nurse seems to be bringing her daughter closer. The faces are composed and set in somewhat conventional expressions, and the poses are rigid. Longhi here is not interested in a psychological reading of the figures; he focuses rather on the details of their dress, using the richness or other features of the figures' clothes to show their social rank. He also draws our attention to the various objects we can see on the dressing table, which he depicts with masterly accuracy. A particularly noticeable element is the spool of thread on the floor.

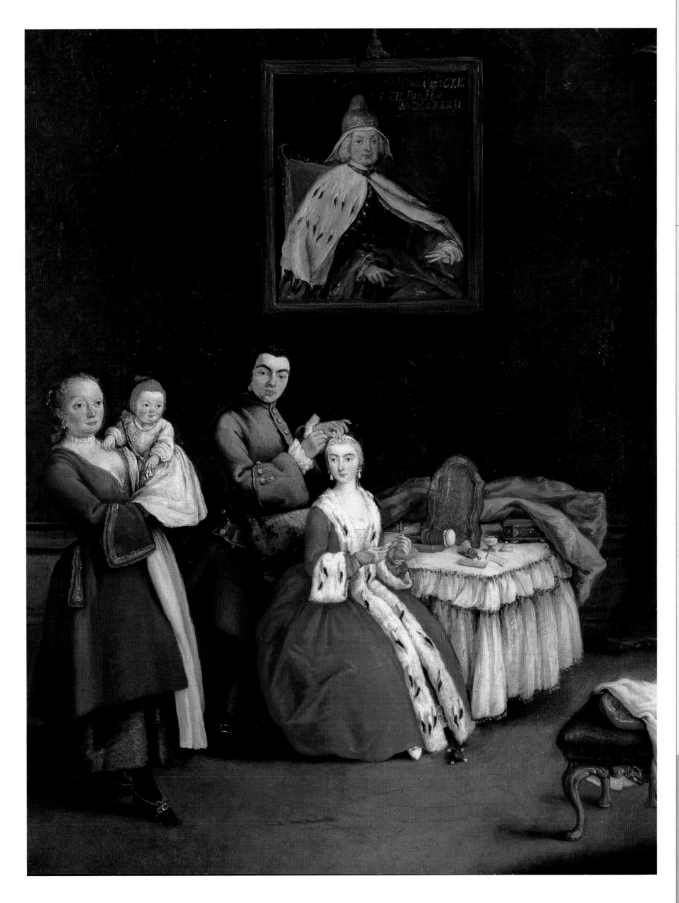

Alessandro Magnasco
The Riverbank, detail
1716.
Brignano Gera d'Adda
(Treviglio), Castello.

Alessandro Magnasco
(b. Genoa 1667, d. 1749)

Magnasco trained at a very young age under his father, Stefano. He was in Milan in 1677, working as an assistant to Filippo Abbiati. He earned considerable success from his genre scenes and worked as a figure painter for painters of real and capriccio landscapes (including Antonio Francesco Peruzzini, Clemente Spera, and Marco Ricci). He spent long periods of time in Florence between 1703 and 1711 under the patronage of Ferdinando de' Medici. He studied the work of Callot and the Dutch and Flemish masters in the grand duke's collections. He painted scenes depicting the life of the poor and courtiers. He lived in Milan until 1735, where he was in contact with families belonging to the "enlightened aristocracy." He disguised his satirical intentions—satire criticizing the lack of learning and culture, the failure to think and reflect, against prejudice and greed—in paintings that were striking for their pictorial qualities. According to contemporary biographies, toward the end of his career he was in Genoa.

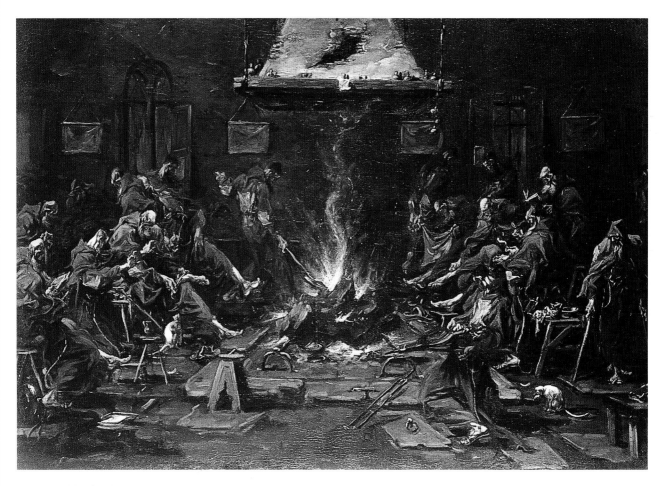

Alessandro Magnasco
Interior with Monks
c. 1725, oil on canvas.
Private collection.

Magnasco painted a number of scenes involving friars or monks, perhaps as a way to satisfy his keen taste for the bizarre. Executed with swift, masterly skill, the friars are depicted going about their silent labors or at rest around the hearth in gloomy, damp rooms. These scenes of monastery life, often teeming with figures and with more than a hint of the grotesque about them, stand in contrast to depictions of solitary hermits. Would it be legitimate to see an alter ego of the artist himself in this emaciated aesthete, induced into temptation?

Jean-Baptiste Oudry

(b. Paris 1686, d. Beauvais 1759)

Oudry received early training from Largillière and around 1720 began to paint animals, hunting scenes, and landscapes. In 1726, he designed cartons for tapestries. In 1734, he was appointed director of the Beauvais factory, which he helped revive, and in 1736, he was placed in charge of the Gobelins factory. Reproduced in tapestries, his drawings had wide-ranging impact upon contemporary French art. He was much sought after and received numerous commissions from aristocrats and crowned heads, including Louis XV, the tsar, the queen of Sweden, and Christian Ludwig von Mecklenburg-Schwerin. He painted wolves, boars, and deer in their natural habitats, in traps, or clashing with packs of royal hunting dogs. Toward the end of his career, he painted still lifes of hanging game in which the dead animals seem to stand out against light, neutral backgrounds in a trompe l'oeil effect. He produced illustrations for the *Fables* of La Fontaine, and in 1739 he painted the exotic animals present in the Versailles Menagerie.

Jean-Baptiste Oudry, *Portrait of Frederick Louis, Hereditary Grand Duke of Mecklenburg-Schwerin*, detail. 1739, oil on canvas. Schwerin, State Museum.

Jean-Baptiste Oudry
The Lacquered Footstool
Work signed and dated 1742, oil on canvas.

Anchored by the vivid red lacquer of the stool and the rich blue of the fabric, this painting is a demonstration of the artist's exquisite mimetic skills, especially in his creative rendering of surfaces and textures. Among the objects on the stool are some prints dated and signed by Oudry himself, as though the artist meant to establish a comparison between the graphic arts and painting.

Facing page:
Jean-Baptiste Oudry
*The Dachshund Pehr
with Dead Game and
a Rifle*
Work signed and dated
1740, oil on canvas.
Stockholm, National
Museum.

The majority of the
hunting dogs painted by
Oudry are depicted at
work, as it were, while
attacking a deer or
pointing out a bird in the
marshes. In the painting
shown here, the dog
Pehr, wrapped in soft,
delicate lighting, seems
to be posing quietly for
the artist as though he
were a household pet
rather than a hunting
dog. In the background
we can see a still life
with game.

Jean-Baptiste Oudry
*Demoiselle Crane,
Toucan and Tufted
Crane*, detail
1745, oil on canvas.
Schwerin, State Museum.

Oudry was exceptionally skilled at reproducing plumage. He revealed his secret in a
conference held in December 1752 at the Royal Academy: "The way to paint birds
is not the same as the technique to paint animals with coats or fur." The painting
shown here, part of a series dedicated to the animals in the Versailles Menagerie,
was commissioned for the royal botanical gardens by Monsieur La Peyronie, chief
surgeon to Louis XV.

Giovanni Battista Piazzetta
Self-Portrait
c. 1720, oil on canvas.

Giovanni Battista Piazzetta
(b. Venice 1683, d. 1754)

The son of a modestly talented sculptor, Piazzetta was living in Bologna in the first decade of the eighteenth century, where he became acquainted with Crespi. He settled in Venice in 1711 as the head of an established workshop, and in 1750, he was head of the school that would eventually become the Venice Academy. He was well known as the painter of large religious compositions (*Assumption*, 1753, Paris, Louvre), although he also executed medium-sized paintings depicting mythological and genre scenes. This "great talent for chiaroscuro," as Antonio Maria Zanetti described Piazzetta in 1733, was also open to the new trends in painting that were emerging in Venetian art. Traces of his careful study of the works of Sebastiano Ricci and the young Giambattista Tiepolo can be found in his paintings from the 1730s and 1740s, which are brighter and use more limpid tones.

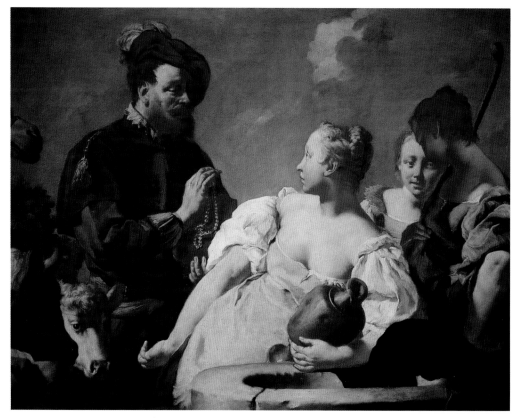

Facing page:
Giovanni Battista Piazzetta
Young Sculptor
Oil on canvas.
Springfield, Museum of Fine Arts.

A master at presenting his subjects wrapped in an intense, shadowy chiaroscuro, Piazzetta often preferred either rather brazen attitudes and expression for his models (as in his self-portraits) or looks of introspection. The unusually low point of view that the artist applies here gives the young man, shown wearing a rather flamboyant fur hat, a certain elegant reserve and unexpected sobriety.

Giovanni Battista Piazzetta
Rebecca at the Well
c. 1738, oil on canvas.
Milan, Brera Art Gallery.

This biblical episode becomes the pretext for a pastoral scene suffused with the warm, radiant sunlight of a late-spring or early-summer morning. The oblong composition is typical of the neo-Veronesi style, as are the close, serpentine figures and their sinuous bearing. Piazzetta also chooses a neo-Veronesi female model for Rebecca: blonde, sensual, her fine white skin almost alabaster. Animal heads and a number of clearly visible objects—the jug, the rope, the well itself, the shepherd's rod—provide a lively rustic framework for the principal scene.

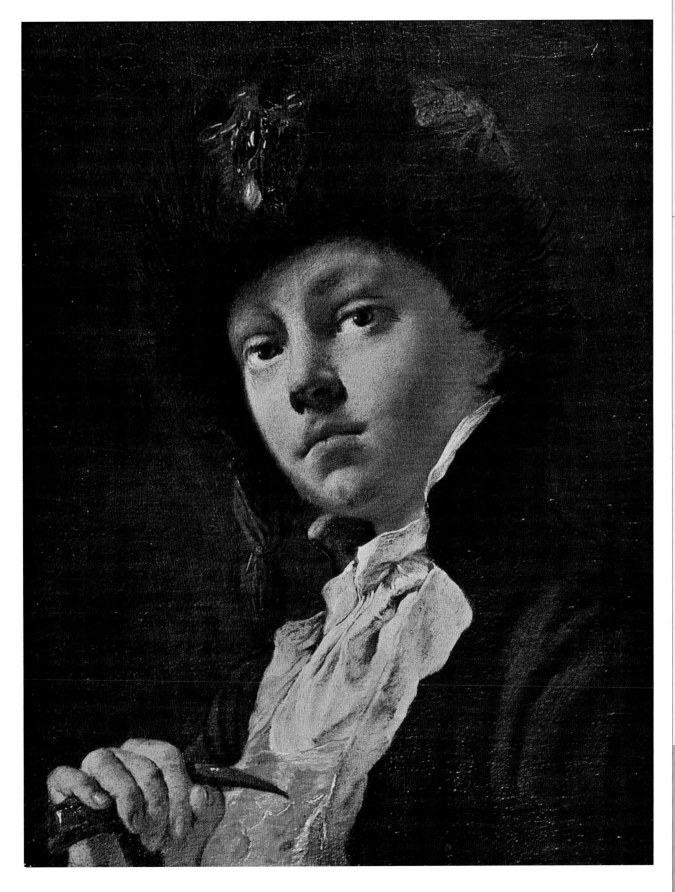

Joshua Reynolds
Self-Portrait, detail
c. 1756, oil on canvas.
Trustees of the Estate of
Countess Olive Fitzwilliam.

Joshua Reynolds
(b. Plympton 1723, d. London 1792)

Reynolds served his apprenticeship under the portrait painter Thomas Hudson. In 1749, he was traveling with Augustus Keppel, commander of the English fleet in the Mediterranean. He stayed in Rome until 1752, and during his journey back to England, he stopped in Florence, Bologna, Parma, Venice, and Paris. In 1753, he was once again in London and began to make a name for himself as a refined portrait painter. His home was a meeting place for artists, writers, actors, politicians, and aristocrats. He was a friend of Angelica Kauffmann, Edmund Burke, and Samuel Johnson. He spurred the Royal Society to take an interest in contemporary art, and he was one of the founders and the first president of the Royal Academy. In 1769, he received highly prestigious social recognition when King George III made him a knight. Between 1769 and 1790, he delivered fifteen lectures at the Royal Academy (his Discourses on Art), in which he illustrated his ideas as an artist and connoisseur.

Left:
Joshua Reynolds
Sir Joshua Reynolds, detail
1747–49, oil on canvas.
London, National Portrait Gallery.

Facing page:
Joshua Reynolds
Self-Portrait
1774, oil on canvas.
Florence, Uffizi Gallery.

On July 9, 1773, Reynolds was made a Doctor of Civil Law at Oxford University, and it is in this guise that he portrayed himself in the same year in an oval painting now in a private collection. In 1774, Reynolds painted himself again dressed in the same way for a canvas executed for the Florence gallery (following a suggestion by the German painter Zoffany). The Florentine portrait met with immediate acclaim and was much copied; in it, the greatest English portrait artist of his day is holding a roll of drawings copied from Michelangelo. The majestic form in the portrait does indeed allude to Michelangelo's "grand manner" and the colossal figures of the Sistine Chapel.

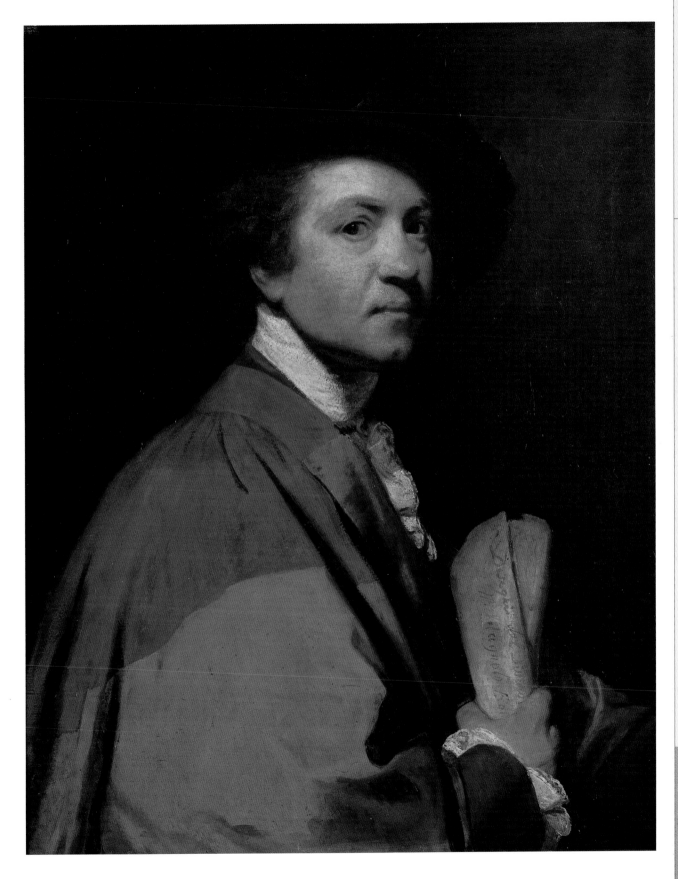

Joshua Reynolds
Lady Worsley
c. 1776, oil on canvas.
Earl and Countess of
Harewood and Trustees
of the Harewood House
Trust.

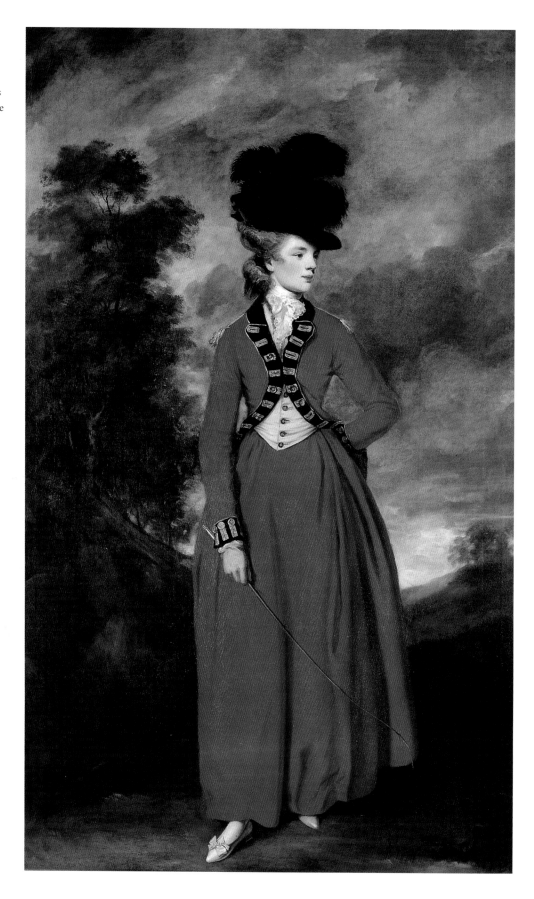

Sebastiano Ricci
(b. Belluno 1659, d. Venice 1734)

Sebastiano Ricci
Self-Portrait, detail
c. 1706, oil on canvas.
Florence, Uffizi Gallery.

At the age of fourteen, Ricci was already apprenticed to a workshop in Venice. During the 1680s, he worked in Bologna and Parma and then in Rome in 1691. He went to Vienna in 1702 and then Florence. He returned to Venice, where he received a number of important commissions, and remained there until he left for England. Between 1708 and 1712, he executed a series of mythological scenes for illustrious patrons, including Lord Burlington. After a brief stay in Paris, Ricci returned to settle in Venice. An established and acclaimed artist, Ricci was a leading exponent of *chiarismo*, the new trend shaping Venetian painting in the last years of the seventeenth century and first decades of the eighteenth century. The approach favored a limpid, bright style reminiscent of Veronese in the lighter, brighter palette used, in the carefully arranged architectural or Arcadian and pastoral settings, and in obvious preferences for visually striking layouts.

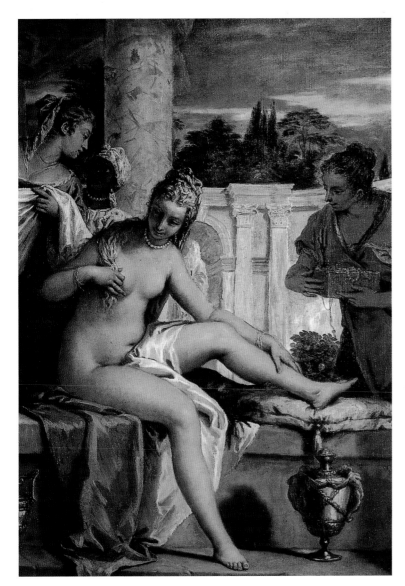

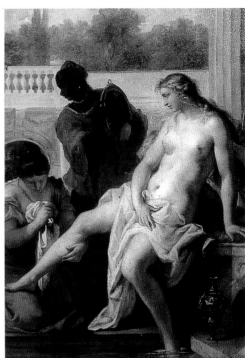

Sebastiano Ricci
The Toilette of Venus
Oil on canvas.
Berlin, State Museum of
Berlin.

Sebastiano Ricci
Bathsheba at Her Bath,
detail
c. 1724, oil on canvas.
Budapest, Museum of
Fine Arts.

Francesco Solimena
(b. Avellino 1657, d. Naples 1747)

Solimena began work in his father Angelo's workshop. Apart from his father, Solimena's first models were Massimo Stanzione and Giovanni Lanfranco. He worked in Naples between 1689 and 1690 on decorations for the sacristy of the church of San Paolo Maggiore, and during this time Solimena had an opportunity to study the innovations introduced by Luca Giordano. In Solimena's compositions from this period, the figures seem to dissolve into a radiant light. He did not hesitate to make use of profane elements in his religious scenes. He went to Rome toward the end of the century and met Maratta and other classical artists who frequented the Academy of France. At this point, Solimena's style suddenly shifted away from the Baroque. He returned to Naples and founded his own successful academy of painting, where students were taught, in strict adherence to the classical tradition, that "painting is no more than draftsmanship."

Francesco Solimena
Apelles Painting Pancaspe, detail
c. 1685, oil on canvas.
Detroit, Detroit Institute of Arts.

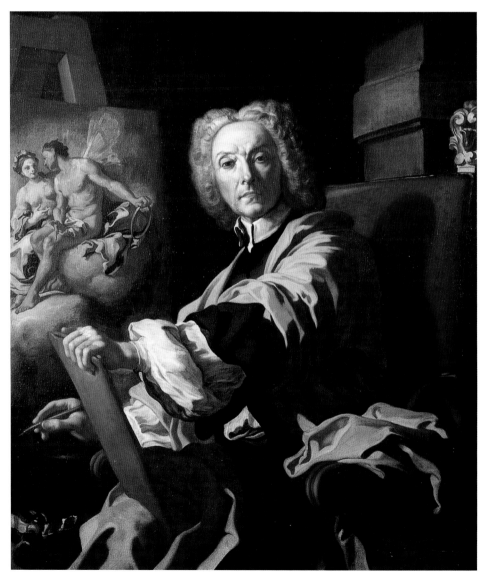

Francesco Solimena
Self-Portrait
c. 1715–20, oil on canvas.
Naples, Museo di San Martino.

Austere and inspired, Solimena portrays himself dressed as an abbot and, recognizably, as a painter. He is telling us that piety and moral scruples should accompany the pursuit of beauty; "studying what is natural," he establishes one of his most cherished principles: "you must do as much as you see, but rendering it in the painting, we must soften it, make it mannerly, noble and excellent." In the left hand is a folder for sketches and drawings, in the right a stylus. In the background we can see an unfinished canvas. A chaste and tender female figure seems to be exhorting a strangely winged male to seek out the ideal.

Francesco Solimena
The Vision of Saint Gregory the Wonder-Worker
c. 1680, oil on canvas.
Solofra (Avellino), San Domenico.

Commissioned by the artist's first protector, Cardinal Orsini, the painting reflects the awed understanding of Lanfranco, Solimena's young model, together with the growing interest for a light that is brighter, fairer than natural, that softly cloaks clothes and flesh. Solimena sets out an elaborate arrangement of light sources and a complex interplay of reflections; a soft, amber light seems to spread over the Virgin's face, while slanting rays of a warmer, more intense light fall upon the shoulder of Saint John and the page of the large book he is holding before pouring over the robe of Gregory, set in an attitude of adoration.

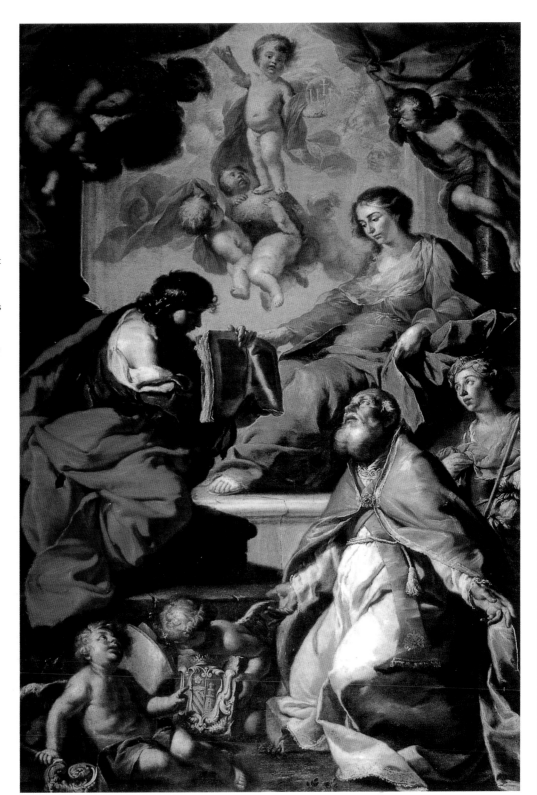

Pierre Subleyras
(b. Saint-Gilles-du-Gard 1699, d. Rome 1749)

Subleyras learned the basics of painting from his father, also a painter. In 1717, he worked in the studio of Antoine Rivalz in Toulouse. Rivalz had only recently returned from Italy, and the old painter's models were Poussin and the Bologna school. After the death of Rivalz, Subleyras went to Paris and won the Prix de Rome at his first attempt in 1727. In 1728, he traveled to Rome. In the Villa Medici he met Nicolas Vleughels, who introduced him to Watteau. He married Maria Felice Tibaldi, daughter of the composer and an accomplished miniaturist in her own right, and was introduced into Rome's ecclesiastical circles. He received a number of prestigious commissions for portraits and religious scenes. Pope Benedict XIV sat for him and commissioned two paintings for his private apartments. Subleyras also painted portraits of Rome's aristocrats. In 1748, he painted *Mass of Saint Basil* for Saint Peter's. The painting was eventually displayed in the church of Santa Maria degli Angeli and was enthusiastically admired, becoming, in effect, the crowning work in Subleyras's career.

Pierre Subleyras
Self-Portrait, detail, verso of
the atelier
1747–49, oil on canvas.
Vienna, Academy of Visual Arts.

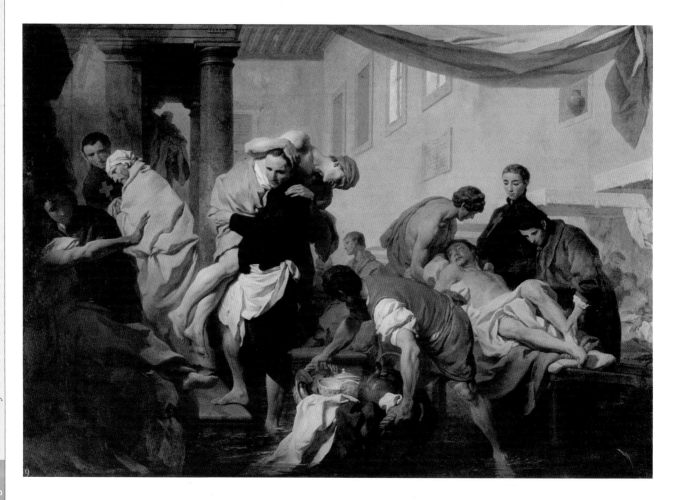

Pierre Subleyras
San Camillo de Lellis Coming to the Rescue of the Diseased
in the Hospital of the Holy Spirit
Work signed and dated 1746, oil on canvas.
Rome, Museo di Roma.

Facing page:
Pierre Subleyras
Charon Passing the Shades
c. 1735, oil on canvas.
Paris, Louvre.

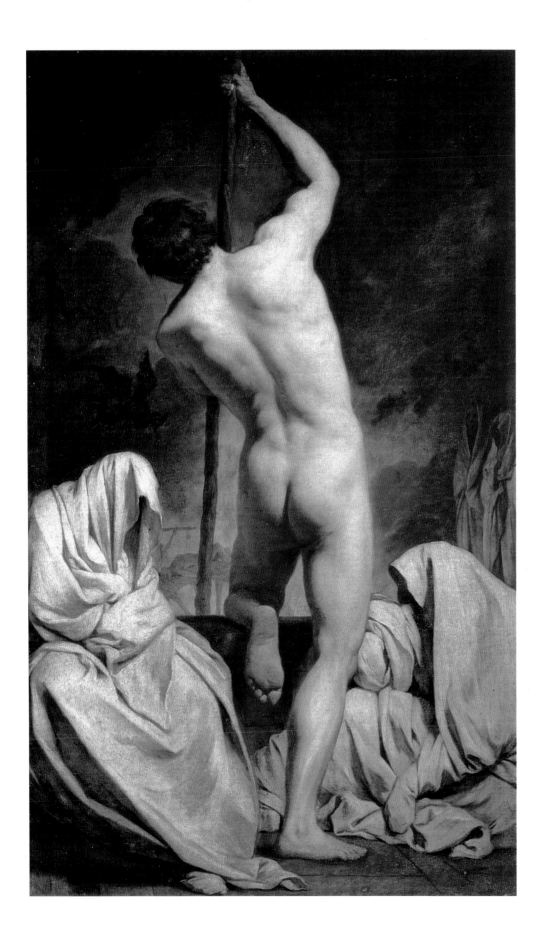

Giambattista Tiepolo
(b. Venice 1696, d. Madrid 1770)

Giambattista Tiepolo
Self-Portrait, detail from the
fresco cycle in the Imperial Hall
and the great stairway at
Würzburg. 1753, fresco.
Würzburg, Residence.

The son of Orsetta and Domenico Tiepolo, a sea trader, Giambattista was both a very accomplished artist and a capable businessman. He was the owner of a prosperous workshop that employed a number of assistants and was in charge of major projects. Two of his seven children worked with him: Giovanni Domenico (Giandomenico) and Lorenzo. He worked in Venice, Udine, and Milan. Tiepolo preferred to execute large narrative fresco cycles rather than paint a single canvas on the easel. In fact, in his quest to remain faithful to the grand Venetian decorative tradition, he did not paint the two genres that were highly fashionable at the time, portraits and views. He was a very knowledgeable connoisseur of Paolo Veronese. Between 1750 and 1753, he worked on the decorations of the Kaisersaal in Würzburg and on the grand staircase of the residence of Prince Bishop Karl Philipp von Greiffenklau. Summoned by Charles III, in 1762 he went to Madrid, where he later died after having encountered the new generation of Neoclassical artists.

Facing page:
Giambattista Tiepolo
Africa, detail
1752–53, fresco.
Würzburg, Residenz.

The allegorical personification of Africa sits astride a camel, regal and imposing in bearing, the face of a servant just at her shoulder. A page boy in the foreground, seen from behind, seems to be genuflecting before Africa. He holds a parasol, burns incense, and carries a quiver. A large blue vase is set on the ground, next to two partially hidden elephant tusks; a fold of valuable fabric tumbles down from the trompe l'oeil frame. Africa's attributes are goods: spices, weapons, silk, ivory. The friezes of the continents show the lively trade that takes place between peoples who are often very distant from one another.

Giambattista Tiepolo
*Death Grants an
Audience*
c. 1735, etching.
Padua, Municipal
Museum.

Produced in the space of a few years and almost certainly published in a limited edition for Antonio Maria Zanetti, the erudite Venetian bibliophile, the *Capricci*, together with the later *Scherzi di Fantasia*, form the whole of Giambattista Tiepolo's corpus of etchings. Bizarre, enigmatic, and heavily characterized in posture, stance, and appearance, the *Capricci* and *Scherzi* were hungrily sought after by collectors from all over Europe as soon as they were published, including the grand dukes of Saxony and Dresden, Pierre-Jean Mariette in Paris, and Joseph Smith, the British consul in Venice.

Giambattista Tiepolo
Antony and Cleopatra
c. 1745–48, fresco.
Venice, Labia Palace.

Summoned to decorate
the walls of the Labia
family's Venetian home,
Tiepolo worked with
Girolamo Mengozzi
Colonna, a specialist in
painting complex trompe
l'oeil compositions, or an
expert *quadraturista*, to
use the contemporary
Italian expression. The
two most famous lovers
in Roman history make
their way to their first
encounter in the
foreground of the
painting, through a
crowd of page boys,
elderly courtiers, and
servants; we see the
lovers through an arch
supported by columns
and pilasters (all painted
by Mengozzi Colonna).
To the right, at the top
of the painting and only
partially visible, we can
make out sails blown by
the wind, rigging, masts,
and sailors climbing them.

Giandomenico Tiepolo
*Pulcinella Painting a Tiepolo
(Pulcinella, Painter of Historical
Subjects)*, detail. 1797–1804,
pencil, charcoal, and ink on paper.

Giandomenico Tiepolo
(b. Venice 1727, d. 1804)

His father's pupil and later assistant, Giandomenico was a keen observer and versatile artist. Like his father, he had a taste for the bizarre and an easy, ample technique in applying the brush. He went on to display his own mature artistic personality and admirable independence in his frescoes for Villa Valmarna and the family home in Villa Zianigo (today conserved in Ca' Rezzonico) and in his astonishing sketches of Punchinello ("Pulcinella), the character from *commedia dell'arte*. He had a talent for comedy and painted idyllic country scenes that were so incredibly natural that they could have been painted from real life (although the paintings were larger than life-size). He was a careful observer of light and lighting effects, and he was especially attracted by radiant early morning light. He manages to bestow an inexplicable beauty on his masks, even the rather deformed and grotesque examples. From 1750 to 1753, he worked alongside his father in Würzburg and then accompanied him to Madrid. He returned to Venice after his father's death and was nominated president of the academy of painting.

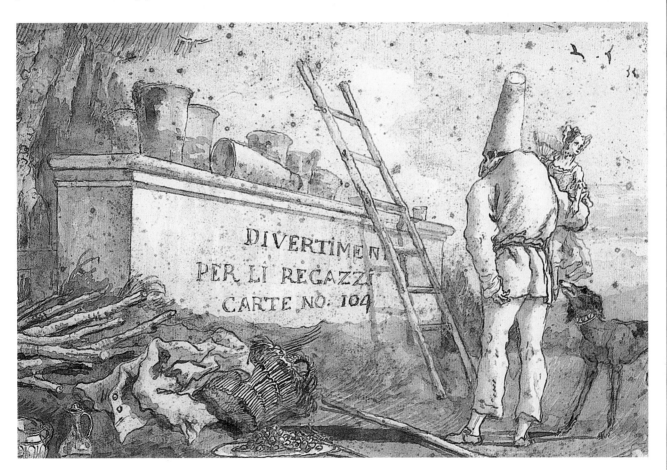

Giandomenico Tiepolo
Frontispiece, from the collection
Life of Pulcinella
1797–1804, pencil, charcoal,
and ink on paper.
Kansas City, Nelson Gallery-
Atkins Museum (Nelson Fund).

Broken up in 1921, this collection of drawings charting the life of Pulcinella is a late work, pervaded with subtle nostalgia. The artist began the series of 104 drawings when he was seventy, and it ended with his death in 1804. It is difficult to establish any clear narrative timeline. Tiepolo, in effect, bestows human traits and behavior on one of the traditional *commedia dell'arte* masks. Pulcinella is by turns brash, coarse, voracious, violent, and disloyal. His world mirrors our own: it is an alternating succession of joys and sorrows, of gratification and pain.

Luigi Vanvitelli
(b. Naples 1700, d. Caserta 1773)

Son of Gaspar van Wittel, the celebrated Dutch *vedutista* resident in Rome, Vanvitelli studied with his father in preparation for becoming a painter. He established a reputation for himself as an architect only after 1730. He worked in Rome, where he took part in the competition for the facade of Saint John Lateran, and elsewhere in central Italy (Perugia, Siena, Loreto, and Ancona). In 1751, he was summoned to Naples. Charles III of Bourbon planned to renovate the city by financing prestigious building projects. He gave Vanvitelli the task of building the new royal residence at Caserta. A versatile architect, Vanvitelli brought a sober and carefully studied approach to executing his commissions. He also worked extensively as a civil engineer, designing barracks, villas (including the Villa Campolieto at Resina, 1766), and churches (Santissima Annunziata, Naples, 1761).

Giacinto Diano
Portrait of Luigi Vanvitelli
c. 1762, oil on canvas.
Caserta, Royal Palace of Caserta.

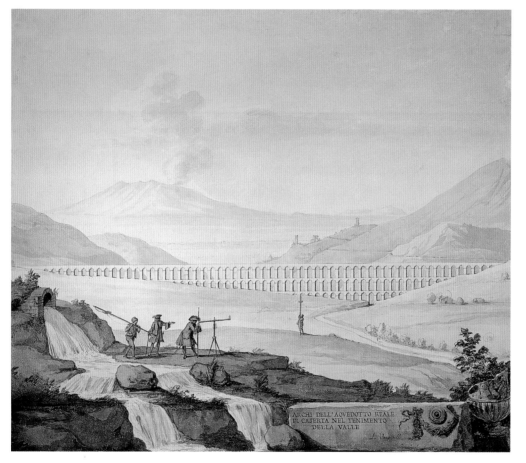

Luigi Vanvitelli
The Aqueduct
1752, pen, gray ink, and watercolor on paper.
Caserta, Royal Palace of Caserta.

The aqueduct was designed to bring water to the palace at Caserta and to guarantee a water supply to the city of Naples (in the end it was never used for the second purpose). The foundations were laid in 1753 and the aqueduct was completed in 1759. Against the background of a charming and picturesque landscape, the view shows the part spanning the valley, the aesthetic centerpiece of the whole project; with its three orders of arches, it recalls the Roman Pont du Gard in Provence (France).

Facing page:
Luigi Vanvitelli
View of the Castle from the Fountain of Venus and Adonis
1752–74. Caserta, Royal Palace of Caserta.

Characterized by the restrained elegance of its exterior and the hyperbolic flamboyance of its interiors, with its 1,200 rooms, facades, hexagonal central hallway, and immense grand staircase, the Reggia di Caserta (Palace of Caserta) easily rivals the great royal residences of Europe, first and foremost Versailles. The rectangular palace is 810 ft. (247m) on its longer sides and 604 ft. (184m) on its shorter sides, with four courtyards designed as parade grounds. The palace is set in grounds extending for 296 acres (120 hectares). It was Vanvitelli's intention that visitors be pleasantly surprised to come across statues of heroes from classical mythology as they made their way through the woods, ponds, and fountains.

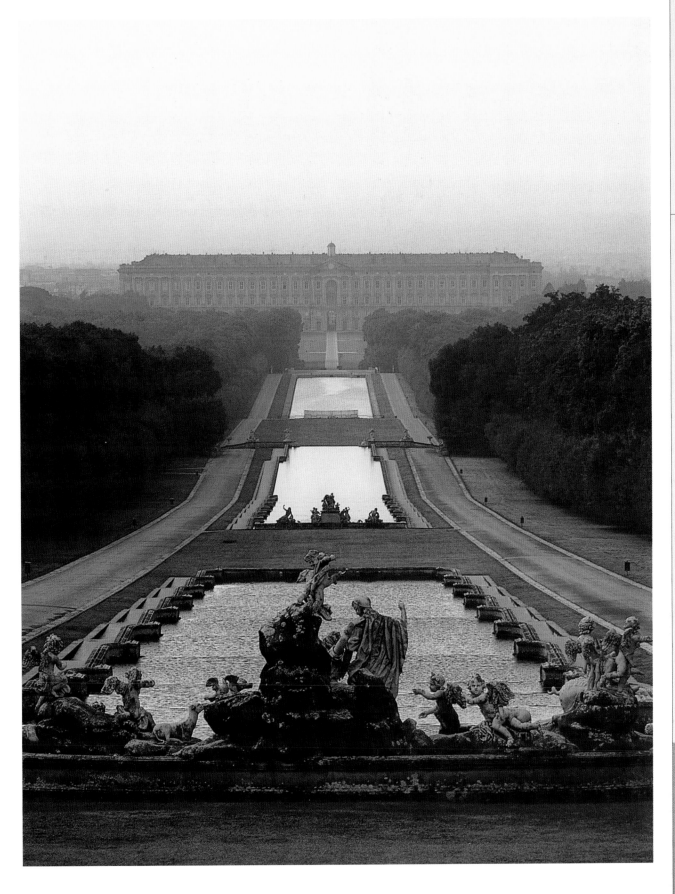

Jean-Antoine Watteau
The Shop Sign, detail
1720, oil on canvas.
Berlin, Charlottenburg Palace.

Jean-Antoine Watteau
(b. Valenciennes 1684, d. Nogent-sur-Marne 1721)

The son of a drunken, violent tile-maker, Watteau began his career painting local people, from shopkeepers to street jesters. He went to Paris in 1702 and met Pierre Mariette. In 1703, he worked in the studio of Claude Gillot, who helped Watteau develop his interest in the theater and the *commedia dell'arte*. In 1708, he studied under Claude Audran, decorator and curator at the Palais de Luxemborg, discovering the series of paintings Rubens executed for Maria de' Medici. He also contributed to establishing chinoiseries and singeries as prized art forms. His very human-looking monkeys satirized pedantic painters devoid of talent. In 1709, he left Paris and moved to Valenciennes. He painted a number of military scenes. Upon his return to Paris, he made the acquaintance of Pierre Crozat, who collected drawings. He competed for the Prix de Rome in 1712, and while his work was acknowledged and appreciated, he did not receive the prize. He became a member of the Royal Academy in 1717, and the institution created a new genre for him, the *fêtes galantes*.

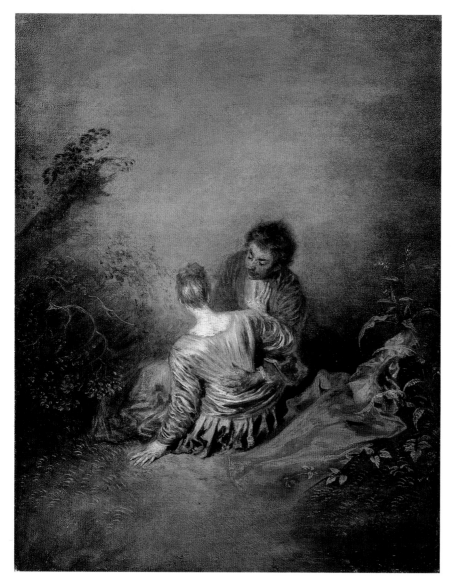

Left:
Jean-Antoine Watteau
Le Faux Pas (The Mistaken Advance)
c. 1717–18, oil on canvas.
Paris, Louvre.

This composition dealing with female virtue and amorous passion, much like *The Toilette* (facing page), is part of the Flemish tradition of licentious and moralizing genre pieces. Watteau makes playful use of the ambiguity inherent in the episode: in fact, we do not know if the young man's insistence will overcome the girl's sense of modesty.

Facing page:
Jean-Antoine Watteau
The Toilette
c. 1717–18, oil on canvas.
London, Wallace Collection.

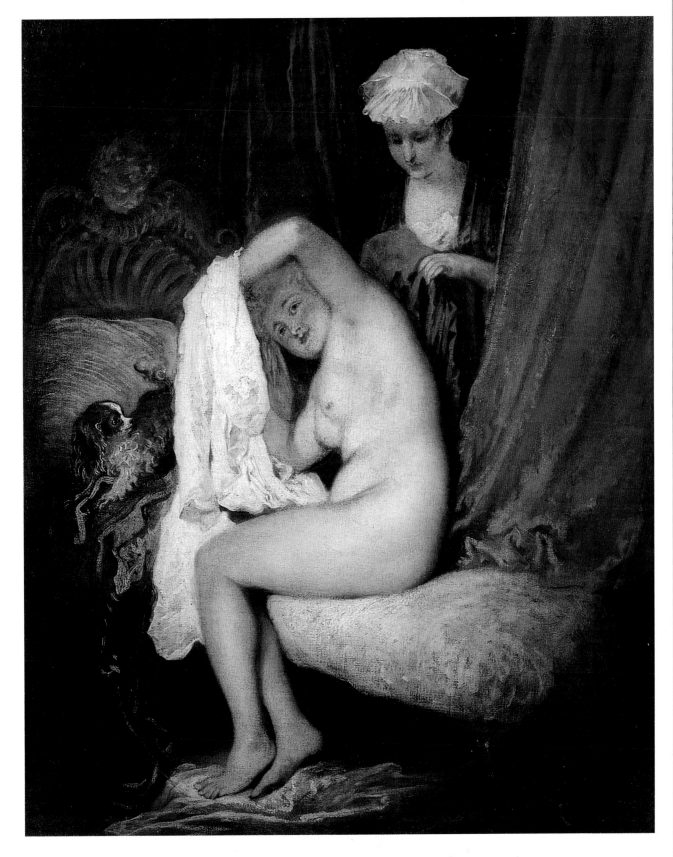

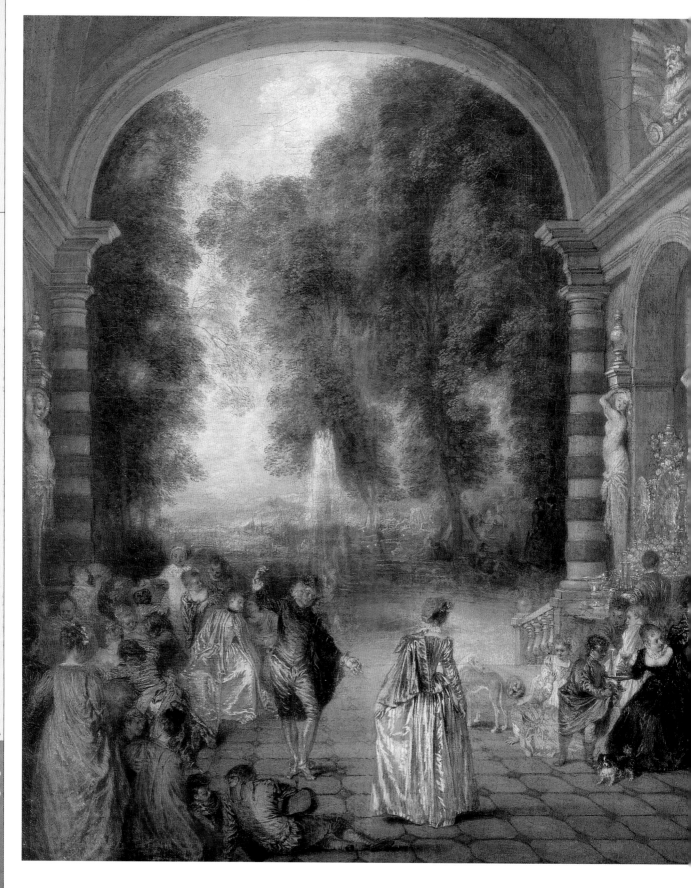

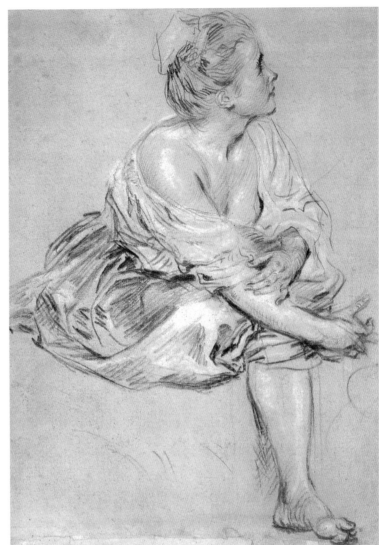

Jean-Antoine Watteau
Pleasures of the Ball
1716–17, oil on canvas.
Dulwich Picture Gallery.

This sumptuous, imaginary setting, with obvious
classical influences, opens onto an idyllic landscape,
and in the distance we can make out a city. This is the
charming theater, where musicians, actors, lovers,
children, dogs, and servants play out life's comedy.
The evident enjoyment of the time spent here does
not seem to offset completely the vein of melancholy
that Watteau appears to be unable to shrug off. This is
one of the great French painter's most controversial
pieces and a series of X-rays has revealed how the
artist made a number of changes to the original scene.
Here, reality and imagination blur to produce an
astounding composition.

Jean-Antoine Watteau
Seated Young Woman
1715–16.
Black, red, and white
chalk on paper
New York, Morgan
Library and Museum.

A painter of
extraordinary talent,
Watteau was also an
exceptional draftsman
during his brief life,
among the greatest of his
age, as is clear from this
preliminary sketch.

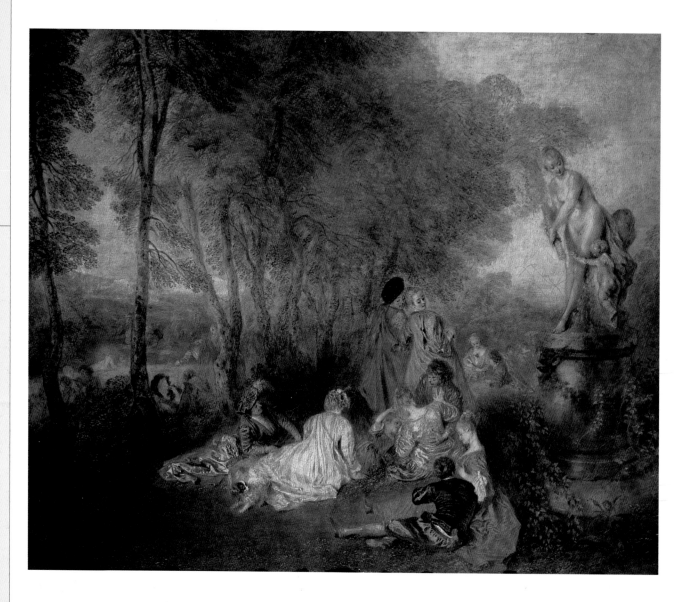

Jean-Antoine Watteau
The Feast of Love
1717, oil on canvas.
Dresden, Old Masters Picture Gallery.

Two young couples enjoy some time together in a
park, at the foot of a group of statues representing
Venus and Cupid. The amorous pleasures of the
young people are thus inspired by the goddess of love.
Some scholars believe that Watteau's source for the
group of statues was Niccolò dell'Abate.

Facing page:
Jean-Antoine Watteau
Pierrot (Gilles)
c. 1718–19, oil on canvas.
Paris, Louvre.

The painting, perhaps originally used as a shop sign for
a café opened by the Italian actor Belloni upon his
retirement from the stage, is among the most enigmatic
creations in the history of art. Acquired by the Louvre
in 1804, it is thought to represent Gilles, a character
from French theater in the seventeenth and eighteenth
centuries, or more probably Pierrot, a character from
the *commedia dell'arte* (Pedrolino in Italian).

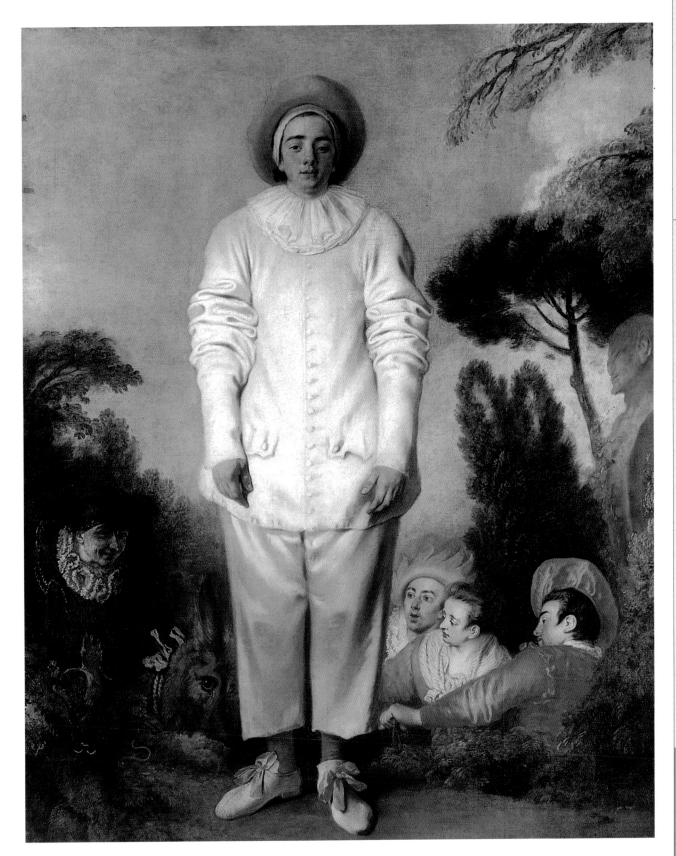

Bibliography

ALPERS, SVETLANA. *The Making of Rubens.* New Haven-London: Yale University Press, 1995.

——. *Rembrandt's Enterprise: The Studio and the Market.* Chicago: University of Chicago Press, 1988.

ALPERS, SVETLANA and Michael Baxandall. *Tiepolo and the Pictorial Intelligence.* New Haven-London: Yale University Press, 1994.

ATKINS, CHRISTOPHER. *Frans Hals's Virtuoso Brushwork.* Zwolle, the Netherlands: Nederlands Kunsthistorisch Jaarboek, 2004.

BACCHI, ANDREA, CATHERINE HESS, JULIAN BROOKS, et al, eds. *Bernini and the Birth of Baroque Portrait Sculpture.* Malibu: J. Paul Getty Trust Publications, 2008.

BAETJER, K., AND J. G. LINKS. *Canaletto.* (Exh. cat., Metropolitan Museum of Art, New York). New York: Abrams, 1989.

BAILEY, COLIN B., PHILIP CONISBEE, AND THOMAS W. GAEHTGENS. *Au temps de Watteau, Chardin et Fragonard: Chefs-d'oeuvre de la peinture de genre en France.* Paris: La Renaissance du Livre, 2003.

BAUER, HERMANN AND ANDREAS PRATER. *Baroque.* Cologne: Taschen, 2006.

BUSSAGLI, MARCO. *Understanding Architecture* (first Italian edition: *Capire l'architettura,* Giunti, Firenze 2003). New York: M. E. Sharpe Reference, 2004.

CAPON, E. AND G. VAUGHAN, eds. *Caravaggio and His World: Darkness and Light* (Exh. cat.). Victoria: Art Gallery of New South Wales, 2003.

Caravaggio: The Final Years (Exh. cat., Capodimonte, Naples, and National Gallery, London, 2004–5). London: National Gallery, 2005.

CHRISTIANSEN, KEITH, AND PIERRE ROSENBERG, eds. *Poussin and Nature: Arcadian Visions.* (Exh. cat.). New York: Metropolitan Museum of Art, 2008.

COFFIN, SARAH D. *Rococo: The Continuing Curve, 1730–2008.* New York: Assouline, New York, 2008.

COSTANTINO FIORATTI, HELEN, AND GLORIA FOSSI, ed. *Il mobile italiano.* Florence: Giunti, 2004.

CUZIN, JEAN-PIERRE. *Fragonard,* Drawing Gallery series. Milan: 5 Continents Editions, 2006.

DROGUET, VINCENT, XAVIER SALMON, AND DANIÈLE VÉRON, *Animaux d'Oudry. Collection des ducs de Mecklembourg-Schwerin.* Paris: RMN, 2003.

ENGGASS, ROBERT, AND JONATHAN BROWN. *Italian and Spanish Art 1600–1750: Sources and Documents.* Evanston, IL: Northwestern University Press, 1993.

FOSSI, GLORIA, ed. *Le Portrait* (Italian edition: *Il ritratto: gli artisti, i modelli, la memoria*). Paris: Gründ, 1996.

——. *Le nu* (Italian edition: *Il nudo: eros, natura, artificio*). Paris: Gründ, 1999.

——. *Uffizi: Art, History, Collections* (first edition 2005). London: David & Charles, 2007.

FOSSI, GLORIA, MATTIA REICHE, AND MARCO BUSSAGLI. *Italian Art: Painting, Sculpture, Architecture from the Origins to the Present Day* (first edition: *Arte Italiana,* Firenze 2000). Florence: Giunti, 2008.

Fragonard, Les plaisirs d'un siècle in the Jacquemart-André Museum. (Exh. cat.). Paris: Musée Jacquemart-André, 2007.

GREGORI, MINA. *Caravaggio.* Milan: Electa, 1990.

GREGORI, MINA AND ERICH SCHLEIER, eds. *La pittura in Italia. Il Seicento,* 2 vols. Milan: Electa, 1989.

HASKELL, FRANCIS. *Patrons and Painters: A Study in the Relations Between Italian Art and Society in the Age of the Baroque* (first edition 1963), revised edition. New Haven-London: Yale University Press, 1980.

HENNING, ANDREAS, SCOTT SCHAEFER, CHARLES DEMPSEY, et al., eds. *Captured Emotions: Baroque Painting in Bologna 1575–1725.* Malibu: J. Paul Getty Trust Publications, 2008.

HYDE, MELISSA. *Making Up the Rococo: Francois Boucher And His Critics.* Malibu: J. Paul Getty Trust Publications, 2006.

Jean-Etienne Liotard: 1702–1789: Masterpieces from the Musées d'Art et d'Histoire of Geneva and Swiss Private Collection. (Exh. cat., Musée d'Art et d'Histoire, Geneva, and the Frick Collection, New York). Paris: Somogy, 2006.

La luce del vero: Caravaggio, La Tour, Rembrandt, Zurbarán (Exh. cat., Galleria d'Arte Moderna e Contemporanea, Bergamo). Milan: Silvana, 2000.

MEIJER, BERT W. *Vermeer: La ragazza alla spinetta e i pittori di Delft.* (Exh. cat., Galleria Estense, Modena, 2007). Florence: Giunti, 2007.

MILLON, HENRY A. *The Triumph of the Baroque. Architecture in Europe 1600–1750* (Exh. cat., Turin/Montreal/Washington, Marseille). London-New York: Phaidon, 1999.

MORRISSEY, JAKE. *The Genius in the Design: Bernini, Borromini, and the Rivalry that Transformed Rome.* New York: William Morrow & Company, 2005.

Nicolas de Largillière 1656–1746, (Exh. cat., Musée Jacquemart André, Paris), Paris 2003.

PUGLISI, CATHERINE. *Caravaggio,* London-New York: Phaidon, 1998–2000.

Rembrandt-Caravaggio, (Exh. cat.). Amsterdam: Van Gogh Museum, 2006.

ROSENBERG, PIERRE. *From Drawing to Painting: Poussin, Watteau, Fragonard, David & Ingres* (the Mellon Lectures). Princeton, NJ: Princeton University Press, 2000.

SPIKE, JOHN T. *Caravaggio.* New York: Abbeville, 2001.

SUTHERLAND HARRIS, ANN. *Seventeenth Century Art and Architecture.* New York: Prentice Hall, 2008.

TOMAN, ROLF, ed. *Baroque: Architecture, Sculpture, Painting* (first edition Konemann, Cologne, 2004). Königswinter, Germany: H. F. Ullman, 2008.

Uylenburgh & Son: Art and Commerce from Rembrandt to De Lairesse, 1625–1675. (Exh. cat., Dulwich Picture Gallery, London, the Rembrandt House, Amsterdam). Amsterdam: Waanders Uitgevers, 2006.

VIDAL, MARY. *Watteau's Painted Conversations: Art, Literature, and Talk in Seventeenth and Eighteenth-Century France.* New Haven-London: Yale University Press, 1992.

WHEELOCK, ARTHUR K. *Dutch Paintings of the Seventeenth Century.* New York: Oxford University Press, 1996.

———. *Vermeer: The Complete Works.* New York, Abrams, 1997.

WITTKOWER, RUDOLF. *Art and Architecture in Italy 1600–1750* (first edition Penguin, Harmondsworth, 1958), New Haven-London, Yale University Press, 1999.

Index

Note: Page numbers in *italics* indicate works of art.